Stirling Art Club.

TURNER ABROAD

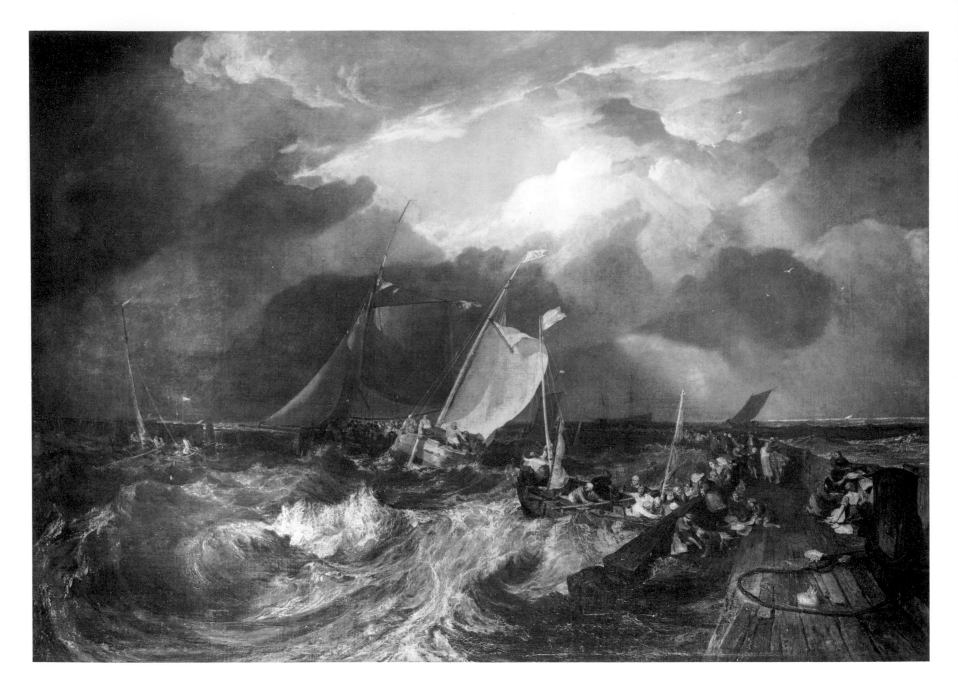

J. M. W. Turner, *Calais Pier, with French poissards preparing for sea : an English packet arriving*, RA 1803. Oil on canvas. 1720 × 2400 mm. The National Gallery, London (472)　B/J 48

TURNER ABROAD

France Italy Germany Switzerland

ANDREW WILTON

A COLONNADE BOOK

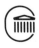

PUBLISHED BY BRITISH MUSEUM PUBLICATIONS LIMITED

Colonnade books
are published by British Museum Publications Ltd
and are offered as contributions to the enjoyment,
study and understanding of art,
archaeology and history.

The same publishers also produce the official
publications of the British Museum.

Reprinted 1984
British Library Cataloguing in Publication Data

Turner, J. M. W.
 Turner abroad. – (A Colonnade book)
 1. Turner, J. M. W. 2. Europe in art
 I. Title II. Wilton, Andrew
 759.2 ND1942.T8

ISBN 0 7141 8047 5

Published by British Museum Publications Limited,
46 Bloomsbury Street, London WC1B 3QQ

Designed by Sebastian Carter
Set in Monophoto Ehrhardt
and printed in Great Britain by Balding + Mansell Limited

Contents

Foreword

Photographic Acknowledgments

The collection of Turner's watercolour drawings assembled in this book has been brought together, first, to give pleasure and, second, to provide easy reference to a number of works that have not often been reproduced. For these reasons, the anthology includes sheets both familiar and unfamiliar; but it is hoped that they will also be seen as illustrating Turner's developing relationship with European landscape and culture. The subjects have been chosen with a deliberately topographical bias, so that Turner's early and enduring concern for the depiction of places acts as a unifying element among the amazing variety of his perceptions and techniques.

In the preparation of this book I have received invaluable help from Martyn Tillier and the Staff of the British Museum Print Room. The photography is the work of Stanley Parker-Ross, and the text has been edited by Celia Clear, whose idea the book was, and Johanna Awdry. To these, and especially to Ann Forsdyke, who has assisted in numerous ways, I extend my grateful thanks.

A.W.

All the sketches and watercolours reproduced are from the Department of Prints and Drawings in the British Museum except where otherwise indicated.

All photographs except those listed below have been taken by Mr Stanley Parker-Ross on behalf of British Museum Publications, who hold the copyright.

The author and publishers are grateful to the following for permission to reproduce photographs:

The Frick Collection, New York page 52
The Tate Gallery pages 11, 25, 27, 43, 45, 60, 74
The Trustees of The British Museum pages 14, 15, 16, 17, 19, 20, 24, 32, 35, 44, 50, 51, 53, 62
The Trustees of The National Gallery page 2
Yale Center for British Art page 23
Walker Art Gallery page 57

Introduction

I was born in 1750, when no man of sophistication would have dreamed of talking about Love of Country, or Native Earth. We were men of Europe, and that was enough.

Peter Shaffer, *Amadeus.*

As Turner lay dying in the winter of 1851, an old man of seventy-six, he was attended by a Dr Bartlett, who later recalled that the painter had 'offered should he recover to take me on the Continent and shew me all the places he had visited'. Such a guided tour would indeed have been a fitting token of his gratitude. Turner's European travels were, next to the works of art that they engendered, among his most prized pleasures; partly for the very reason that they stimulated his genius to a remarkable degree. Old, frail and exhausted, he hankered still after the foreign parts in which he had found so much of his inspiration.

The frequency of his visits to Europe during his active life was exceptional, even for a painter who specialised in landscape and topographical subjects. Unlike many of his contemporaries, who were content to make notes for a lifetime's output during one or two tours abroad, Turner seems to have needed the constant recharging of mind and spirit that travel afforded. This fact in itself says much for the level of his response to the places he visited. It was certainly not the case that he needed to refresh his memory; that served him vividly enough. Between 1817, when he first took advantage of the reopening of Europe after the French wars, and 1845, when the infirmities of old age confined him at home, he made no less than eighteen Continental journeys, which took him as far afield as Naples, Berlin, Vienna and Prague. His first sally abroad had taken place in 1802, when he was twenty-seven and newly elected a member of the Royal Academy, eager for those Continental experiences that his professional colleagues regarded as formative and indispensable for a serious artist. But he did not restrict himself to the well-worn routes between London and Rome. Over the years he evolved an entirely personal relationship with the Continent, a relationship that cannot be accounted for simply in terms of conventional practice, for his approach to landscape was never conventional. His needs and perceptions were distinctively different from those of other artists. He was not merely a topographer, gleaning 'views' of places that would be recognised by tourists, although he was all the same the greatest of the tourists' topographers. He sought to record and convey in his art a deeper understanding of the complex organism, natural, cultural and social that was Europe. During his long lifetime that organism underwent far-reaching changes which were observed with the utmost interest from England.

The English have always enjoyed a strangely ambiguous relationship with the great Continent to which their island lies so close, but from which it is so decisively cut off by the Channel. They have been able, thanks to this isolation, to cultivate their prejudices undisturbed by outside pressures. They have been free to believe themselves the greatest of nations, or the feeblest of nations, and consequently to find in Europe all that is evil, or all that is good. They have fostered a sense of virtuous pride in leading Europe out of the Middle Ages into modern constitutional democracy, even while despising themselves for the

inadequacies of their own system and the vulgarity of their emancipated classes. The twenty-five-year-old Matthew Arnold expressed something of this ambiguous sense of isolation and independence when he wrote in 1848: 'I am not sure but I agree in Lamartine's prophecy that 100 years hence the Continent will be a great united Federal Republic, and England, all her colonies gone, in a dull steady decay'. Arnold's contemporaries were, on the whole, less inclined to be critical and gave vent to their feelings of insularity with jingoistic self-confidence, imbibing as they were those intoxicating draughts of commercial prosperity, laced with the diplomatic bravura of Palmerston, which led to that orgy of justified self-satisfaction, the Great Exhibition of 1851.

Yet Arnold was, in G. M. Trevelyan's phrase, 'poet and prophet of the age he abused', and the smugness of the early Victorians was naturally disturbed by the events on the Continent of 1848. They were, after all, only demonstrating that sense of pride in national identity which was one of the mainsprings of the 'year of revolutions'. It was at the root of Lamartine's own remark. The French poet-revolutionary saw the 1848 uprisings in his own country and across Europe as 'the sublimest of poems', an epic of the profoundest significance for the future of the whole Continent. But while the countries of Europe – Germany, Austria, Hungary and Poland, as well as France – were convulsed in rebellion, Britain was enjoying the benefits of a burgeoning economy bolstered by a newly won national serenity due to the popularity of the young Queen Victoria and her Consort, and to the socially palliative domestic policies of Sir Robert Peel. Surveying Europe, the English had much to be thankful for, and a little to be afraid of.

Theirs was, in any case, a security that was very new. For most of the first half of the century, the confusion spread by the French Revolution, which had flared up in 1789, and the ensuing wars in which Britain was almost continuously involved from 1793 to 1815, had resulted in widespread economic and social disorder. The fear, first of Jacobin sedition, later of invasion by Napoleon, kept the nation in a state of chronic disarray, but reinforced all the same its real cohesion. There was an element in the chaos that the English could recognise as valuable and, indeed, exciting. As the new Europe painfully emerged, the idea that drew together all the strands of Britain's isolation was the notion of Liberty. The revolutionary French had popularised the word as a slogan, but in so far as the struggling peoples of Europe sought Liberty, they followed in Britain's enlightened footsteps; in so far as they suffered under harsh tyrannies, they were set apart, to be pitied or succoured, but were not members of the privileged club. The habit of seeing Europe in terms of its political conditions, and of assessing those conditions as they approached or diverged from the ideal of British Liberty, was well entrenched. If the French Revolution and Napoleon's wars of conquest had given fresh point to the theme, it was the War of the Spanish Succession and the triumphs of Marlborough a hundred years earlier which had called forth the first expressions of patriotic fervour specifically linked with the concept of Liberty. The then quite recent Glorious (and bloodless) Revolution of 1688, followed by the Act of Union with Scotland in 1707, had settled the Kingdom on a course of peace and prosperity that was to last, interrupted only by the Napoleonic threat, substantially until 1914. Already in 1701 Joseph Addison, on the Grand Tour that had become obligatory to the English gentleman, could temper his admiration of the 'Classick ground' of Italy with the reservation that politically the Italians were in an unacceptable state:

How has kind Heaven adorn'd the happy Land
And scatter'd Blessings with a wasteful hand!
But what avail her unexhausted Stores,
In blooming Mountains, and her sunny Shores,
With all the Gifts that Heaven and Earth Impart,
The Smiles of Nature, and her Charms of Art;
While proud Oppression in the Valleys reigns,
And Tyranny usurps her happy Plains?

Indeed, he argued, it was better to have none of the cultural and climatic advantages of Italy, but to enjoy political freedom:

O Liberty, thou Goddess heav'nly bright,
Profuse of Bliss, and pregnant with Delight,
Eternal Pleasures in thy Presence reign,
And smiling Plenty leads thy wanton Train!
Eas'd of her load, Subjection grows more light,
And Poverty looks cheerful in thy Sight;
Thou mak'st the gloomy face of Nature gay,
Giv'st beauty to the Sun and Pleasure to the Day. . . .
'Tis Liberty that crowns Britannia's Isle,
And makes her barren Rocks and her bleak Mountains smile.

The moral superiority thus conferred gave Britain a special role *vis-à-vis* Europe:

'Tis Britain's Care to watch o'er Europe's Fate,
And hold in balance each contending State,
To threaten bold presumptuous Kings with War,
And answer her afflicted Neighbour's Pray'r.

(*A Letter from Italy, to the Right Honourable Charles, Lord Halifax*, 1701, published 1709)

It became increasingly difficult for the British to travel in Europe without applying this touchstone wherever they went. The whole of history could be read as an heroic pursuit of political freedom. Europe was the stage on which that drama, enacted for centuries, could be revived and witnessed by the imaginative tourist. In the eighteenth century, as in the early nineteenth, the two attitudes, of humility and arrogance, existed together. James Thomson, who, though a Scot, was a true child of the Union, could enunciate in his lengthy poem *Liberty*, of 1735–6, a view that derived from Addison's, but acknowledged that much of the cultural advantage enjoyed by a free Britain had been inherited from earlier 'free' civilisations – ancient Greece, republican Rome and Renaissance Italy. And Dr Johnson, as his recent biographer John Wain has remarked, 'was a European. France and England were both provinces of that large centralised civilisation, European Christendom, whose natural focus was "the shores of the Mediterranean".' It was from those shores, Johnson asserted, that 'All our religion, almost all our law, almost all our arts, almost all that sets us above savages, has come'. To see the Mediterranean and the sites of the 'four great empires of the world; the Assyrian, the Persian, the Grecian and the Roman' was 'The grand object of travelling'.

But while the eighteenth-century traveller could tour Europe for the sake of its institutions, the romantics tended to personify the virtues of those institutions in individual heroes. It is no accident that the greatest celebration of Europe for early nineteenth-century Englishmen was the work of a poet who himself earned the title of hero. Byron's *Childe Harold's Pilgrimage* appeared in four cantos, the first two in 1812, the third in 1816 and the last in 1818. Its protagonist journeys, meditating on life and civilisation, nature and history, through Portugal and Spain, Greece, Germany and Italy. Where Harold did not invoke the name of some hero or martyr to Liberty, he left his own indelible associations with the places he described, and when Byron met his death in Greece in 1824, fighting in the cause of Greek independence, he and his poetry were consecrated in the faith. He was sanctified with the title 'Laureate of Liberty'; and his name joined the long list of heroes and martyrs to Liberty that travellers carried with them abroad. He became a protagonist in the drama of the Englishman's romance with Europe. W. T. Stead, a late nineteenth-century publisher of Byron's poems, was to observe:

Sir Walter Scott, in his 'Lady of the Lake', made the fortune of the hotels between Callender and Loch Lomond. But . . . Messrs. Gaze and Sons have not yet discovered the extent to which the pilgrim Childe leads every year multitudes to the Continent, and Messrs. Cook hardly appear to be even so much as aware of the fact that one of the greatest of British Bards has marked out in deathless verse the objects of interest in his own phrase – 'those magical and memorable abodes' which year after year attract continually increasing crowds of pilgrims.

The poet, the artist, the philosopher was as much eligible for the pantheon as the statesman, the soldier or the revolutionary leader. We find the germ of the idea already in the eulogium of ancient Athens pronounced by Thomson's Goddess of Liberty (a classically conceived deity, who however is dressed as Britannia):

In Attic bounds hence heroes, sages, wits,
Shone thick as stars, the milky way of Greece! . . .
My spirit pours a vigour through the soul,
The unfettered thought with energy inspired,
Invincible in arts, in the bright field
Of nobler science as in that of arms.

The theme was taken up and cultivated universally in the early nineteenth century; Thomas Carlyle's series of studies *On Heroes, Hero-Worship and the Heroic in History* of 1841 is perhaps the most familiar manifestation of the phenomenon. Political liberty, in particular, became identified in a singular fashion with individual heroes, so that Thomas Campbell, in his *Pleasures of Hope*, published in 1799, could quite naturally equate the fall of Poland to Russia in 1794 with the capture of one man:

Freedom shrieked – as Koskiusko fell!

And so, if the fires of 1848 were the sapling trees of Liberty, the history and culture of the Continent, during the decades that preceded that conflagration, were a field of germinating seeds which might be turned up in the soil wherever the bookish enquirer chose to dig. If one crossed to France, one was immediately in the very land of Revolution, a country that had suffered such extraordinary reverses of fortune that whatever one's political colour it afforded matter for gratifying reflection. By the time of Napoleon's Empire even conservatives could agree that the *ancien régime* had been deservedly toppled; while the Reign of Terror had, of course, cured many early sympathisers of their questionable optimism. Napoleon raised

further difficulties. A product of the Revolution, he had become first a hero and then a monster, 'wading through blood to a throne'. Such political and philosophical problems were the daily fare of the thoughtful traveller of the time. Current events were a burning-glass which collected and focused the odd mixture of attractions and repulsions that have always characterised Anglo-French relations.

Throughout the second half of the eighteenth century, popular prints gruesomely exaggerating the contrast between the life of the well-fed, prosperous English and the under-nourished, miserable and oppressed French were a common feature of English visual experience. The Revolution and Terror, of course, gave the subject a new lease of life. The topic received its original impetus from an artist who influenced the whole genre of political and social satire in England, William Hogarth (1697–1764). Hogarth did not make any very lengthy excursions into Europe but he twice visited France briefly, which was enough at least to confirm his vigorously held prejudices:

The first time one goes from hence to france by way of Calais he cannot avoid being struck with the Extreem different face things appear with at so little distance as from Dover: a farcical pomp of war, parade of religion, and Bustle with little with very little business in short poverty slavery and Insolence with an affectation of politeness give you even here the first specimen of the whole country nor are those figure[s] less opposed to those of dover than the two shores. Fish wemen have faces of leather and soldiers rag[g]ed and lean.

Hogarth's second trip was made in 1748, and he painted a picture entitled *Calais Gate*, or *The Roast-Beef of Old England* shortly afterwards. The sub-title is a reference to the central group in the composition, a fat monk who prods with anticipatory relish a huge side of beef carried by a servant. The 'ragged and lean' inhabitants of Calais, with the military prominent among them, troop by while Hogarth himself, in the background, sketches the old gate of the town. The artist had in fact been arrested and

William Hogarth, *O the Roast Beef of Old England : Calais Gate*, 1748. Oil on canvas. 839 × 998 mm. The Tate Gallery, London (1464)

nearly imprisoned for making drawings at Calais, and the allusion to this incident completes his account of a society oppressed by a tyrannous central government, while the church gluts itself at the expense of the rest.

When Turner made his first venture abroad a half-century later, he too celebrated his arrival in France by painting an incident from his own experience at Calais. In 1802 'the Extreem different face' of the two countries was of exceptional interest, for it was the first time that communications between them had been normal since the Revolution a decade earlier. Hundreds of people made the journey in that summer and autumn, taking the opportunity afforded by the brief Peace of Amiens to inspect and assess the startling developments of the past ten years. For some,

like Wordsworth, it was a rather alarming facing-up to new realities:

> The coast of France – the coast of France, how near!
> Drawn almost into frightful neighbourhood . . .

The fears and hopes of Englishmen were to be tested in earnest. Wordsworth noted with contempt how

> Lords, lawyers, statesmen, squires of low degree,
> Men known and unknown, sick, lame, and blind,
> Post forward all, like creatures of one kind,
> With first-fruit offerings crowd to bend the knee
> In France, before the new-born Majesty.

Paris was the obvious goal, the capital of the new Empire, the theatre of the Revolution itself. For the many artists who went, too, it had a special attraction: it was the temporary home of a vast collection of pictures, assembled in the Louvre from the great galleries of Italy which Napoleon had emptied. But for Turner even this was of secondary significance. At this early date in his career, France was to him little more than a corridor into Europe, and he travelled through it with all speed. His view of Calais, therefore, is a record of the traveller's frustrations, of some of the minutiae of a long journey. He entitled the canvas *Calais Pier, with French poissards preparing for sea: an English packet arriving*. One of the sketches that he made for the picture is inscribed 'Our landing at Calais. Nearly swampt'; and in its heroic and theatrical mode the picture celebrates this experience, epitomising, as it were, the way in which English travellers were compelled to see Europe through the perspective of discomfort and danger. And if he makes no political comment, Turner, even more than Hogarth, is concerned with the plight of the visitor in a foreign land. His fishermen and sailors, fishwives and travellers are as vividly realised as Hogarth's figures, although they are all placed in a subordinate relationship to the sea and the weather that create their environment. For Turner, the geography and climate of the country supply the essential all-embracing reality,

as the political and social conditions do for Hogarth. Just as the meaning of a political state of affairs is measured in the *Calais Gate* by its effect on individual privilege or hardship, so in Turner's painting natural conditions are gauged by their influence on human life. The English travellers, the French 'poissards' – by which we presume Turner means fishing-crews – are brought into juxtaposition under conditions taxing for both. This is indeed how nation meets nation, in the banal and necessary discharge of ordinary business. What is stimulating to the traveller is the novelty of the experience itself. William Hazlitt, who confessed 'I should not feel confident in venturing on a journey in a foreign country without a companion', found that 'I did not feel this want or craving very pressing once, when I first set my foot on the laughing shores of France. Calais was peopled with novelty and delight. The confused, busy murmur of the place was like oil and wine poured into my ears; nor did the mariners' hymn, which was sung from the top of an old crazy vessel in the harbour, as the sun went down, send an alien sound into my soul. I only breathed the air of general humanity'. It is that air which blows so fresh and persuasive in Turner's response to a much stormier Calais.

The absence of an obvious social or political 'point' in the *Calais Pier* indicates a fundamental difference between Turner and Hogarth; but it should not lead us to imagine that Turner was indifferent to those aspects of his experience. His lively interest in the activities of the people who work in Calais harbour takes that larger context for granted. In so far as his art as a landscape painter was about the human beings who make landscape what it is, he was a keen observer of every facet of their existence; their clothes, their occupations, their opinions. The range and depth of his observations, indeed, went far beyond what was needed to paint mere landscape views. A fragmentary journal, begun when he set out for Italy for the first time in 1819, offers us a rare glimpse of his mind as he travelled. It is scribbled in unusually tiny handwriting on the first page of one of his sketchbooks, and begins obviously enough:

Left Dover at 10 arr. at Calais at 3 in a Boat from the Packet Boat. beset as usual. began to rain [next morn. *inserted*] on the setting out of the Dil[igence]

But Turner then begins to record more unexpected things:

Conversation in the diligence the Russe 2 Frenchmen and 2 English Cab. 3 Engl. Russe great par Example the Emperor Alexander tooit part tout the French tres bon zens [*sc*. gens] but the English everything at last was bad, Pitt the cause of all, the King's death [and fall?] and Robespierre their tool.

This brief 'journal' ends with a reversion to commonplaces; though the final remark is clearly the comment of someone in search of suitable subject-matter for landscapes:

Raind the whole way to Paris. Beaumont sur Oise [?] good

Confused and unintelligible as it is, Turner's reporting of the 'conversation in the diligence' gives us lively proof that he went about with his ears open, and listened with interest to men's opinions on the matters of the day. Precisely what his own political stance was we cannot accurately say. His earliest full biographer, Walter Thornbury, believed 'he was a Tory', but added that 'he loved liberty and those who fought for it' – in other words, he shared the attitudes common to most of his fellow-countrymen. Nevertheless, his close friendship with the Yorkshire landowner Walter Fawkes, of Farnley Hall near Leeds, leads us to think that Turner would have been unlikely to call himself a Tory. Fawkes was a Whig, and on some subjects, such as slavery and Parliamentary reform, an outspoken progressive. For him, 'Tories' were 'those whose doctrine it is, that Government must possess an UNLAWFUL and UNDUE INFLUENCE to carry their measures into effect, and that an equal Representation of the People, is neither PRACTICABLE nor USEFUL'. When campaigning for the reform of the electoral system, Fawkes found even the Whigs unsatisfactory, their proposals '*arbitrary – mere discretion*, without any criterion of *justice*, or any correct idea of *equitable distribution* or *common*

right'. He was, of course, attacked as a dangerous radical: one gentleman signing himself 'a Yorkshire Freeholder' pretended to understand him, but argued that 'those . . . having higher game in view, will take advantage of *his* discontent, to present their own revolutionary scheme, and thus make his wish for *some* change, a stepping-stone to their *meditated overthrow of every thing that is sacred, of every thing that is useful, and great, and good, in the Institutions of our Country*'.

Yet Fawkes was a conservative in the most fundamental sense; his arguments for Reform were all based on an appeal to the established constitution of England: 'The Reformers of England proclaim that those principles are hourly violated, which their ancestors established with so much industry and toil – principles which they upheld, in the closet and the dungeon, in the senate, the field, and on the scaffold'. What Fawkes was invoking was his own political inheritance. He modelled himself on his great forebear, the Cromwellian General Thomas Fairfax, whose relics he treasured at Farnley. Turner made for him a series of watercolour drawings incorporating these relics, tracing the story of the Civil War and Fairfax's part in it, from a symbolic design representing the 'First Period' of Charles I's reign, with references to 'Arbitrary Arrest', 'Arbitrary Measures', 'Bad Advisers', 'The King's Word Law', to a trophy celebrating the 'REVOLUTION 1688', with allusions to 'Magna Charta', the 'Bill of Rights' and 'Parliament Full Free and Frequent'. Despite his Cromwellian connection, however, Fawkes was by no means a republican. He founded his reformed state on the conception of a controlled monarchy: 'First, a King, clothed with all the splendour requisite to give dignity to his exalted station, and armed with every prerogative necessary to conduct the affairs of the Country, with energy and promptitude; but, at the same time, strictly limited by the law – a King . . . by whom, when they surrender themselves to his keeping, it is expected, by his subjects, that certain conditions will be performed and respected'. He also endorsed the role of the House of Lords, 'a patrician body, wisely placed as a barrier between the Crown and the People – to protect the Crown against the People, should faction ever prevail; to protect the People against the Crown,

should timidity or subserviency ever sway the votes of their elected Representatives'. Fawkes's Aristocracy was 'splendid, but useful . . . content with its own great and peculiar privileges, without presuming to interfere with the rights and liberties of the People'.

This enlightened conservatism chimes well with what we know of Turner's own views. That he applied his mind to such matters we cannot doubt. He was a regular reader of the newspapers – the *Times* at least – and subscribed to periodicals such as the *Edinburgh Review*. His friendship with Fawkes, a progressive country gentleman, was perhaps symbolic of his own paradoxical position: a self-made man who never tried to shed his working-class origins, but whose greatest loyalty was to the Establishment body of the Royal Academy. Other friends and patrons fit into this picture of ambiguity: the Earl of Egremont, whose home at Petworth was notoriously easy-going and devoid of protocols and class-distinctions; the French 'citizen king', Louis Philippe, whose acquaintance Turner first made at Twickenham in 1815, and who remained a friend all his life. Of all these contacts, that with Fawkes was probably the one in which politics figured most. The mutual affection of the two men was no doubt strengthened by their shared experience of being pilloried 'radicals' in their respective fields, while they thought of themselves rather as the enlightened proponents of a long-standing and vital tradition. But although Fawkes was actively committed politically, it was for his art that he principally admired and loved Turner. The same must have been true of the painter's other friends. Turner was too much of an artist to see politics with the eyes of the politician merely. His view of that hero of late eighteenth-century revolutions, Tom Paine, was decidedly coloured by aesthetic considerations: 'we may reasonably conclude [Paine]', he said, 'to be destitute of all delicacy of refined taste.'

As an artist, he was sometimes surprisingly unaware of political activity going on around him. In a letter of 28 December 1844 to Fawkes's son, Hawkesworth, he says he has been in Switzerland, 'little thinking or supposing such a cauldron of squabbling, political or religious, I was walking over'. The

13

'cauldron' had been seething for some years, and was shortly to boil over in the formation of the *Sonderbund*, a protest against political and religious reforms then in hand in the Cantons. It is odd that Turner, who had been in Switzerland not only in 1844 but in the three preceding years, should have been unconscious of these important events. However, in February of 1845, when his young friend and admirer John Ruskin was planning a journey to the Alps, he did take note of an article in the *Times* giving further 'sad news from Switzerland'. His ignorance of the state of affairs as he travelled was no doubt partly due, at least, to his inability to speak foreign languages. His sketchbooks contain numerous jottings of words, phrases, and grammatical hints designed to aid his progress in France, Germany or Italy; but it is evident that he never mastered more than the rudiments of conversation in a European language. He could rarely, if ever, enjoy what John Stuart Mill called 'the free and genial atmosphere of Continental life' – the enlightened conversation of cultivated people. He journeyed in a very English – and very Turnerian – isolation.

The generation of topographical and antiquarian artists who travelled with wealthy patrons making drawings as souvenirs or archaeological records was virtually past; when Turner rejected the Earl of Elgin's invitation to accompany him as official artist on his expedition to Athens in 1799, he lost his only opportunity to visit Greece, and renounced for ever that eighteenth-century relationship between artist and patron. He was not invariably without travelling companions: on this very trip, of 1844, he is recorded as having been accompanied by a gentleman with the initials W.B. It is possible that these are a misreading of 'H.B.' and that the companion was Henry Bright (1814–73), a landscape artist who we know travelled with Turner in Europe on one occasion. But in general he was jealous of his privacy, and particularly in the 1840s seems to have been wrapped in a private dream of exploration and contemplation in which other people could not be included. He travelled far and hard, and neither relished nor needed society.

He was indeed a thorough professional in the matter of travel. As the painting of Calais Pier shows, he never lost sight of the

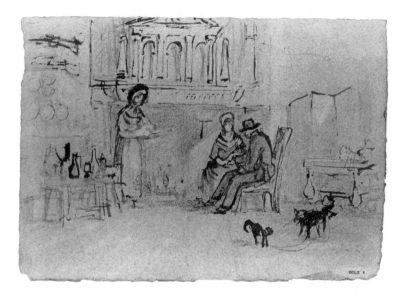

J. M. W. Turner, *Interior of an inn*, ?1829. Pencil and brown ink on blue paper. 140 × 191 mm. (TB CCLX-6)

fact that it was as a traveller that he saw Europe. The complex organism that was the Continent was something that he witnessed as a visitor, a stranger. The means of access to it played a vital role in his total view of it: not only the Channel crossing, but the time-honoured tourists' priorities – hotel accommodation, transport – reflected economic conditions as a whole. Ruskin, though a much younger man, was positively dismayed at his willingness to include 'ugly hotels' and even railways in his landscapes. But he did perceive the central importance of roads in the traveller's appreciation of Europe. We tend to forget that before the development of the railways a great deal of trade, as well as much social and political activity, depended on the state of the highways, which was not to be relied on as it is today. Turner, who spent a sizeable proportion of his time journeying long distances in Britain as well as in Europe, might well give some attention to the roads along which he travelled, and the

vehicles in which he was conveyed. Twice he made finished watercolours depicting road accidents in which he had been involved, and it is significant that each occasion is also recorded in the lively prose of Turner's letters. The hazards of travel were obstacles to be overcome, worth celebrating in art, and affording material for amused reminiscence even several years afterwards. So the watercolour of 1820 that Turner entitled *Passage of Mont Cenis Jan 15 1820* introduces into the grandest of Alpine stormscapes the specific reference of a private diary, and describes an event that Turner could recount in detail when writing to his friend James Holworthy as late as January 1826:

> Mont Cenis has been closed up for some time, tho the papers say some hot-headed Englishman did venture to cross a pied a month ago, and what they considered *there* next to madness to attempt, which honour was conferred once on me and my companion de voiture. We were capsized on the top. Very lucky it was so; and the carriage door so completely frozen that we were obliged to get out at the window – the guide and Cantonier began to fight, and the driver was by a process verbal put into prison, so doing while we had to march or rather flounder up to our knees nothing less in snow all the way down to Lanslebourg by the King of Roadmakers' Road, not the Colossus of Roads, Mr. MacAdam, but Bonaparte, filled up by snow and only known by the precipitous zig-zag.

We may gather from the opening remark here that Turner kept himself well informed as to developments affecting travel abroad. He has the latest news on the state of the Mont Cenis road. He recalls his adventure of six years earlier with the gusto of the addicted traveller, delighting in the jokes that it gives rise to. It must be admitted that the rather good pun about MacAdam as the 'Colossus of Roads' was not his own; it was generally current at the time, and had been given literary status by Thomas Hood in his *Ode to Mr. McAdam*, published in 1825, which starts:

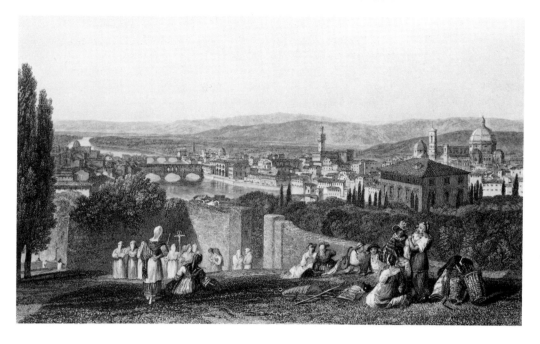

George Cooke after J. M. W. Turner, *Florence from the Chiesa al Monte*, 1820. Engraving. 140 × 220 mm. Published in Hakewill's *Picturesque Tour in Italy*, 1818–20 (R. 158)

> M^cAdam, hail!
> Hail, Roadian! Hail, Colossus! who dost stand
> Striding ten thousand turnpikes on the land!
> Oh universal Leveller, all hail!

But the sense of fun is as much Turner's as Hood's, and it is confirmed by the second of the 'road-accident' watercolours painted shortly after his return from Italy in January 1829 (see plate 1). The drawing was exhibited at the Royal Academy exhibition that spring, with the jocular title *Messieurs les Voyageurs on their return from Italy (par la diligence) in a snow drift upon Mount Tarrar – 22nd of January, 1829* (plate 1): even

more precise in detail than the inscription on the Mont Cenis watercolour, it manages to convey something of the delighted reminiscence that we find in the earlier description to Holworthy. And this incident too was recalled at some length in a letter. By citing dates and relating the watercolours thus to particular events, Turner places them in a special category among his works, that small group which documents his personal life. For travel was the personal side of his professional search for subject-matter. To confirm this, he even goes so far as to introduce a self-portrait into the 1829 drawing: slightly apart from the main group of travellers, hunched beneath a rather crumpled hat, and facing away from us, he is both a participant in the scene and its quiet, amused yet sympathetic observer. It is a position that typifies his relationship with the world that he drew.

As an intelligent traveller, acutely observant of the world about him, he could act as his countrymen's eyes, taking in and recording what all travellers wished to see and remember, and feeling what all travellers wished to feel. Far from rejecting the label of 'tourist', he aspired to be the ideal tourist, who could give enduring expression to the often intangible joys and excitements of imaginative exploration. As a sensible businessman, too, he had every reason to ensure that his pictures and drawings reflected something of the predilections of his public. From his youth he had paid close attention to the guide-books which would direct him to places of interest, and when he visited the Continent he was as assiduously thorough as ever in this respect.

J. M. W. Turner, twelve sketches copied from *Select Views in Italy*, published by John Smith, William Byrne and John Emes, c.1792–6, 1819. Pen and brown ink. 155 × 102 mm. (TB CLXXII-19)

16

Sometimes he would carefully transcribe a précis of a guide-book into one of his own notebooks, to take with him on the journey; for his first visit to Italy he even equipped himself with thumbnail sketches taken from Italian views in a book of engravings. And for the same journey, a friend, James Hakewill, who had asked him to make illustrations for his own *Picturesque Tour in Italy*, kindly composed what A. J. Finberg called 'a manuscript guidebook, written specially for Turner's benefit', in a little notebook that Turner labelled 'Route to Rome'. It includes information about hostelries, preferable itineraries and buildings or scenery worth looking out for, together with all the little titbits of advice that one can only acquire from a knowledgeable friend. Here is a sample:

Don't go to Brig but to Glise at the foot of the Simplon – go leisurely over the Mountain. The descent on the Italian side the finest. Good Inn at Domo Dossola and at Baveno where you take boat to visit the Islands in the Lago Maggiore. See the Isola Bella (and if you have time the Isola Madre but it not particular) Como – go up the Lake to Cadinabbia stopping at the Plinciana &c. – go opposite Cadinabbia to the Villa of a Duke (I forget his name). Take two boatmen and pay them 3 francs ea. p. day. The men will point out what is worth seeing . . .

At Milan – Go to the Albergo Reale in the Street, tre Re (sounded tra ra). The Inn kept by Baccala – A few doors higher up lives a printseller who talks English well, and will be civil, buying of him the Maps &c. which you may want – perhaps he will remember my name . . .

Mem: Baccale will give you a letter of introduction to the houses in his line at Genoa &c. &c. and having fixed yr price with him, you will be saved the trouble of further altercation; but remember not to commence inmate in any house without first settling this necessary business – Genoa – Go to the Durazzo Palace, without the Walls for a good view of the City – In the Church of St. Etienne, a famous picture of the Stoning of the Saint. See the Bridge of Carignano & Church. Yr attendant will take you to the principal palaces –

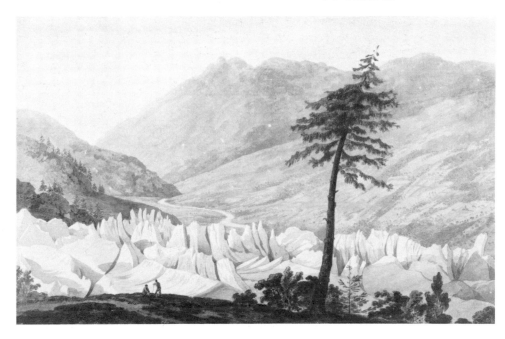

William Pars, *The Glacier of Grindelwald*, 1770. Watercolour and pen and grey ink over pencil; some gum arabic. 326 × 490 mm. (1870-5-14-1216)

On no account trust yourself in a felucca – But hire horses & guides to Spezia. The remainder may be posted. – Before you arrive at Massa visit the quarries of the Carrara marble. Inn. The Dongella, dear but good . . .

No doubt such tips as where to find 'a good view' of Genoa were inserted by Hakewill at Turner's particular request; the search for fine prospects and panoramas was a perennial one for him. At the date of his first trips abroad after the end of the French wars, relatively little existed in the way of published topographical views; these were to appear in large quantities during the ensuing decades, but for artists on the Continent before 1820 the choice of subject was often a matter of trial and error. The sites

themselves were of course well known from descriptions, but few outside the limits prescribed by the Grand Tour to Italy had been drawn by modern artists. It is sometimes forgotten that, with the exception of John Robert Cozens (1752–97) and the watercolourists working around Rome and Naples in the 1770s and 1780s, remarkably few English artists had produced more than a handful of Continental views in the fifty years prior to 1800, and foreign works of topography were also usually confined to the most important Italian sites; Switzerland was generally represented by views of its towns and cities, and it was the English – Cozens and, still earlier, William Pars (1742–82) – who had done something to indicate the splendours of the mountains themselves to their fellow-artists.

Rome was, of course, the exception; it was, if anything, over-familiar: Rome, where every artist aspired to live and study, the whole city, as Sir Joshua Reynolds put it, 'an Academy' in which the student could learn from the greatest masters both of ancient and modern times. If, politically, Rome had lost its glory with the death of Brutus and the establishment of the Empire, it had by no means relinquished its ascendancy as far as the arts were concerned. Even the young American, Benjamin West (1738–1820), travelling from his native Pennsylvania to seek his fortune as a painter in the mother country, went to London by way of Rome. The English-speaking community there was large and active, and in it Turner was much less isolated than elsewhere in Europe. His first visit seems to have been devoted mainly to his habitual feverish sketching, and he made few contacts; but in 1828, when he set up a studio in the 'Eternal City' and actually held an exhibition of his paintings there, he was more at home, and apparently intended to return. In the following year Peter Powell wrote to Turner's colleague Charles Robert Leslie from Rome:

We are all sorry that Turner has not been able to come out this year as he intended. He made himself very social and seemed to enjoy himself, too, amongst us.

Turner's own letters from Rome also suggest that he was particularly happy there. For him, Italy was 'Terra Pictura', and the combination of all the paintings that Rome had to show, with the opportunity to paint there himself, must have been peculiarly stimulating. Before everything he was anxious to see whatever he could in the way of art, and at Rome he could study not only the masterpieces of the past, but the activities of his contemporaries, which equally interested him. In the same way, when he visited Paris, Vienna, Dresden or Berlin he saw as much as he could of the collections of paintings on public view, making notes, even quite late in his life, of pictures that he can have had no thought of imitating in his own output.

There can be little doubt, as we look through the many sketchbooks that Turner used in Rome, that he was preoccupied with the splendour of its paintings and sculpture, the grandeur of its ancient monuments; and it is noticeable in the finished works that nearly all the Roman subjects show human life dwarfed almost to insignificance by architecture: the Colosseum (plate 38), the nave of St Peter's, the Forum (plate 36), are treated for themselves and with scant regard for the activities of their occupants. This is far from being the case elsewhere in Italy. In the finished watercolours of Venice and Naples Turner includes characteristic specimens of local life – the sort of details that he noted carefully in his sketchbooks, where we find a wealth of such information: exact memoranda of how the boats on Lake Maggiore are manned and operated; a jotting to remind him that 'Women of Albano and Gensarno' wear 'White Caps with a star behind, some a Black cap. The Hair is often fastened with Ribbons, on which a White cloth is fixed. The front appears flat and square, the back falls to a point in some, others open work . . .'; near Naples he notices a 'Girl dancing with Cansonets' and 'Fishermen'; and in another book he gives details of a number of Neapolitan occupations:

Girl dancing to the Tabor or Tamborine one plays, two dance face to face If two Women – a lewd dance and great gesticulation; when the man dances with the Women a great coyness on his part till she can catch him Idle and toss him up or out of time by her hip then the laugh is against him by the

18

crowd. Boy with Ring and Ball holds out cards . . . Man selling aqua vita by a handcart Boy drawing it. Painted red and Green and ornamented with paper. Boys with dogs meat or hawking [?] Butchers with Tongues . . .

Such memoranda were by no means incidental to his purpose, supplying merely formal 'staffage' with 'business'. We have only to compare the figures that Turner introduces into his finished watercolours with those of any of the other Continental topographers of his time – Prout, Harding, Callow, or Boys – to perceive a difference of intention in their very conception. For Turner, the life of the landscape frequently *is* its population of human figures and their doings. Repeatedly, he selects for his subject-matter scenes that involve large crowds. Thronging cities, busy market-places, public holidays and festivals he depicts with delight wherever he comes upon them. The crowded wharves of Le Havre or Dieppe, the colourful market in front of Rouen Cathedral, the *flâneurs* and *bouquinistes* of the Paris waterfront (see plates 55 and 56) figure prominently even in the small sheets of the *Rivers of France* drawings; and they were not added merely as a sop to public taste: they are integral to Turner's vision of these places. Among his sketches along the Seine are several sheets which show him studying the convivial meetings of peasants in taverns, in the shade of their trellised house-yards, or dancing in the street. In the larger finished watercolours, such activity fills the foregrounds, and even, in the great panorama of Zurich before the Vintage festival which he drew in 1842 (plate 99), floods every corner of the scene so that the population of the city actually becomes Zurich itself.

In the comprehensive humanity of these crowd scenes, in their humour and insight, Turner shows himself, after all, a descendant of Hogarth. His vision, however, rises above the petty obscenities of individual mortals to dwell firmly and clearly on the enduring comedy of man in his world. His art conveys more convincingly than any other painter's that awestruck sense of the unity of man and nature which so dazzled the poets of his generation. It was a deeply felt and passionate thrill of awareness, a new penetration into the heart of existence, and in

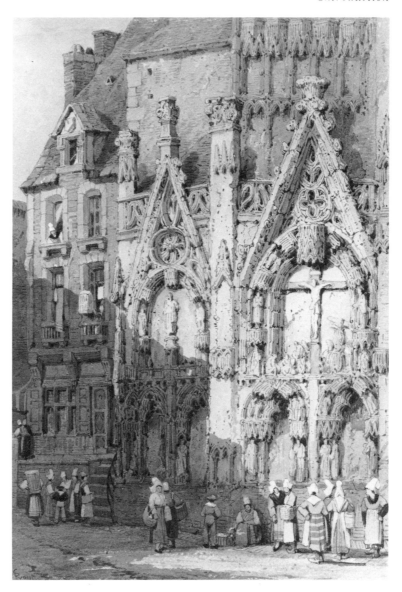

Samuel Prout, *Church of St Lô, Normandy*, *c*.1830. Watercolour, pen and brown ink. 355 × 236 mm. (1900-8-24-530)

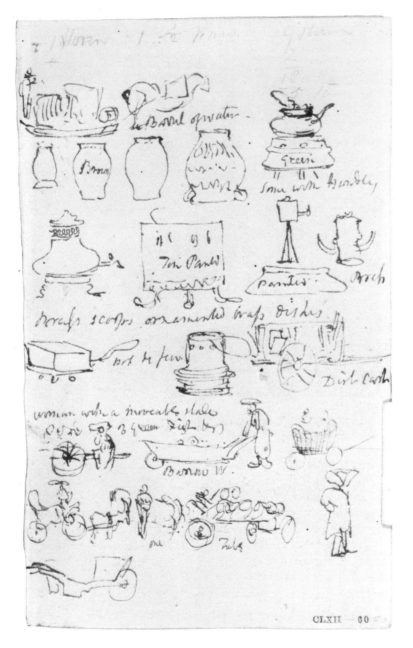

some of them it engendered a kind of mental instability, the divine madness that is so easily and uncomprehendingly associated with Romanticism. Shelley confessed that when he saw the Alps 'the immensity of these aerial summits excited, when they suddenly burst upon the sight, a sentiment of ecstatic wonder, not unallied to madness'. And it was not the works of unaided nature alone which could provoke such a strong response. Henry Fuseli (1741–1825), that painter of the wildest horrors of the Gothick imagination, had a very similar reaction to the city of Rome: 'with the sound of Rome', he wrote in 1778, 'my heart swells, my eye kindles, and frenzy seizes me'. The achievements of man were as potent an inspiration as nature's own. Hence, on his first visit to Rome, Turner could concentrate with undivided attention on the Colosseum or the Basilica of Constantine just as, in 1802, he had made studies of the ravines and gullies, glaciers and crags of the Alps with little concern for the local inhabitants. Once the great facts of either place had been studied and understood, they could take their place in an increasingly broad picture of life.

The European landscape was always replete with implicit meaning, and that meaning was related directly to the human beings who experienced it. Sometimes the connection was self-evident, as in the case of the Alps as a barrier between nations; as Sir Walter Scott, in his *Life of Napoleon*, commented:

Napoleon has himself observed, that no country in the world is more distinctly marked out by its natural boundaries than Italy. The Alps seem a barrier erected by Nature herself, on which she has inscribed in gigantic characters, 'here let ambition be staid'.

This was a point that Turner had made in his great canvas of *Hannibal and his army crossing the Alps* of 1812, and was to repeat

J. M. W. Turner, *Sketches of crockery ware, &c*, 1817. Pen and brown ink. 156 × 95 mm. (TB CLXII-60)

in a watercolour of 1815 depicting a more recent military foray in the mountains, the Napoleonic *Battle of Fort Rock, Val d'Aosta, Piedmont 1796.*

Sometimes the symbolic reference of landscape is more subtly suggested. For a fervid radical like Shelley, it could become an elaborate metaphor for political and social conditions. In 1818 he described an incident during a journey through Savoy:

After dinner we ascended les Eschelles, winding along a road, cut through perpendicular rocks, of immense elevation, by Charles Emmanuel, Duke of Savoy, in 1582. The rocks, which cannot be less than a thousand feet in perpendicular height, sometimes overhang the road on each side, and almost shut out the sky. The scene is like that described in the Prometheus of Æschylus. Vast rifts and caverns in the granite precipices, wintry mountains with ice and snow above; the loud sounds of unseen waters within the caverns, and walls of toppling rocks . . .

Under the dominion of this tyranny, the inhabitants of the fertile valleys, bounded by the mountains, are in a state of most frightful poverty and disease. At the foot of this ascent, were cut into the rocks in several places, stories of the misery of the inhabitants, to move the compassion of the traveller. One old man, lame and blind, crawled out of a hole in the rock, wet with the perpetual melting of the snows of above, and dripping like a shower-bath.

In this passage it is difficult to be sure whether Shelley blames nature or the rulers of Savoy for the condition of the inhabitants. Whichever is the culprit, the human spirit is the victim, and that is what engages his concern. The reference to Charles Emmanuel of Savoy is itself fraught with connotations of tyranny and heroism in the cause of Liberty – the 'lightning of the nations' as Shelley called it. Two years before Shelley's tour, Byron had published his romantic account of the *Prisoner of Chillon*, celebrating the Genevan hero Bonnivard, who, as was explained in the advertisement to the poem, 'became a martyr of his country', being imprisoned by the invading Duke of Savoy in

the infamous castle by Lake Geneva (see plate 13). Byron's general point is made in his introductory *Sonnet on Chillon*:

Eternal Spirit of the chainless Mind!
Brightest in dungeons, Liberty, thou art!

The quasi-religious phraseology is characteristic of the period: Thomson's stolid classical personification of Liberty has been replaced by a more mystical conception, in which the human spirit itself is a god-like force. Byron expressed a crucial tenet of the Romantic faith: the identity of God and Man as the presiding joint divinity of the universe. This underlying awareness of man's place in a vaster system was most authoritatively asserted by Wordsworth – for instance, while musing in the Simplon Pass, in 1799:

The torrents shooting from the clear blue sky,
The rocks that muttered close upon our ears,
Black drizzling crags that spake by the wayside
As if a voice were in them, the sick sight
And giddy prospect of the varying stream,
The unfettered clouds and region of the heavens,
Tumult and peace, the darkness and the light –
Were all like workings of one mind, the features
Of one face, blossoms upon one tree,
Characters of the great Apocalypse,
The types and symbols of Eternity,
Of first, and last, and midst, and without end.

Wordsworth, of course, possessed in an extreme degree that Romantic capacity to penetrate into the inner meaning of nature, to derive a profound spiritual revelation from the world about him, and to identify passionately with external phenomena, concrete or abstract. His commanding presence in the English poetry of the early nineteenth century, essentially unrecognised though it was until long after his work had declined into mere verbiage, gives us the only equivalent in contemporary verse to the grandiose yet profoundly human landscape visions of

Turner. The rapt intensity of Wordsworth's communings has no parallel in art if not in the passionate yet tranquil essays that Turner produced in Switzerland towards the end of his life. And if we seek an elucidation of that delicate balance of forces whereby, in his watercolours, the sheer beauty and grandeur of nature is understood in conjunction with the historical and moral overtones that exist everywhere in Europe, then, again, it is Wordsworth who can offer a verbal approximation. There is even a more precise parallel: both Wordsworth and Turner progressed from a specific love of nature as such, to a perception of the natural world as the necessary context for man. 'Nature then', Wordsworth said of his youth, 'was sovereign in my mind', and, as Turner rushed through France in 1802 to explore the desolate Alps, he betrayed the same preference,

> A feeling and a love
> That had no need of a remoter charm
> Unborrowed from the eye.

But for him as for Wordsworth the pattern shifted:

> That time is past,
> And all its aching joys are now no more,
> And all its dizzy raptures . . .
> For I have learned
> To look on nature, not as in the hour
> Of thoughtless youth; but hearing oftentimes
> The still, sad music of humanity,
> Nor harsh nor grating, though of ample power
> To chasten and subdue.

There was nothing in Wordsworth's poetry to supply a foundation for Turner's art; if it expressed similar ideas it did so in an entirely verbal way, sufficient in itself. Certainly Turner did not for the most part find humanity's 'music' either still or sad; rather it generally struck him as an ebullient and bustling, if not always joyous, business. It was to another poet, less profound perhaps, but more fertile of colourful visual ideas, that he turned for recurrent inspiration in his pursuit of man in nature: Byron.

In Byron's work the place of man in the landscape is made explicit and, at the same time, heroic and dramatic. Likewise, as we have seen, he created a tourist 'pilgrimage' which was of the greatest value to the artist in search of subject-matter. It is not surprising that *Childe Harold* had a considerable influence on Turner's exploration of Europe. True, he never went to Spain, Portugal or Greece, the countries covered by the first two cantos of the poem; it is a matter for speculation whether, had he been able to do so when they first appeared in 1812, he would have rushed off immediately in Harold's footsteps. By the time the Peace had reopened Europe to the English the excitement of the Peninsular War had been replaced by the euphoria of Waterloo, and when Turner eventually managed to get abroad, in the autumn of 1817, Byron had brought out a third canto (it was published in the preceding year) celebrating at length the triumph and the tragedy of that epoch-making battle. It is perfectly possible, as has been recently suggested, that Turner was directed to the poem by a quotation in Campbell's guide-book to the Waterloo area, and his knowledge of and interest in *Childe Harold* could date from that event. That he immediately linked Waterloo with Byron is plain from the fact that when he returned from his 1817 tour he painted a picture of the *Field of Waterloo* which explicitly illustrated a stanza of the poem. But Harold continues his journey from the plains of Belgium to the Rhine, and it surely cannot entirely be coincidence that this was the tour that Turner planned for himself. When he drew the fortress of Ehrenbreitstein on the Rhine opposite Coblenz (see plates 75 and 76) he must have been conscious of the additional dimension that Byron had given it, not only in his verses but in the gloss that he characteristically provided as a footnote:

Ehrenbreitstein, i.e. 'the broad stone of honour,' one of the strongest fortresses in Europe, was dismantled and blown up by the French at the truce of Leoben. It had been, and could only be, reduced by famine or treachery. It yielded to the former, aided by surprise. After having seen the fortifications of Gibraltar and Malta, it did not much strike by comparison;

but the situation is commanding. General Marceau beseiged it in vain for some time; and I slept in a room where I was shown a window at which he is said to have been standing, observing the progress of the siege by moonlight, when a ball struck immediately below it.

As Byron admits, the fort is hardly impressive in itself: it is for its connotations that it is worthy of the traveller's attention; and Turner, meditating on it repeatedly as he did, must have done so for the sake of those connotations. The association with Marceau, indeed, proved to be specially important, for in 1835 Turner submitted to the Academy exhibition a painting of *The bright stone of honour (Ehrenbreitstein) and the tomb of Marceau* with a reference to *Childe Harold.* The relevant stanza runs:

> . . . There is a small and simple pyramid,
> Crowning the summit of the verdant mound;
> Beneath its base are heroes' ashes hid,
> Our enemy's – but let not that forbid
> Honour to Marceau!

And the footnote adds mention of General Hoche, buried 'in the same grave' and 'a gallant man also in every sense of the word'. The monument erected to Hoche at Weissenthurm formed the subject of one of Turner's 1817 Rhine studies.

Again, it might seem more than coincidental that a year after the fourth canto of *Childe Harold* appeared, with its long disquisition on Italy,

> Mother of Arts! as once of Arms!

Turner went to that country for the first time. But we know that he had long wished to go there; and indeed it would be absurd to propose that a British artist required the stimulus of *Childe Harold* to visit Italy, of all places. Byron and Turner, rather, both responded to Italy as Englishmen typically did, and each in his own way presented his countrymen with an ideal interpretation of that legendary land. It is not surprising, therefore,

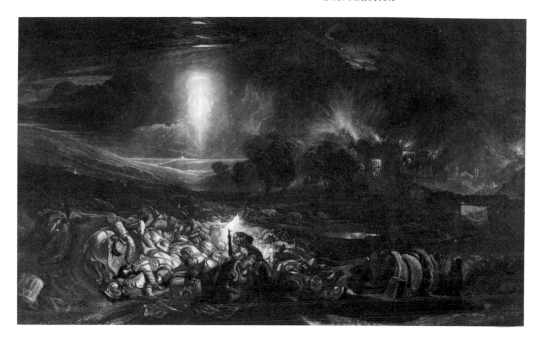

Frederick Christian Lewis after J. M. W. Turner, *Field of Waterloo*, 1830. Mezzotint after the oil-painting of 1818. 354 × 584 mm. Yale Center for British Art, Paul Mellon Collection (B1977.14.8339)

that Turner should have felt that Byron had defined in an important way what it was that he, Turner, had to say about Italy. He made this clear when he used the fourth canto as a source for quotations applied to several of his pictures in the Royal Academy catalogues. His own vivid sympathy with the Italian scenes he visited was heightened and focused by what Byron had written, and no doubt on some occasions his choice of subjects was affected by Byron's. When he made his series of studies of the ruins of ancient Rome, and especially an extraordinary view of the Colosseum by moonlight, he may well have been thinking specifically of a passage from that canto:

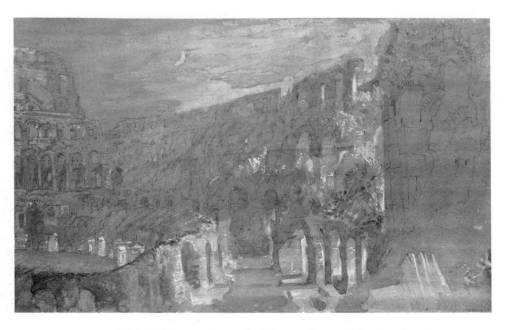

J. M. W. Turner, *Rome: the Colosseum by moonlight*, 1819. Pencil, watercolour and bodycolour on white paper prepared with a grey wash. 231 × 369 mm. (TB CLXXXIX-13)

Arches on arches! as it were that Rome,
Collecting the chief trophies of her line,
Would build up all her triumphs in one dome,
Her Coliseum stands: the moonbeams shine
As 'twere its natural torches, for divine
Should be the light which streams here, to illume
This long explored but still exhaustless mine
Of contemplation; and the azure gloom
Of an Italian night, where the deep skies assume
Hues which have words, and speak to ye of heaven,
Floats o'er this vast and wondrous monument,
And shadows forth its glory.

In 1832 Turner even exhibited a painting entitled simply *Childe Harold's pilgrimage – Italy*, citing in the catalogue the famous stanza in which Byron celebrates the unrivalled beauty and grandeur of a decaying civilisation –

Thy very weeds are beautiful, thy waste
More rich than other climes' fertility . . .

The painting shows us an idealised and archetypally Turnerian dream landscape, which sets Turner's Italy and Byron's side by side as rightful and well-matched partners.

He was justified in this self-conscious sense of the highly personal vision that he brought to the places he visited, not only by his own awareness of the unique quality of his creative power, but from the testimony of the outside world. It was constantly being reinforced by the criticism, both adverse and favourable, that his work attracted. Even before he had visited Italy, he was 'always associated' with the scenery of that country, in the mind of his eminent colleague at the Academy, Thomas Lawrence (1769–1830). And significantly, when he made his views on the Loire and the Seine they were published under the general title of *Turner's Annual Tour*. It may have seemed eminently practicable, when that project was planned, to publish the results of his European journeys in this way, for they had become almost an annual event and his designs for the engraver were popular. But the exigencies of publishing, to say nothing of Turner's intractable and independent nature, militated against the long continuance of the venture. Even so, Ruskin, perhaps rather unexpectedly, believed that Turner felt more at home in France than anywhere else: 'Of all foreign countries Turner has most entirely entered into the spirit of France,' he wrote, arguing that this was 'partly because here he found more fellowship of scene with his own England, partly because an amount of thought which will miss of Italy or Switzerland will fathom France . . .'. It is difficult to follow Ruskin in his judgment here. As we have seen, Turner himself had a strong sense of affinity with Italy, born largely out of his reverence for its art, but also, as is evident from his work, from a specially intense appreciation of the light

and warmth to which so many Englishmen have responded. His eager jotting in an Italian sketchbook of 1819 – 'the first bit of Claude' – sums up the affectionate recognition of the painter on arriving in Italy. Even the flat, cloudy northern landscape of Holland could exercise something of the same spell over him, thanks to the old masters it had inspired, and who had inspired him: 'Quite a Cuyp,' he noted of the landscape near Amsterdam on his first visit there in 1817. With France he had no such link. It was, first of all, the country through which he passed to reach Switzerland or Italy; later, he toured it in search of the picturesque architectural subjects fashionable in the 1820s and 1830s; but, except in the mountains of Savoy and the Dauphiné, France never yielded him the grand scenery that he found elsewhere in Europe. If he had looked for it, he would surely have found it (as he did, briefly, on the southern coast between Marseilles and Menton in 1828); but he preferred to look elsewhere. According to one account, preserved by Turner's first biographer, Walter Thornbury, the artist once entertained an acquaintance 'describing various scenes' in the Pyrenees; but there is no surviving evidence in his sketchbooks of any journey into the south-west of France.

As for Switzerland, and the Alps generally from Austria to Savoy, that region was one which became more and more important for Turner as he grew older. No doubt increasing age prevented his making the longer journey to Italy after 1840, but he insisted on returning to central Switzerland while his health permitted. There his mind and spirit could expand without constraint amid the most magnificent of European scenery, and there he sought out the ineffable calm of the great mountains and lakes, a calm which they possess even when disturbed by storms. There, he can have been in no doubt of his enduring affinity with the landscape that he drew in a long stream of studies, at a time when even his observations of English light and climate had become intermittent and scrappy. Nevertheless, these wonderful works of the 1840s are still irradiated with the glow of Byronic reminiscence. Turner had not forgotten, as he watched long hours on the shore of Lake Geneva, that Byron had stood there and meditated:

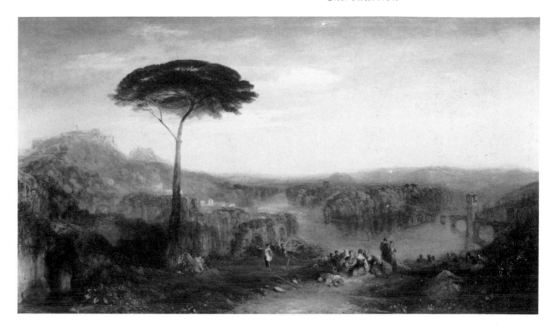

J. M. W. Turner, *Childe Harold's Pilgrimage – Italy*, RA 1832. Oil on canvas. 1420 × 2480 mm. The Tate Gallery, London (516) B/J 342

Are not the mountains, waves, and skies a part
Of me and of my soul, as I of them?
Is not the love of these deep in my heart
With a pure passion?

He may have recalled, too, the long passage in *Childe Harold* concerning the tribulations of Jean-Jacques Rousseau at Geneva, and remembered that Rousseau's *La Nouvelle Héloïse* was written at Clarens, near Lausanne. At Lausanne itself (plate 91), the proper touristic procedure was to visit the summer-house in which Gibbon had composed the *Decline and Fall of the Roman Empire* – 'At Lausanne,' wrote Sir James Mackintosh in his journal, 'we ran to Gibbon's house'; and no doubt Turner's appreciation of the city was sharpened by his knowledge of

Gibbon's connection with it, just as, perhaps, he had borne in mind while drawing the Forum at Rome that this was where Gibbon's great history had been conceived. The Lake of Geneva was resonant with associations, and Byron had summed them up:

Rousseau – Voltaire – our Gibbon – de Staël –
Leman! these names are worthy of thy shore,
Thy shore of names like these . . .
To them thy banks were lovely as to all,
But they have made them lovelier, for the lore
Of mighty minds doth hallow in the core
Of human hearts the ruin of a wall
Where dwelt the wise and wondrous; but by *thee*,
How much more, Lake of Beauty! do we feel,
In sweetly gliding o'er thy crystal sea,
The wild glow of that not ungentle zeal,
Which of the heirs of immortality
Is proud, and makes the breath of glory real!

All these ideas we may legitimately include in our understanding of Turner's response to the lake and its shores. But that response is first and foremost his own – the personal vision of a man as great as those whom Byron invoked, and who, perhaps, was well aware of the validity and power of his own reflections.

He knew that his other favourite haunt, the Lake of Lucerne at Brunnen (see plates 97 and 114), was equally replete with associations – they had been committed to verse in a poem which he had himself illustrated in the late 1820s, Samuel Rogers's *Italy*; and Mary Wollstonecraft, who went there with Shelley in 1814, had defined precisely the relationship between landscape and history in speaking of the view along the Bay of Uri from Brunnen:

Nothing could be more magnificent than the view from this spot. The high mountains encompassed us, darkening the waters; at a distance, on the shores of Uri, we could perceive the chapel of Tell, and this was the village where he matured the conspiracy which was to overthrow the tyrant of his country; and indeed, this lovely lake, these sublime mountains, and wild forests, seemed a fit cradle for a mind aspiring to high adventure and heroic deeds.

Nothing of the drama of Switzerland's early struggle for freedom enters into Turner's distillations of eternal calm from its mountains and lakes; but the historical consciousness which was so firmly embedded in the outlook of his time can always be understood to lie behind them. We may choose to ignore a dimension of landscape that Turner seems to make irrelevant, but in doing so we should remember that for him it was not so much irrelevant as self-evident.

We should also recall the very first of his Continental subjects, *Calais Pier*. In that canvas, which depicts a French harbour in the language of the great Dutch marine painters, the protagonist, around whom the sailors and fishermen collect, is Turner himself; it is his own experience that he quite deliberately records. The swarming crowds of Zurich and Paris, no less than the silently revolving mountains and lakes and plains of Switzerland and Italy, are the cast of his own drama, a drama of which he is both author and hero. He had always acknowledged with reverence the heroic stature of the European artists to whom he owed both instruction and inspiration; they figured largely in his output, both as the evident models of many of his paintings, from Titian to Claude, and as the explicit principals of 'historical' subjects: Van Goyen, Rembrandt, Canaletto, or Watteau. Turner knew that he was one of their number, and allied himself to their traditions in every way that he could. This was perhaps one important motive for his constant journeying abroad.

In 1840, on what was to be the last of his extensive tours of discovery, he travelled along the Danube and made drawings of the Walhalla then being built to the orders of King Ludwig I of Bavaria outside Regensburg (see plate 73). This huge Doric temple, designed in imitation of the Athenian Parthenon by the neo-classical architect Leo von Klenze, was a monumental Hall of Fame to the great of Germany, past and present. It was not

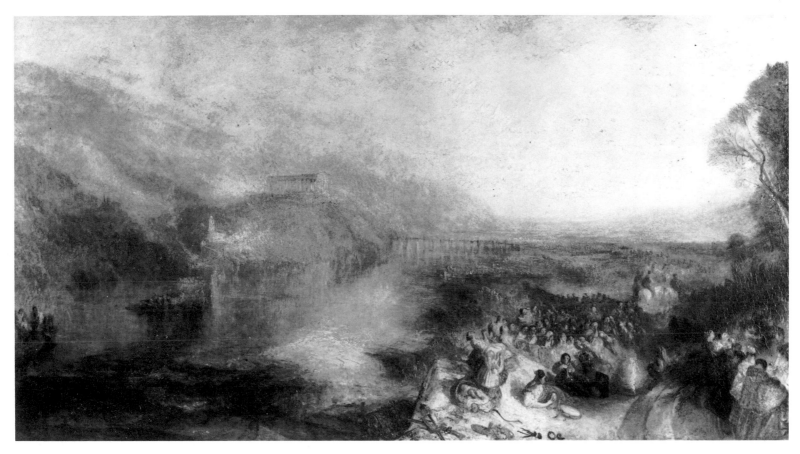

inaugurated until 18 October 1842, two years after Turner saw it; but the whole idea of the Walhalla so interested him that he painted a large picture of *The opening of the Walhalla* in which the building rises majestically serene in the centre of a landscape thronged with innumerable people, a vast Turnerian idyll of men and nature caught up in a glowing and reverberant harmony of purpose. The function of the Walhalla, celebrating the great men of Germany, is seen very much as Ludwig intended it to be, as the focus of peace and prosperity, after a period of war.

J. M. W. Turner, *The opening of the Walhalla*, 1842. RA 1843. Oil on panel. 1125 × 2005 mm. The Tate Gallery, London (533) B/J 401

Turner's verses for the Royal Academy catalogue make the point explicit:

Who rode on thy relentless car fallacious Hope?
He, though scathed at Ratisbon, poured on
The tide of war o'er all thy plain, Bavare,
Like the swollen Danube to the gates of Wien.
But peace returns – the morning ray
Beams on the Walhalla, reared to science and the arts,
For men renowned, of German fatherland.

The River Danube, in a characteristically Turnerian image, is made to act as a symbol of the destructive progress of war; but above it rises the sun of peace, blazing on a temple erected to the glory of human achievement. And although the achievement in question was strictly that of the German people, Turner evidently felt that what Ludwig of Bavaria was doing in spirit was to celebrate and sanctify the greatness of all Europe, that 'large centralised civilisation' to which Turner, like Dr Johnson, knew he belonged. Perhaps he saluted the advent of a European federation such as Lamartine foretold. For in 1845 he sent his *Walhalla* to appear in an exhibition of European Art at the Temple of Art and Industry newly opened in Munich, a rare gesture on his part, and one of the relatively few occasions on which his work could be seen on the Continent other than through the medium of prints. Sadly, the picture was greeted with uncomprehending resentment as a satirical attack on Ludwig's enterprise. This was an ironic misconception. Turner seems to have associated much of what was best in contemporary culture with the achievements of Germany. When he read Goethe's *Farbenlehre* (Theory of Colour) in Eastlake's translation of 1840, he marked for special attention this passage:

In general it were to be wished that the Germans, who render such good service to science, while they adopt all that is good from other nations, could by degrees accustom themselves to work in concert. We live, it must be confessed, in an age, the habits of which are directly opposed to such a wish. Every one seeks, not only to be original in his views, but to be independent of the labours of others . . . It is very often remarked that men who undoubtedly have accomplished much, quote themselves only, their own writings, journals, and compendiums; whereas it would be far more advantageous for the individual, and for the world, if many were devoted to a common pursuit.

Turner's *Walhalla* sums up one of the most persistent and earnest of his ideas: the heroic stature of the creative intellect, and the community of all those who by means of that intellect further the liberty and happiness of humanity. It is his most comprehensively 'European' subject because it deals not only with the landscape but with the ideals and attainments – the 'common pursuit' – of the Continent as a whole.

Chronology of Turner's European Tours

1802 15 July – 20 October

Paris – Lyons – Grenoble – Geneva – Bonneville – Chamonix –
Courmayeur – Aosta – Great St Bernard Pass – Martigny – Thun –
Interlaken – Grindelwald – Meiringen – Brienz – Lucerne –
St Gothard – Zurich – Schaffhausen – Basle

1817 10 August – mid-September

Belgium: Battlefield of Waterloo
The River Rhine: Cologne – Remagen – Coblenz – St Goar – Mainz
Holland: Rotterdam – The Hague – Amsterdam – Dordrecht

1819 August

Calais – Paris – Lyons – Mont Cenis – Turin – Como – Milan –
Verona – Venice – Bologna – Ancona

13 October

Rome – Tivoli – Naples – Pompeii – Paestum – Florence – Turin

1820 15 January – 1 February

Mont Cenis – London

1821 mid-September

Havre – River Seine between Rouen and Paris – Dieppe

1825 ?28 August

Holland and the first Meuse-Moselle tour:
Rotterdam – The Hague – Amsterdam – Utrecht – River Meuse to
Verdun – River Moselle, Metz to Coblenz – Cologne –
Aix-la-Chapelle – Liège – Antwerp – Bruges – Ostend

1826

Calais – Abbeville – Dieppe
River Loire: Nantes – Angers – Saumur – Blois – Beaugency –
Orleans – Paris

1828 11 August – early October

Paris – Orleans – Lyons – Avignon – Marseilles – Nice – Genoa –
Florence – Rome

1829 January – 22 January

Ancona – Turin – Mont Tarare – Paris

August – early September

Paris – River Seine to Harfleur
Normandy: Cherbourg – St Malo
Guernsey

1832

Paris – River Seine

1833 (or 1835)

The Baltic – Stettin – Berlin – Dresden – Prague – Vienna –
Ratisbon – Passau – Venice

1834 July or later

Brussels – Liège – Verdun – Metz – River Moselle to Coblenz – up
the River Rhine to Mainz – down the River Rhine to Cologne –
Aix-la-Chapelle

1836

Calais – Rheims – Dijon – Geneva – Bonneville – Sallanches –
Chamonix – Courmayeur – Val d'Aosta – Ivrea – Turin – Mont
Cenis – ? River Rhine

1840 August – early October

Rotterdam – River Rhine – Bregenz – Venice – Meran – Innsbruck –
Munich – Passau – Ratisbon – Nuremberg – Coburg – Rosenau –
Heidelberg

1841 end of July

Rotterdam – Basle – Schaffhausen – Constance – Zurich – Lucerne –
Brunnen – Fluelen – Brienz – Thun – Lausanne – Geneva –
Fribourg – Bern – Basle

1842 1 August

Östend – Cologne – Basle – Lucerne – Brunnen – St Gothard –
Bellinzona – Locarno – Lugano – Lake Como – Bolzano –
? Constance – ? Basle

1843

Basle – Lucerne – Goldau – Fluelen – St Gothard – Bellinzona –
Como – Splugen – Zurich – Basle

1844 ? August – early October

Basle – Rheinfelden – Schaffhausen – Zurich – Goldau – Brunnen –
Brunig – Meiringen – Grindelwald – Interlaken – Thun – Bern –
Basle

1845 September

Dieppe – Coast of Picardy – Tréport – Eu – Boulogne

Notes on the Plates

Note on abbreviations

The following abbreviations are used in referring to catalogues and basic works of reference (full details are given in the Bibliography):

B/J M. Butlin and E. Joll, *The Paintings of J. M. W. Turner*, 1977

R. W. G. Rawlinson, *The Engraved Work of J. M. W. Turner*, 1908 and 1913, and *Turner's Liber Studiorum*, 1906

TB A. J. Finberg, *A Complete Inventory of the Turner Bequest*, 1909

W. A. Wilton, *Life and Work of J. M. W. Turner*, 1979 (catalogue of watercolours)

I

Messieurs les Voyageurs on their return from Italy (par la diligence) in a snow drift upon Mount Tarrar, 22nd of January, 1829

Watercolour and bodycolour with scraping-out 545 × 747 mm

Coll: William Moir; Mrs Moir; bt Agnew 1899; S. G. Holland, sale Christie 26 June 1908 (259) bt Agnew; Sir Joseph Beecham, sale Christie 4 May 1917 (157); R. W. Lloyd, who bequeathed it to the British Museum, 1958
1958-7-12-431 (W. 405)

In this poignantly comic reminiscence of the miseries that attended the achievement of that 'grand object of travelling', the visit to Italy, Turner sums up much of what his lifetime of dedicated journeying meant to him. His letter to Charles Lock Eastlake, written in February 1829 – possibly at the very time this watercolour was in hand – provides a vivid and equally ebullient account in words (see p. 80).

2

A Mountainous Valley 1802

Pencil and black chalk with white bodycolour on grey paper
214 × 283 mm

TB LXXIV-74

When Turner first crossed the Channel in July 1802 he went briefly to Paris where, it seems, he did not stay long enough to see the sights but completed his equipment for an intensive sketching tour in the South and in Switzerland. This sheet comes from a book of grey paper watermarked *Papeterie du Marais*, in which he stored an extraordinary quantity of material gathered during the tour. The choice of grey as opposed to his more usual white sketchbook paper is perhaps an indication of the special status these drawings were to have for him. Although some are only slight studies in pencil, many, like this one, are worked up with black chalk and white bodycolour to achieve a completeness that, for Turner, was clearly a step towards the finished work of art.

This scene is perhaps near the Grande Chartreuse, which Turner

visited on his way into Switzerland from Lyons and Grenoble. The series of fine studies of this last town which the book contains has led to its being known as the *Grenoble* sketchbook. Other sheets from it are illustrated in plates 4 and 5.

3

The Convent of the Great St Bernard 1802

Pencil and black chalk with white bodycolour on grey paper
211 × 283 mm

TB LXXIV-4

Turner made several studies of the Great St Bernard Convent and its hospice, set bleakly at the top of one of the most inimical passes of the Alps. But, although he evidently essayed a finished watercolour of the Hospice (see note to plate 5), the austerity of the subject apparently daunted him. It was not until much later that he was able to use his sketches for finished works, and these, surprisingly enough, were on the diminutive scale of vignette illustrations. Both accompany the description of the pass and the rescue work of the monks in Samuel Rogers's poem *Italy*; Turner's designs were published in 1830. This view of the Convent, which Turner labelled 'Le Sumit de Mont Bernard', was transcribed almost exactly for the purpose of the vignette.

4

Lake Brienz 1802

Pencil and black chalk with white bodycolour on grey paper
219 × 281 mm

TB LXXIV-50

This sheet from the *Grenoble* sketchbook (see note to plate 2) illustrates the degree of completeness to which many of the drawings in that book were taken. They have, often, all the essentials of finished compositions

J. M. W. Turner, *Hospice of the Great St Bernard*, *c*. 1827. Pencil and watercolour. 244 × 304 mm. Vignette engraved by W. R. Smith, 1892, for Rogers's *Italy*, 1830 (R. 351). (TB CCLXXX-153) W. 1155

apart from colour. In this they recall the chalk drawings of Rome and its surroundings that Richard Wilson (1714–82) made in the 1750s, which were described by Turner's Academy colleague Joseph Farington as having 'all the quality of his pictures except the colour'. The romantic subject-matter of the Swiss lakes and mountains is very different from that of Rome; but just as, for Wilson, Rome was the most fitting place for an artist to create pictures, so for Turner's generation the wilder grandeur of the Alps was a prime source of inspiration. This subject was developed later into a finished watercolour, and another sheet (plate 5) shows Turner experimenting with the colour into which the whole idea was to be translated.

5

Lake Brienz: colour study ?c.1809

Watercolour with some pencil 295 × 437 mm

TB LXXX-C

Several studies of this type are to be found among the loose sheets of Turner's Bequest, showing him developing in terms of colour the ideas he had studied in monochrome in his *Grenoble* sketchbook. Not all of them were to result in finished watercolours; the brooding study of the *Hospice of the Great St Bernard*, for instance (TB CCLXIII-195) never led further; but this one was the basis for a serene lake view of about 1809 (W. 391). The finished drawing was bought by Thomas Wright of Upton, but most of the Swiss watercolours that Turner completed in the first decade of the century entered the collection of Walter Fawkes, who owned a slightly smaller view of Lake Brienz which we might regard as the pair to this one: it shows the town of Brienz seen from the lake by moonlight (W. 374).

6

Contamines 1802

Pencil, watercolour and bodycolour on white paper prepared with a grey wash 318 × 479 mm

TB LXXV-24

Apart from the *Grenoble* sketchbook, the most important of the books used on Turner's 1802 tour of Switzerland was the *St Gothard and Mont Blanc* sketchbook, which contains large sheets of white paper prepared with a wash of grey colour as a ground on which the subjects are drawn. Turner had already made use of such a ground for studies made among the mountains of North Wales and Scotland; but it was particularly suited to the weighty sublimity of his Alpine sketches. This sheet comes from that book. Contamines is a small village which lies immediately below Mont Blanc, isolated among the Savoy mountains. In this study Turner conveys something of the austere dignity of such a lonely outpost of human habitation: the buildings are drawn with sober weight and have an almost classical presence; the light is gloomy and cold, suggestive of the bleakness of the spot.

7

The Mer de Glace 1802

Pencil, watercolour and bodycolour on white paper prepared with a grey wash 314 × 468 mm

TB LXXV-23

Of all the drawings that Turner made among the mountains of Switzerland in 1802, none gives a more vivid idea than this one, from the *St Gothard and Mont Blanc* sketchbook, of the sheer inhumanity of the rocks and glaciers. There is no sign of life; everything is hard granite and ice. Not only does the glacier itself recall a frozen sea: the very peaks, the 'Aiguilles' that tower above Chamonix, have the character of huge waves turned to stone. Shelley, who saw the Mer de Glace in 1816, provides a graphic description of the scene:

> On all sides precipitous mountains, the abodes of unrelenting frost, surround this vale: their sides are banked up with ice and snow, broken, heaped high, and exhibiting terrific chasms. The summits are sharp and naked pinnacles, whose overhanging steepness will not even permit snow to rest upon them. Lines of dazzling ice occupy here and there their perpendicular rifts, and shine through the driving vapours with inexpressible brilliance: they pierce the clouds like things not belonging to this earth. The vale itself is filled with a mass of undulating ice, and has an ascent sufficiently gradual even to the remotest abysses of these horrible deserts . . . It exhibits an appearance as if frost had suddenly bound up the waves and whirlpools of a mighty torrent . . .

The economy and simplicity of Turner's rendering of these phenomena, the chill restriction of his colour, state all that need be said, and it is perhaps no accident that a finished watercolour of the subject never appeared. Turner did include it, however, in his *Liber Studiorum* as the most uncompromisingly sublime of all its 'Mountainous' category (R. 50).

8

The Castle of Aosta *c.*1804

Watercolour 198 × 282 mm

TB LXXX-B

The short dog-leg from Courmayeur down to Aosta and back through the Great St Bernard Pass which formed part of Turner's 1802 tour can be said to constitute his first experience of Italy; and indeed Ruskin thought he detected, in some of the studies of Aosta, 'unusual pains to mark its classicalness, as opposed to the wild Swiss peaks above'. Turner's drawings of the Roman Arch at Aosta in the *Grenoble* sketchbook might, indeed, illustrate the feelings expressed by Shelley in April 1818: 'A ruined arch of magnificent proportions, in the Greek taste, standing in a kind of road of green lawn, overgrown with violets and primroses, and in the midst of the stupendous mountains, and a *blonde* woman, of light and graceful manners, something in the style of Fuseli's Eve, were the first things we met in Italy'. A similar sense of duality and contrast is present in this view of the Castle of Aosta, with its carefully achieved compositional balance. The design is based directly on a study in the *Grenoble* sketchbook, and is on a sheet much smaller than those Turner generally used for his early Swiss subjects. It is treated with a delicacy and lightness of touch almost unparalleled among these watercolours. Ruskin felt this to be because Turner 'was yet hampered by old rules and former precedents. He is still trying to tame the Alps into submission to Richard Wilson . . .'. There are, however, some watercolours from the years immediately following 1802 in which a classical poise and serenity is deliberately aimed at and magnificently achieved – the *Lake of Geneva with Mont Blanc* now in the Yale Center for British Art, for example (W. 370), which, for all its great size, is a graceful and airy design very different from the oppressive mountain subjects most typical of these years.

9

Bonneville 1802

Pencil, watercolour and bodycolour on white paper prepared with a grey wash 314 × 477 mm

Inscribed lower left: *Bonneville*

TB LXXV-7

Like some of the *Grenoble* sketchbook studies, this view of Bonneville from the *St Gothard and Mont Blanc* book has already acquired a classical balance and harmony which suggests that Turner was determined to bring the vast scale of the Alps (which he was seeing, of course, for the first time here in Savoy) firmly under a discipline learned from masters such as Gaspard Poussin. It also anticipates the finished works that were to be derived from it, and in the case of this particular composition an unusually large number of these were involved. Two oil paintings and two watercolours, as well as a plate of the *Liber Studiorum*, are taken directly from this study (B/J 46,124; W. 381, 385 – see plate 10 – and R. 64).

10

Bonneville *c.*1809

Watercolour with some scraping-out 277 × 394 mm

Signed and dated lower right: *JMW Turner RA 09* (or *08*?)

Coll: ? Sir John Swinburne, who may have commissioned it with other Swiss subjects of this date (e.g. plate 12); Abel Buckley; Messrs Agnew, 1906; George Salting, who bequeathed it to the British Museum, 1910
1910-2-12-284 (W. 385)

This finished watercolour derives from the study in the *St Gothard and Mont Blanc* sketchbook reproduced here, plate 9. It was not the first watercolour to be made from that sketch, for Turner had already executed one for Walter Fawkes a year or so earlier (W. 381). This version was perhaps made for one of the North Country neighbours of

Fawkes who occasionally asked for subjects they had seen in his collection. The town of Bonneville is portrayed in a broad landscape setting, much as Turner had shown English and Welsh towns in his early designs for the 'Pocket Magazines' of the 1790s. Now the 'general view' of a town is wedded to a more powerful conception of landscape to express a mature appreciation of the place of human life in its natural context. It is a theme that was to be developed throughout Turner's career, culminating in the views of Lucerne, Fribourg, Zurich and Heidelberg that he produced in the 1840s.

11

The Great St Bernard Pass ?c.1803

Pencil and watercolour with stopping-out 664 × 990 mm

TB LXXX-D (W. 363)

A full-scale colour study, this very large sheet is characteristic of the scale on which Turner liked to work just after his 1802 tour of Switzerland. Although it cannot be described as a finished work, it may well be an incomplete one, rather than a sketch which was not intended to be taken further. If so, it provides interesting evidence of Turner's processes while creating his largest watercolours. The broad masses are laid in with bold sweeps of the brush, but details such as figures are already indicated by the method of stopping-out, or blotting-out, for which Turner was notorious by this date. Having laid in his ground wash, he allowed it to dry and then drew with a wet brush (without colour) the forms to be removed; when the paint was thus wetted, it could be lifted by blotting with pieces of bread, or with a dry brush. The *Great St Bernard Pass* remained in the artist's studio and passed into his Bequest. Its subject has not been confirmed.

12

Lake Brienz 1809

Watercolour 388 × 556 mm

Signed and dated lower right: *IMW Turner RA. PP 1809*

J. M. W. Turner, *On the Lake of Brienz*, 1802. Pencil, charcoal and white bodycolour on grey paper. 214 × 284 mm. (TB LXXIV-43)

Coll: Sir John Swinburne; by descent to Julia Swinburne, sale Christie 26 May 1916 (118); R. W. Lloyd, who bequeathed it to the British Museum, 1958
1958-7-12-409 (W. 386)

This composition is derived from a worked-up study in Turner's *Grenoble* sketchbook (TB LXXIV-43) and is one of a group of Swiss views that he produced in or around 1809, in which much of the sublime wildness of his first Alpine subjects is replaced by a more idyllic atmosphere of calm sunshine. There is indeed almost an Italian flavour in the group of buildings and figures in the foreground – the wharf of the little town of Brienz itself, at the eastern end of the lake. The stately line of the mountains is seen, therefore, not in close-up, but beyond a foreground of bustling human activity. This has an effect rather different from that suggested by Ruskin in his comments on the

drawing: in his opinion it 'inclines rather to a gloomy view of Swiss landscape, and is very self-denying in the matter of snow'. Another watercolour showing the town of Brienz, seen from the lake by moonlight, was executed at about the same time (W. 374). Both views were originally noted by Turner in his *Rhine, Strassburg, Oxford* sketchbook.

13

The Castle of Chillon *c.*1809

Watercolour with scraping-out 280 × 395 mm

Signed lower left: *JMW Turner RA*

Coll: Sir John Swinburne; by descent to Julia Swinburne, sale Christie 26 May 1916 (119) bt Agnew; R. W. Lloyd, who bequeathed it to the British Museum, 1958
1958-7-12-410 (W. 390)

Mary Shelley, at Chillon in 1816, inspected the dungeons of the castle with fascinated loathing, pronouncing them to be an enduring symbol of 'that cold and inhuman tyranny, which it has been the delight of man to exercise over man'. The mood of Turner's watercolour, however, is lyrical and tranquil, presenting the scene as it would appear to a traveller on a fine day, and leaving the historical and moral connotations of the spot to the mind of the beholder. This drawing was probably executed in 1809, at the same time as the *Lake of Brienz* (plate 12) which was also done on commission for Sir John Swinburne, and with which it shares its mood of sunny calm.

14

Lauffenbourgh on the Rhine *c.*1810

Pen and brown wash 179 × 258 mm

TB CXVII-H

A few drawings made on the Rhine at Lauffenburg and Schaffhausen were assigned by Ruskin to a sketchbook which he called 'the

Schaffhausen Book' but which Finberg renamed the *Fonthill* sketchbook. It is a large book, measuring 473 × 330 mm, and had already, before Turner left for Switzerland, been used for drawings at Fonthill Abbey in Wiltshire. He was to choose subjects at both Lauffenburg and Schaffhausen as plates in the long series of published selections from his works, the *Liber Studiorum*; but while the view of the great waterfall at Schaffhausen was never engraved, this one of Lauffenburg appeared in an issue of 1811 (R. 31). A surprising number of the views of cities that figure in the *Liber* are Swiss: Basle, Thun and Lucerne (see plate 15) occur as well as this subject, suggesting that although Turner reported to Joseph Farington that the 'Houses in Switzerland' had 'bad forms – tiles abominable red colour', he nevertheless found them replete with pictorial possibilities. He was to reaffirm his predilection for Swiss towns much later, when, in the 1840s, he spent so much time in Lausanne, Fribourg and Zurich (see plates 90–94, 98–9, 121).

15

Lucerne: moonlight *c.*1815–20

Brush and brown wash 215 × 277 mm

TB CXVIII-b (Vaughan Bequest)

Most of the published designs for the *Liber Studiorum*, on which Turner worked from 1806 until nearly 1820, were executed in brown wash strengthened with outlines in pen. These pen outlines Turner himself generally etched on to the copper plates, leaving the work of engraving the tones by means of the mezzotint process to various engravers. Some of the studies, however, were never published, and these frequently have no pen outline. Turner seems to have translated them himself into the mezzotint medium in a series of plates specially designed to exploit the strong contrasts of light and shade to which mezzotint lends itself. This moonlight view of Lucerne appears to be one of these subjects, although Turner never actually engraved it. Unlike the majority of the published *Liber* plates, it bears no relation to any work already in existence; but it does foreshadow in a most interesting way the moonlit view of Lucerne that he was to execute as a finished watercolour in 1843 (plate 110).

16

Abbey near Coblenz 1817

Bodycolour on white paper prepared with a grey wash
195 × 313 mm

Coll: Walter Fawkes; by descent to Frederick H. Fawkes; Messrs
Agnew 1912; R. W. Lloyd, who bequeathed it to the British
Museum, 1958
1958-7-12-412 (w. 672)

The fifty-one views along the Rhine that Turner made in 1817 have
been the subject of much controversy. Turner's early biographer,
Walter Thornbury, tells us that 'they were done at the prodigious rate
of three a day' and recounts that when Turner had completed his tour
of Holland, Belgium and the Rhine in the autumn of 1817 he 'landed at
Hull, and came straight to Farnley; where, even before taking off his
great-coat, he produced the drawings, in a slovenly roll, from his
breast-pocket; and Mr. Fawkes bought the lot for some £500 . . .'. A
later biographer, A. J. Finberg, doubted this story, but it has recently
been given more credence (as has much of Thornbury's evidence). The
drawings are of a type which Turner might have made on tour, though
he evidently did not make them in front of the motif: they derive from
sketches, for the most part tiny, in his *Waterloo and Rhine* and *Rhine*
sketchbooks (TB CLX and CLXI). If Turner did not go direct to Farnley
but first visited Raby Castle to execute his large painting of the castle
for the Earl of Darlington, he might have worked on the series there. At
all events they are not strictly to be classified as finished watercolours;
many of them make use of the grey ground which Turner often used
when sketching but never employed for finished works; and later, in
1820, he actually used some of the subjects for finished drawings which
have a decidedly different character (see plates 23 and 24).

17

Oberlahnstein 1817

Bodycolour on white paper prepared with a grey wash
198 × 316 mm

Coll: Walter Fawkes; by descent to the Rev. Ayscough Fawkes, sale
Christie 27 June 1890 (20) bt Agnew; W. F. Morice; sale Christie 21
May 1922 (61) bt Agnew; R. W. Lloyd, who bequeathed it to the
British Museum, 1958
1958-7-12-413 (w. 654)

The Rhine studies of 1817 vary greatly in degree of finish, and equally
in their emotional content. The river was of general interest to the
traveller as one of the greatest of European waterways, intimately
associated with many crucial events in the history of the Continent,
quite apart from its natural grandeur. As John Black wrote in the
Preface to his translation of Baron von Gerning's *Picturesque Tour
along the Rhine from Mentz to Cologne* (London 1820): 'The rank which
the Rhine holds among the great rivers of Europe, and the beauty and
fertility of most of the countries through which it flows, must be well
known to almost every description of readers. From the time of Caesar
to the present day, this noble stream has occupied a large portion of the
pages of history. Its genial banks were early the abode of learning, art,
and industry; and nearly all the great wars of modern Europe have been
carried out in its vicinity'.

 These considerations alone were enough to justify the publication of
countless guides (it was the subject of Baedeker's first, in 1828) and
illustrated tours. Whether Turner initially conceived his series as
subjects for the engraver is uncertain. He probably did not, since he
disposed of them so promptly to Fawkes; though he later entered into a
contract with the engraver W. B. Cooke to produce publishable
designs, and began work making use of the Fawkes set. The project was
abandoned shortly afterwards.

18

Lurleiberg and St Goarhausen 1817

Bodycolour on white paper prepared with a grey wash
197 × 309 mm

Coll: Walter Fawkes; by descent to Frederick H. Fawkes; Messrs
Agnew, 1913; R. W. Lloyd, who bequeathed it to the British
Museum, 1958
1958-7-12-416 (w. 684)

Even when he was engaged on a series of subjects apparently designed to give a comprehensive survey of a particular topographical area, Turner usually lingered on one motif with special tenderness: later in his life, he was to give much attention to the Rhine fortress of Ehrenbreitstein. While he was making the fifty-one Rhine drawings of 1817 it was the Lurleiberg or rock of the Lorelei which fascinated him; it figures in no less than six of them. Its famous legend was not of any great antiquity, but very much a romantic embroidery on the mysterious echo given out by the rock. It originated with Clemens Brentano, in his *Zu Bacharach am Rheine wohnte eine Zauberin*, a mock-archaic ballad of 1800, and was later developed by Heinrich Heine in his poem about the siren who lures boatmen to their death on the rock. Turner's interest was no doubt prompted by this evocative fiction, though his repeated treatment of the subject is probably due to the natural grandeur of the 427-foot precipice above the river.

19

Hirzenach, below St Goar 1817

Bodycolour on white paper prepared with a grey wash 210 × 325 mm

Coll: Walter Fawkes; by descent to Frederick H. Fawkes; Messrs Agnew, 1913; R. W. Lloyd, who bequeathed it to the British Museum, 1958
1958-7-12-415 (w. 681)

While some of the Rhine studies of 1817 are of a direct topographical cast, like the view of *Oberlahnstein* (plate 17), others, like the studies of the Lurleiberg (plate 18) and this sheet, seem more concerned with expressing the poetry of the rugged and 'castellated Rhine', as Byron called it. The restricted palette of ochres, greens and greys, combined with Turner's favourite grey ground, gives this series a homogeneous character distinctively its own – a sombre warmth unlike Turner's response to other places, though certainly with some affinity to the drawings that he made of Farnley itself in the same medium and at about the same date. Thornbury found them 'most exquisite for sad tenderness, purity, twilight poetry, truth and perfection of harmony. They are to the eye', he suggested, 'what the finest verses of Tennyson are to the ear; and they do what so few things on earth do: they completely satisfy the mind'.

20

Sooneck with Bacharach in the distance 1817

Bodycolour on white paper prepared with a grey wash
221 × 359 mm

Coll: Walter Fawkes; by descent; Messrs Agnew; R. W. Lloyd, who bequeathed it to the British Museum, 1958
1958-7-12-417 (w. 671)

This is one of the most expansively beautiful of the 1817 Rhine views, and one that Turner chose to use as the basis for a larger, finished watercolour of about 1820, probably one of the small group of Rhine subjects that he executed for the Swinburne family in that year (see plates 23 and 24). The subject combines the serenity of the broad river with the lowering grandeur of its cliffs to make a peculiarly rich and intense design which Turner evidently felt would merit greater elaboration. A colour study of the general composition is in the Turner Bequest CCLXIII-120.

21

Bingen from the Lorch 1817

Bodycolour on white paper prepared with a grey wash
198 × 318 mm

Coll: Walter Fawkes; Sir R. Hardy; R. W. Lloyd, who bequeathed it to the British Museum, 1958
1958-7-12-414 (w. 682)

Like the view of *Oberlahnstein* (plate 17), this drawing from the 1817 Rhine series depicts a town with the topographer's concern for architectural detail; but the handsome bridge and distant buildings are here combined with a romantic landscape that suffuses the whole subject with the robust yet sombre poetry typical of the group.

22

Johannisberg 1817

Watercolour and bodycolour on white paper prepared with a grey wash 213 × 337 mm

Coll: Walter Fawkes; by descent to Frederick H. Fawkes; Messrs Agnew, 1913; H. E. Walters; Messrs Agnew, 1918; A. E. Lawley, sale Christie 25 February 1921 (127); R. W. Lloyd, who bequeathed it to the British Museum, 1958
1958-7-12-418 (w. 673)

One of a small group of the 1817 Rhine drawings which deal not with the dramatic or picturesque events of the river's banks, but with the broad expanses of its stream and the shipping that it carries. A similar subject, the view of Schloss Biebrich, was worked up into a finished watercolour which is illustrated here (plate 23).

23

Schloss Biebrich 1820

Watercolour 293 × 453 mm

Coll: Swinburne family; N. E. Hayman; Messrs Agnew, 1912; R. W. Lloyd, who bequeathed it to the British Museum, 1958
1958-7-12-420 (w. 691)

Sir John Swinburne and his son Edward, of Capheaton in Northumberland, seem to have been acquainted with Turner from an early date; an accomplished copy by Edward Swinburne of a watercolour by Turner of about 1800, showing Dunstanborough Castle, is now in the Yale Center for British Art. However, the Swinburnes apparently selected many of the subjects that they commissioned from among the watercolours acquired by Walter Fawkes. After Fawkes had bought the fifty-one Rhine drawings of 1817 *en bloc*, the Swinburnes asked Turner to execute some of the subjects for them. Two, this view of Biebrich, and the *Marxbourg* (plate 24), certainly come from their collection; and the *Bacharach* now at Aberdeen (W. 693) may also have belonged to them. The Palace of the

Dukes of Nassau at Biebrich is the subject of a study now in the National Museum of Wales (W. 638), which Turner used as the foundation for this work.

24

Marxbourg 1820

Watercolour 291 × 458 mm

Signed and dated lower right: *IMW Turner | 1820* and inscribed: *MARXBOURG and BRUGBERG on the RHINE*

Coll: Swinburne family; sale Christie 17 March 1900 (78) bt Vokins; C. Fairfax Murray; R. W. Lloyd, who bequeathed it to the British Museum, 1958
1958-7-12-422 (w. 692)

One of the two finished watercolours of Rhine subjects which are known to have been commissioned from Turner by Sir John Swinburne or his son Edward. The other is the *Schloss Biebrich* (plate 23). As in the case of that drawing, the foundation study was chosen from the Rhine series that belonged to Walter Fawkes; in this instance, the sheet now in the Pantzer collection, Indianapolis Museum of Art (W. 653). The 'Brugberg' of Turner's inscription is the modern Braubach.

25

Caub and the Castle of Gutenfels on the Rhine
c.1820–30

Watercolour with some pencil and stopping-out 391 × 500 mm

TB CCLXIII-387

After the small group of Rhine watercolours executed for the Swinburnes about 1820, and an unfinished series on which he embarked for the printmaker and publisher William Bernard Cooke at the same time, Turner continued to draw the Rhine landscape throughout the remainder of his life. It is perhaps no accident that

among the great Swiss watercolours of 1842–5 the only subject taken from elsewhere is the view of Coblenz Bridge (see plate 101), one of his favourite Rhine motifs. Possibly, some of the finished Rhine water-colours of the 1830s – the *Ehrenbreitstein* now at Bury (W. 1051), the *Berncastel* (W. 1378a), and the *Caub and the Castle of Gutenfels* (W. 1378) – were intended to form a series, but there is no direct evidence for this beyond the tendency for such series to develop out of any project on which Turner was working. This magnificent study is directly related to the finished watercolour of the same subject, but may itself date from a few years earlier than that, being cast in a rich and subtle chromatic idiom which by the '30s had given way to broader colour structures not usually studied in preliminary sketches with such detailed care. A colour study with the same subject as that reproduced here is TB CCLXIII-388.

26

Venice: S. Giorgio Maggiore from the Dogana 1819

Watercolour 225 × 288 mm

TB CLXXXI-4

There could hardly be a more striking contrast than that between Turner's Rhine studies of 1817 and the watercolour sketches that he made in Venice two years later. It was not that he abandoned the familiar grey ground on arrival in the sunny south – see the studies that he made in Rome on the same trip (plates 34–7). Nor was it a question of careful drawing in one case, and free unconfined washes in the other. Like the Rhine subjects, the Venetian views are recorded directly in colour; but unlike many of the Roman ones, they dispense with the grey ground. The airy liquidity of the resulting impressions has always struck commentators as the quintessence of Turner's response to Venice, and as a foreshadowing of the remarkable series of studies that he was to make in the city later in life (see plates 79–85).

27

Venice: looking east from the Giudecca – sunrise
1819

Watercolour 222 × 287 mm

TB CLXXXI-5

If there is any evidence that his experience of Italy in 1819 formed the turning-point of Turner's career, it must rest in this series of Venetian watercolours. In them we encounter a new luminosity, a willingness to allow the white paper to speak for itself, that lend a completely fresh character to his style. He had employed these technical means from time to time in his sketchbooks, when noting colour effects in connection with pencil studies; but he had rarely used watercolour alone with such economy and control. This does not constitute a great leap of technical progress, for Turner had long possessed the capacity to work in this way; now for the first time he found scenes that required such a response, and elicited the most exquisite and sensitive studies as a consequence.

28

Venice: the Dogana from the Hotel Europa 1819

Watercolour 224 × 286 mm

TB CLXXXI-6

The title of this sheet is traditional, but somewhat misleading. Turner stayed at the Hotel Europa opposite the Dogana and San Giorgio Maggiore when he visited Venice in the 1840s; but when he made this study, in 1819, the Europa had not yet come into existence. James Hakewill in his manuscript guide to Italy (see Introduction, p. 17) had recommended him to 'go to the Leone Bianco on the Grand Canal' near the Rialto, and it is likely that Turner stayed there. It is obvious, from this and two of the other watercolours he made during the visit, that he was particularly attracted to the mouth of the Grand Canal with its extensive views across the Bacino towards San Giorgio Maggiore and the Giudecca. The fact that all the Venetian watercolour studies were done from points near this spot illustrates Turner's disinclination to

travel far with the incumbrance of watercolours and brushes. As another Englishman reported of him in Naples: he said 'it would take up too much time to colour in the open air – he could make 15 or 16 pencil sketches to one coloured'.

29

Venice: the Campanile of St Mark's and the Doge's Palace 1819

Watercolour 225 × 287 mm

TB CLXXXI-7

Unlike the other watercolour studies made in Venice in 1819, this sheet is rather coarse and bold; its blocks of strong colour contrast with their airy vaporousness. Turner's intention in making it was clearly rather different. Instead of depicting buildings seen at a distance through the characteristic Venetian haze, he presents a foursquare statement of the masses of masonry that one sees when confronting the Piazzetta from the Bacino. The simple, direct composition and hot, clear colour are reminiscent of Canaletto's pictures, and it may be that Turner was thinking of this, very different but equally typical, Venetian association here. Much later, in 1840, he was to paint a picture of the façade of the Doge's Palace presented head-on like this, and gloss it with Byron's famous line from *Childe Harold*:

> I stood upon a bridge, a palace and a prison on each hand.

And in 1833 the first of his Venetian paintings to be exhibited actually included this view, seen in the distance beyond the Dogana, and showed 'Canaletti painting' on a quay in the foreground.

30

Naples: the Castel dell'Ovo, with Capri and Sorrento in the distance 1819

Pencil and watercolour 253 × 401 mm

TB CLXXXVII-6

This sheet, and the other views around Naples and Rome illustrated here, come from two large sketchbooks used while Turner was abroad in 1819 which are labelled *Naples: Rome C. Studies* (TB CLXXXVII) and *Rome: C. Studies* (TB CLXXXIX). A third, smaller book, TB CXC, is labelled *Small Roman C. Studies*. All three have their pages washed with the grey ground that Turner had been fond of since his Swiss tour of 1802 and even earlier, and on that account the initial 'C' has been thought to mean 'Chiaroscuro'; but if that were the case it would have been logical for Turner to have labelled his *Tivoli* sketchbook (TB CLXXXIII) in the same way, for that contains nothing but monochrome studies in pencil with scraping-out on a grey ground; but it is simply called *Tivoli*. The 'C', therefore, evidently refers to the fact that it was in these three books that Turner made all his colour studies of Naples and Rome. All the remaining sketchbooks in use on the tour contain pencil notes only; except for the *Como and Venice* book and, possibly, a book of sky studies which may have been filled during the trip (TB CLXXXI and CLVIII). But although many of these drawings are made on the grey ground, some, like this one, are on unprepared white paper, and have all the freshness and immediacy of the Venice studies, the sharp yet enraptured vision of the newcomer in a land of wonders.

31

Naples from Capodimonte 1819

Pencil and watercolour 253 × 402 mm

TB CLXXXVII-13

One of the acknowledged wonders of Italy, Naples and its beautiful bay was a subject for the lyrics of innumerable poets, Shelley among them; and among painters Turner's immediate precursor in watercolour,

John Robert Cozens, had evoked with mastery the sonorous sweep and muted colours of the panorama in summer haze. Turner himself drew the area with a strong sense of its poetic overtones, but did not – could not – import into his views the melancholy that is typical of Cozens. This ravishing study, in which the city is made the palpable throbbing heart of the vast landscape, was to become the foundation for a finished watercolour of 1820 acquired by Fawkes with the rest of the Italian views (W. 722). In that work the addition of women in brightly coloured aprons tending fruit and flowers on the hot hillside below us increases our sense of the vitality of the city that shimmers in the huge space beyond. It is possible that the study reproduced here was not itself sketched on the spot, for Turner made a pencil drawing of the view in his *Gandolfo to Naples* sketchbook (TB CLXXXIV-53 verso – 54 recto), which is the more likely starting-point for his idea.

32

Tivoli 1819

Pencil and watercolour 253 × 404 mm

TB CLXXXVII-32

If Rome was the Mecca of history painters, Tivoli was undoubtedly the most significant spot in all Italy for the landscape artist in search of his roots. Its cliffs and cascades, its towers and temples – especially the little round Temple of the Sibyl perched on the edge of the precipice – had been used and re-used by the seventeenth-century masters in the creation of their ideal landscape subjects. The basic elements appeared in countless pictures, rearranged, altered almost beyond recognition, yet always and essentially the features of Tivoli. Turner had copied views of it in his youth and as recently as 1817 he had painted in watercolour a *Landscape: Composition of Tivoli* (W. 495) which had proclaimed on the Royal Academy walls his longing to see for himself the haunts of Claude and Gaspard Poussin. He devoted the whole of a large sketchbook to studies at Tivoli; and in addition produced a few watercolour sketches, of which this is one, which comprehend the town and its surroundings in a single gentle but penetrating sweep of the eye. These broadly handled drawings set the mood for all the many oil studies that Turner was later to make of Tivoli.

33

View across the Campagna with a low sun 1819

Watercolour 254 × 403 mm

TB CLXXXVII-43

Apart from his intensive perambulations of the city of Rome itself, Turner spent much time in the autumn of 1819 wandering through the surrounding Campagna, acquainting himself with the locations that his forerunners in landscape had made so familiar. But the colour studies he produced reveal a more general interest in the way the warm, clear light brilliantly illuminates the plain to the distant peaks of the snow-capped Apennines, taking in the ruined bridges and aqueducts scattered across it. That is the penetrating light of early morning, which seems to have been Turner's usual hour for such explorations. Here, though, he chooses to study the warm close of a hot day, while the human activity that enlivens the Campagna is still going on; scratching chickens and the drowsing ruins of the Claudean aqueduct are equally involved in the panorama.

34

Rome: St Peter's from the Villa Barberini 1819

Pencil, watercolour and bodycolour on white paper prepared with a grey wash 226 × 368 mm

TB CLXXXIX-21

This is a sheet from the sketchbook labelled by Turner *Rome: C. Studies*, and makes use of the grey ground which he frequently employed while he was working in Rome itself. He did not, apparently, feel the need for it at Naples (see plates 30 and 31). Although executed in a technique very similar to that of the Rhine studies of 1817 (plates 16–22), this drawing could hardly present a greater contrast. The soft warmth of colour, the late afternoon haze, are at a far remove from the rainy and leaden washes of the Rhine group.

35

The Claudian Aqueduct 1819

Pencil, watercolour and bodycolour with pen and brown ink on white paper prepared with a grey wash 228 × 368 mm

TB CLXXXIX-36

The Temple of Minerva Medica, as it was known to Romantic tourists, figures frequently in the Roman landscapes of Richard Wilson and his followers, having almost as irresistible an attraction for them as the Temple of the Sibyl at Tivoli (see note plate 32). Turner however invests it with a quite unexpected drama, and, just as he does in the Forum (plate 36), responds to a stock image with an entirely personal interpretation which is heavily dependent on his use of the grey ground.

36

Rome: the Forum with a rainbow 1819

Pencil, watercolour and bodycolour on white paper prepared with a grey wash 229 × 367 mm

TB CLXXXIX-46

This is one of the few subjects in the *Rome: C. Studies* sketchbook which consort naturally with his habitual grey ground; yet even here, with a stormy sky and sombre light, the subject is suffused with Italian warmth, far removed from Swiss or Rhenish storms. The ruined Forum, in which Gibbon had conceived his great history of the *Decline and Fall of the Roman Empire*, was a paradigm of departed grandeur and power; the ruins of the buildings that adorned the very heart of the Roman Empire could not be seen by men of Turner's generation without the drawing of a moral. Yet Turner here seems to be offering an entirely opposite symbolism: what promise does the rainbow hold for a civilisation so long entombed in dust? Perhaps he alludes to the re-use of ancient temples as Christian churches; but that was not generally seen by Protestants as anything more than the replacement of one corrupt and superstitious tyranny by another. More probably, this drawing simply records an effect of nature which Turner actually

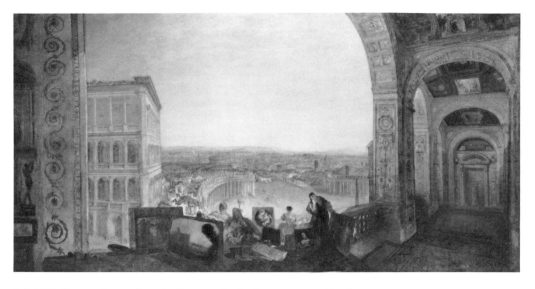

J. M. W. Turner, *Rome, from the Vatican. Raffaelle, accompanied by La Fornarina, preparing his pictures for the decoration of the Loggia,* RA 1820. Oil on canvas. 1770 × 3355 mm. The Tate Gallery, London (503) B/J 228

observed in the Forum. Such a direct and unencumbered statement would be entirely appropriate to these marvellously spontaneous studies.

37

Rome: the Church of SS. Giovanni e Paolo 1819

Pencil, watercolour and bodycolour on white paper prepared with a grey wash 230 × 367 mm

TB CLXXXIX-39

Turner made more colour studies in Rome than in any other Italian city; a number of them are devoted to the recording of large groups of

buildings, seen often in a panoramic cityscape from one of the hills. The delicacy with which these complex views are composed, and their colouring rendered in touches which usually do not cover the whole sheet, are among the most remarkable aspects of the work of this tour. It may be that by this time he had already decided to paint his vast panorama of *Rome from the Vatican* (B/J 228) for exhibition at the Royal Academy, and was consequently anxious to make for his own reference as complete a record of the appearance of the city as possible.

38

Rome: The Colosseum 1820

Watercolour 277 × 393 mm

Inscribed lower right: *Colliseum Rome W Turner 1820*

Coll: Walter Fawkes; Rev. J. W. R. Brocklebank; sale Christie 25 November 1927 (91); R. W. Lloyd, who bequeathed it to the British Museum, 1958
1958-7-12-421 (W. 723)

This is one of the seven finished watercolours of Italian subjects that Turner made after his return from Italy in 1820. All of them were acquired by Walter Fawkes. Two are works of pure architectural topography: this close-up view of the Colosseum (compare the view of the Château de Blois, plate 48) and an interior of St Peter's (W. 724). For this drawing Turner relied on one of his studies on a grey ground in pencil only, TB CLXXXIX-23. Just as the interior of St Peter's is modelled on a composition of the painter of architectural capriccios, G. P. Pannini (1691–1765), so this subject recalls the magnificent etched views of Roman ruins by G. B. Piranesi (1720–78), whom we know Turner admired. The Colosseum was a particularly poignant reminder to the tourist of what Rome had been; Addison had described it in his *Letter from Italy*:

> An Amphitheater's amazing height
> Here fills my Eye with Terror and Delight,
> That on its publick Shows unpeopled Rome,
> And held uncrowded Nations in its Womb.

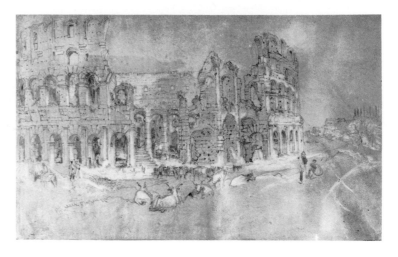

J. M. W. Turner, *Rome: the Colosseum*, 1819. Pencil on white paper prepared with a grey wash (lights rubbed out) 232 × 368 mm. (TB CLXXXIX-23)

39

The Bay of Baiae: colour study *c.*1828

Watercolour 320 × 474 mm

TB CCLXIII-350

One of the three large canvases that Turner painted after his first Italian visit was the magnificently classical *Bay of Baiae with Apollo and the Sibyl*, exhibited at the Royal Academy in 1823 (B/J 230). He made a number of pencil sketches of the bay in his *Naples: Rome C. Studies* sketchbook (TB CLXXXVII), and it is possible that this preliminary colour study for a watercolour view of the Bay was based on sketches dating from 1819. We know that Turner began work on a series of *Picturesque Views in Italy* for Charles Heath at about the time of his second Italian journey, and there seems every reason to suppose that this study is connected with it, although no finished work is recorded. Another study for the series is that of *Florence* (plate 40).

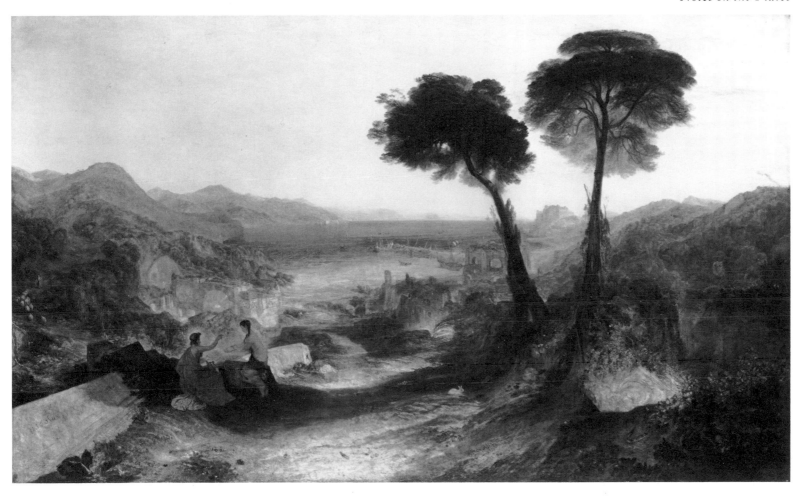

J. M. W. Turner, *The Bay of Baiae, with Apollo and the Sybil*, RA 1823. Oil on canvas. 1455 × 2390 mm. The Tate Gallery, London (505) B/J 230

40

Florence: colour study *c*.1828

Watercolour 328 × 486 mm

TB CCLXIII-16

It has not previously been noticed that this broad study is a 'colour structure' for Turner's finished watercolour view of Florence (plate 41). The distinctive composition of that work, with its forceful central vertical, is not at first apparent in this sheet: but the basic opposition of warm colours on the right – the salmon pinks and ochres of the city – to the cooler hues of the river on the left is essentially the same in both. The elaborate double perspective that Turner ultimately super-imposed on this scheme, and daringly emphasised by means of the line of cypress trees, gives the colour contrast additional weight. It is characteristic of him to work out the underlying unity of a complex design in studies such as this, and he seems to have used the procedure most consistently at about this date.

41

Florence from San Miniato *c*.1828

Watercolour and bodycolour 286 × 418 mm

Coll: H. A. J. Munro of Novar; Sir J. Pender; sale Christie 29 May 1897 (16) bt Agnew; Hon. W. F. D. Smith; Messrs Agnew 1908; Sir Joseph Beecham, sale Christie 4 May 1917 (149); R. W. Lloyd, who bequeathed it to the British Museum, 1958
1958-7-12-426 (w. 728)

Charles Heath, the publisher of the *Picturesque Views in England and Wales* which occupied Turner for ten years from 1825, planned to make use of the artist in several ways before the *England and Wales* project ran into financial difficulties in the mid-1830s. One of his schemes was a work 'on Italy . . . of a similar kind', and three finished watercolours, together with some colour studies (see plates 39 and 40) seem to be connected with it. This view of Florence, however, exists in at least two other versions, and it is a slightly different subject, now in a private collection (W. 726) which was engraved for Heath's *Keepsake* annual in 1828.

42

Domfront (?) *c*.1825

Pencil and watercolour 170 × 239 mm

TB CCXX-G

Ruskin suggested that Turner had a particular affinity with the landscape of France, because there 'he found more fellowship of scene with his own in England'. Certainly the drawings of French subjects that he made on his various tours of the country in the 1820s and 1830s often display an 'English' quality that we do not find among the Swiss or Italian views. This small sheet, for instance, has much of the liquid and spontaneous handling that Turner brought to English subjects in the 1810s and might be a meditation on some hill town of Dorset or Devon. It has been connected with the *Rivers of England* project of the early 1820s; and the town was at one time identified as Besançon, in Eastern France. This is not entirely convincing, however, and the subject may in fact be rather closer to England: Domfront, in Normandy, which Turner might have visited on one of his tours of Northern France in the 1820s, or on his journey from the Channel Islands along the north coast in 1830. Other views of the same town are TB CCXX-F, H, and two further studies of it are in the Fitzwilliam Museum, Cambridge (W. 421, 422).

43

Avignon *c.*1828

Bodycolour on blue paper 140 × 188 mm

TB CCLIX-150

Turner's second journey to Italy, in August 1828, took him to the south coast of France and he made a number of studies in Provence and along the Corniche in his 'Rivers of Europe' medium of bodycolour on small sheets of blue paper (see note to plate 47); though it is not likely that these were conceived as part of that series. Next to the studies that he made on the Moselle and Meuse, these are among the most unorthodox in palette, and constitute a group of great expressive force. This panoramic view of Avignon exemplifies the economy and simplicity with which he evokes a vast landscape, using a range of colour that would be unthought of by any other artist until the Post-Impressionists.

44

The lighthouse at Marseilles, from the sea *c.*1828

Bodycolour on grey paper 141 × 190 mm

TB CCLIX-139

Turner made notes of the harbour at Marseilles during his journey to Rome in 1828, using the *Lyons to Marseilles* sketchbook, TB CCXXX. The brilliant colour of this sheet is similar to that of other subjects along the Mediterranean coast (compare plate 45), and reflects the clear atmosphere and strong light of the South. English travellers in the early nineteenth century usually found Marseilles shocking in its squalor and dirt. Dickens was 'afraid there is no doubt that it is a dirty and disagreeable place. But the prospect, from the fortified heights, of the beautiful Mediterranean, with its lovely rocks and islands, is most delightful. These heights are a desirable retreat, for less picturesque reasons – as an escape from a compound of vile smells perpetually rising from a great harbour full of stagnant water, and befouled by the refuse of innumerable ships with all sorts of cargoes: which, in hot weather, is dreadful in the last degree . . .' (*Pictures from Italy*, 1846).

45

A village on the south coast of France 1828

Bodycolour with some pen on grey paper 142 × 192 mm

TB CCLIX-140

There is no documentary evidence to connect this sheet directly with any of the groups of drawings that Turner executed in the medium of bodycolour on blue or grey paper around 1830; but the similarity of the palette in this study to that of the view of Marseilles (plate 44), coupled with the fact that both are on grey rather than blue paper, strongly suggests that it shows a view on the Southern coast of France, or possibly on the coast of Genoa. See also plate 46.

46

The Coast of Genoa *c.*1828

Bodycolour with pen on blue paper 143 × 194 mm

TB CCLIX-138

Turner travelled to Italy in 1828, not across the Alps as he had done in 1819, but along the Mediterranean coast from Marseilles to Genoa. The scenery of the Corniche impressed him considerably; he went so far as to say as much in a letter to his fellow-Academician and old friend George Jones (1786–1869) which he wrote from Rome on 13 October 1828: 'Genoa, and all the sea-coast from Nice to Spezzia is remarkably rugged and fine . . .'. He recorded it in a series of studies on blue or grey paper, which at that date he seems to have habitually carried with him; though he was also, of course, making pencil notes in his customary pocket sketchbooks. The resulting alliance of southern light and brilliant bodycolour has given us some of Turner's most ambitious chromatic essays in a series of drawings that deserve to be better known (see also plates 43–5).

47

Beaugency *c*.1829

Bodycolour on blue paper 138 × 190 mm

TB CCLIX-95

Among other projects that Turner undertook with the publisher Charles Heath (they included the long series of *Picturesque Views in England and Wales* on which he was engaged for over ten years from 1825), a scheme to illustrate the scenery of the 'Great Rivers of Europe' occupied much of his time in the late 1820s and early 1830s. Advertised in June 1833, the series was inaugurated with a volume of engravings, accompanied by a text by Leitch Ritchie, descriptive of a tour along the Loire. In the two following years the 'Annual Tours', as Heath called them, explored the Seine. Then the project was abandoned; but not before Turner had made numerous studies and finished drawings for other tours. They all use small rectangles of blue (or occasionally grey) paper, and are executed in bodycolour with some penwork. Their brilliant colour and small scale relate them to the vignette designs that he was making for illustrations to the poetry of Byron, Rogers, Scott and Campbell in the same period, but in their experimental and often highly expressionistic use of bodycolour they proclaim a new approach to the problem of drawing for the engraver. Turner had used bodycolour in some of his Roman studies, possibly with the Continental gouache tradition in mind; in the 'Rivers of Europe' drawings he takes to an extreme the potential of the medium for brilliant colour without chiaroscuro.

48

The Château de Blois *c*.1829

Bodycolour on blue paper 139 × 190 mm

TB CCLIX-97

An unpublished design for the *Annual Tour* of the Loire, this sheet is a fine example of Turner's occasional love of the architectural close-up – a type of subject in which he was well versed, having made many such 'antiquarian' views in the 1790s. It was then that he learnt, with his colleague Thomas Girtin, to increase the drama of an imposing structure by allowing it to soar up out of sight. He was to employ the same device when drawing Rouen Cathedral for the Seine tour of 1834 (W. 965). An equally impressive though more distant view of the Château was engraved for the tour (W. 934).

49

Saumur *c*.1829

Bodycolour on blue paper 126 × 189 mm

TB CCLIX-145

There are a number of studies of Saumur, both in the Turner Bequest and elsewhere: Turner was evidently particularly attracted to this old town on the Loire, dominated by its great fourteenth-century fortress. One of these views on blue paper, showing the town and castle from the other side of the river, was engraved for the *Annual Tour* of 1833. In that year, Balzac published his famous novel *Eugénie Grandet* which is set in Saumur; he depicts the place in gloomy terms as a medieval town in the final stages of decay. This composition with its crisp perspectives is rather like the stage on which the drama of a novel will be acted, and indeed Turner used it for just such a purpose when he executed his finished watercolour of *Saumur* (see plate 50). The pencil notes that he made on the spot are to be found in the *Nantes, Angers and Saumur* sketchbook, TB CCXLVIII, used during his tour of the Loire in the autumn of 1826.

50

Saumur c.1830

Watercolour 283 × 423 mm

Coll: John Ruskin; H. A. J. Munro of Novar, sale Foster 1855; John Dillon, sale Foster 7 June 1856 (144); J. H. Maw, 1857; Hon. W. F. D. Smith; Sir Joseph Beecham, sale Christie 4 May 1917 (153) bt in; sale Christie 10 May 1918 (87); R. W. Lloyd, who bequeathed it to the British Museum, 1958
1958-7-12-430 (W. 1046)

A number of finished watercolours emerged from the work that Turner did on the French rivers for Heath's *Annual Tours*; it is likely that Heath contemplated a series of 'picturesque' views in France, as he did for Italy (see note to plate 41). In the event, however, he published six subjects individually as small plates in his annual *The Keepsake* between 1830 and 1834 (W. 1044–49). This view of Saumur appeared in an engraving by Robert Wallis in 1830. It is based on the small colour study on blue paper reproduced here (plate 49), and executed in an experimental watercolour style which seems to belong to that year or thereabouts; other finished works in this fresh, loose, briskly hatched manner are the *Marly-sur-Seine* from the same French group (plate 63) and some subjects from the *Picturesque views in England and Wales* on which Turner was engaged at the same time – those of *Richmond Hill and Bridge* and *Margate*, for example (W. 833, 839). The rather cool palette of greys and ochres that gives the *Saumur* its distinctive atmosphere is related to the colour schemes of several *Loire* studies.

51

St Florent le Vieil, Loire c.1829

Watercolour and bodycolour on blue paper 143 × 193 mm

TB CCLIX-9

A finished view of St Florent was published in *Turner's Annual Tour – the Loire* (1832; W. 944). It is based on sketches in the *Nantes, Angers and Saumur* sketchbook, TB CCXLVIII-18, 19. This study is not

directly related to it, but in its soft colouring and delicacy of handling reflects some of the character of the entire *Loire* series, which Turner imbued with an atmosphere distinctively different from that of the *Seine* sequence (see plates 53–62).

52

Château Hamelin, on the Loire c.1829

Bodycolour on blue paper 141 × 189 mm

TB CCLIX-98

Château Hamelin, the modern Champtoceaux, is one of the most dramatic points in the course of the Loire below Orleans. A high wooded cliff rises on one side of the river, above the ruins of an ancient stone bridge. The old castle is no longer visible as Turner drew it on the cliff top, its position being obscured by trees. The castle appears in a drawing engraved for the 1833 *Annual Tour* and now in the Ashmolean Museum (W. 946), and another unpublished design shows the site from the opposite bank of the river (W. 997a).

53

Paris: view of the Seine from the Barrière de Passy, with the Louvre in the distance c.1832

Bodycolour with some pen on blue paper 140 × 191 mm

TB CCLIX-117 (W. 983)

In the five views of Paris that Turner included in his *Annual Tour* of the Seine, published in 1835, the series reaches a brilliant climax. The small scale of the *French Rivers* designs, and their relatively coarse technique, are made to yield views as complex in their detail as any of his larger finished watercolours. At the same time the medium of bodycolour gives a sparkling quality to the palette that makes these among the most joyous of Turner's urban views. His innate love of the bustle and noise of a crowd emerges vividly. This introductory scene is

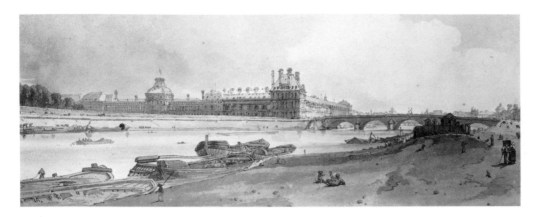

Thomas Girtin, *Paris: the Louvre seen from across the Seine*, 1802. Soft-ground etching and grey wash. 178 × 448 mm. (1965-6-12-8)

classical in its structure and dominated by the austere architecture of Ledoux's Barrière at the left, and by the firm horizontal of a modern bridge. Beyond are the Tuileries and the Louvre, with the twin towers of Nôtre Dame in the distance. These features were noted in the *Paris and Environs* sketchbook, TB CCLVII-156.

54

Paris: the Pont Neuf and the Ile de la Cité *c.*1832

Bodycolour on blue paper 141 × 190 mm

TB CCLIX-118 (W. 984)

The foursquare composition of the view of Paris from Passy (plate 53) gives way now to the opposing stresses and rhythms that enact for us the life of the French capital. At this date a number of British artists were making views in Paris, following the example of Richard Parkes Bonington (1802–28); prominent among them were Thomas Shotter

Boys (1803–74) and William Callow (1812–1908). Turner's bright, blonde palette in this series of Paris subjects may reflect the influence of Bonington and his school. He must also have had in mind the memorable group of soft-ground etchings executed by his early friend Thomas Girtin (1775–1802) in 1802, and though he does not borrow Girtin's panoramic format, he compresses into a small sheet just as much topographical information.

55

Paris: Marché aux fleurs and Pont au Change *c.*1832

Watercolour and bodycolour on blue paper 140 × 192 mm

TB CCLIX-120 (W. 985)

Like the view of the Pont Neuf (plate 54), this subject comprehends a wealth of vivid life, and contrasts the activity of the crowds in the foreground with the stately façades of the Louvre and the Tuileries along the river beyond. As with the rest of the Paris subjects executed for the 1835 *Annual Tour*, this one depends on a sketch in the *Paris and Environs* sketchbook, TB CCLVII-67 verso.

56

Paris: Hôtel de Ville and Pont d'Arcole *c.*1832

Watercolour and bodycolour on blue paper 141 × 190 mm

TB CCLIX-119 (W. 986)

Based on a study in the *Paris and Environs* sketchbook, TB CCLVII-66, this drawing takes us to the heart of the old city, and is compositionally the most involved of the Paris views, with its double perspective in the foreground and piles of buildings beyond. The brilliant creamy light that illuminates the scene is once again reminiscent of Bonington, and a hallmark of this group of drawings. A fifth Paris subject, showing the Boulevard des Italiens, was also engraved, and is now in a private collection (W. 987).

J. M. W. Turner, *Paris: Hôtel de Ville and Pont d'Arcole*, *c*.1830. Pencil. 108 × 177 mm. (TB CCLVII-66)

57

Harfleur *c*.1832

Bodycolour with pen on blue paper 138 × 187 mm

TB CCLIX-86

Although this is a highly wrought drawing – one of the most jewel-like of the whole series in its sharply defined detail and brilliant colour – it was not the view of Harfleur which was engraved and published in the 1834 *Annual Tour*. That subject (TB CCLIX-102; W. 955) shows the old silted-up harbour, with the white spire of the church rearing beyond it. This sheet concerns itself more specifically with the busy activity of the quayside and the picturesque architecture of the ancient buildings.

58

Caudebec *c*.1832

Bodycolour on blue paper 138 × 190 mm

TB CCLIX-105 (W. 960)

The long sweeps of the Seine under its imposing cliffs between Le Havre and Rouen afforded Turner many opportunities to design views on a grand scale, and, as in this instance, he did not shrink from theatrical exaggeration when it was appropriate. As Leitch Ritchie, Turner's copywriter, remarked: 'I was curious in observing what he made of the objects he selected for his sketches, and was frequently surprised to find what a forcible idea he conveyed of a place with scarcely a single correct detail. His exaggerations, when it suited his purpose to exaggerate, were wonderful, lifting up, for instance, by two or three stories, the steeple, or rather stunted cone, of a village church . . .'. Pencil studies at Caudebec, which show that this view bears out Ritchie's comments, occur in Turner's *Guernsey* sketchbook, TB CCLII, 17 verso-18 recto and verso, and a preliminary study in bodycolour on a sheet of blue paper is TB CCLIX-195. Ritchie says that the view was 'sketched from an eminence above the road' and that in it 'Turner has done all that pencil could in so small a space; yet it comprehends only half the view from Caudebec'. It was perhaps the challenge implicit in Ritchie's comments which spurred Turner to draw the panorama from Château Gaillard, further up the Seine, for another plate in the Seine series: a double perspective along two meandering reaches of the river seen from high above, which is one of his most remarkable *tours de force* (W. 975).

59

The Seine between Mantes and Vernon *c*.1832

Bodycolour with some pen on blue paper 142 × 193 mm

TB CCLIX-114

A classic celebration of Turner's love of travel, this sunny composition shows the river and the road running together into the distance in a

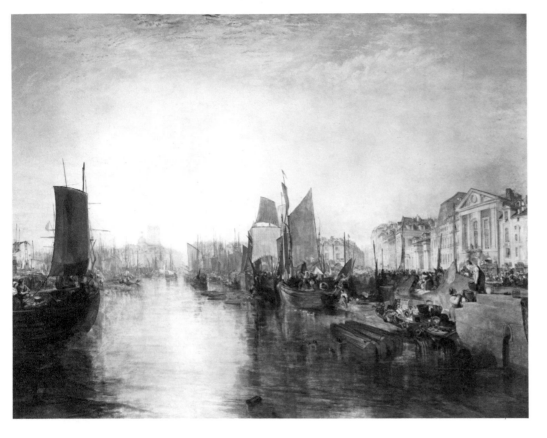

J. M. W. Turner, *Harbour of Dieppe (Changement de Domicile)*, RA 1825. Oil on canvas. 1737 × 2254 mm. The Frick Collection, New York (14.1.122) B/J 231

typically Turnerian pair of vistas, with wayside refreshment in the form of a table laid *al fresco* under the trees. The parallel perspective recurs in the finished watercolour of *Marly-sur-Seine* (plate 63) which is a kindred work in its delighted recording of the pleasures of touring in France.

60

St Denis *c.*1832

Bodycolour on blue paper 138 × 193 mm

TB CCLIX-121 (W. 979)

Leitch Ritchie recounted in his text the mythical origin of the great religious foundation of St Denis:

> The abbot Saint Denis, as we are informed by a chronicler of the ninth century, having been decapitated on Montmartre, took up his head in his hands, and walked off with it, accompanied by a train of angels singing a duet, composed of the *Gloria tibi Domine*, and the response *Alleluia*. The saint stopped at a village called Catolicam, where a basilicon was erected on the spot, commenced, it is said, by Saint Genevieve . . . Dagobert had the credit of elevating the chapel built by the holy shepherdess into a great temple; and when he died, in 638, his body was deposited therein. The example was followed on behalf of his successors; and the place remains the tomb of the French kings to this day . . .

Although Turner often painted the twilight of late evening, and frequently included the moon in his landscapes, he rarely drew a night scene of such intensity as this. The subject is reminiscent of the nocturnes that he executed in mezzotint for the series known as the 'Little Liber Studiorium' in the mid-1820s, which achieve a similar ecstatic calm.

61

Shipping off Havre *c.*1830

Bodycolour on blue paper 142 × 195 mm

TB CCLIX-161

Just as the harbour of Calais attracted Turner's particular attention when he first visited it in 1802, so the other north French ports offered him material for marine views on later journeys. According to Alaric Watts, in his *Biographical Sketch* of Turner, the artist and his

collaborator Leitch Ritchie 'travelled . . . very little in company; their tastes in everything but art being exceedingly dissimilar'. But Ritchie himself gives the impression that on at any rate one occasion they did cross the Channel together, and describes, with a rapture attributable, no doubt, to his need to fill space, the journey from Southampton to Havre-de-Grace which apparently took place in fine weather. Turner seems to have spent much time loitering about the harbour, both here and at Dieppe and Cherbourg, and he made numerous studies of the shipping that frequented them.

Ruskin found much to praise in the spontaneous exactness of this study: 'The subtlety of gradation of grey light from behind the fort to the left; of shadow at the edge of the fort itself; of rosy colour from the dark edge of the lightest cloud; of green in the water, caused not by reflection, but by the striking of the rainy sunshine on its local colour, and the placing of the boat's flag, the drift of breeze which is coming out of the light of the sky, are all in his noblest manner'.

J. M. W. Turner, *Marly-sur-Seine*, 1892. Pencil, pen and brown ink and white bodycolour on blue paper. 95 × 282 mm. (TB CCLX-58)

62

Havre *c.*1832

Bodycolour on blue paper 139 × 192 mm

TB CCLIX-133 (W. 952)

Despite the assertion of Alaric Watts that the artist rarely accompanied Leitch Ritchie on the 'Wanderings' by French rivers they jointly undertook, there are times when it is hard to believe that they do not describe a shared experience. Ritchie's account of Le Havre perfectly matches the drawing that Turner made:

> It was already the commencement of evening when we landed at Havre; and the crowds on the pier, the lights here and there in the windows, and the noises of the busy streets, gave indication of a great and populous town . . . it is necessary to view the town in its sea-port aspect; and the splendid engraving which accompanies this page will enable the reader to do so as well as if he stood upon the pier itself. A steam-boat is just about to leave the quay, probably for Southampton – no, for Honfleur – which will account for the unusual crowd . . .

It is characteristic of Turner's method as a topographer (and as landscape artist) to choose a moment in the life of the community which displays it in the greatest possible animation, and in the most beautiful and subtly lit atmospheric conditions. A very similar scene, and closely parallel composition, appears in the large oil-painting of *Harbour of Dieppe* which Turner exhibited in 1825 (B/J 231).

63

Marly-sur-Seine *c.*1831

Watercolour and bodycolour 286 × 426 mm

Coll: H. A. J. Munro of Novar, sale Christie 2 June 1877 (37), bt White; John Heugh; sale Christie 10 May 1878 (157); Rev. J. W. R. Brocklebank; R. W. Lloyd, who bequeathed it to the British Museum, 1958
1958-7-12-433 (W. 1047)

Turner made a careful drawing in a panoramic format on his customary blue paper (see fig. above), on which he relied almost entirely for this

subject, although several other studies in and around Marly exist in the artist's Bequest. Several of these show the splendid arcade of the aqueduct on the hills above the town, and this is just visible in the finished watercolour, between the trees at the extreme left. The celebration of famous buildings was not, however, Turner's main intention in making this view, which belongs to the small group of French subjects published by Charles Heath in his *Keepsake* annual, and was engraved by William Miller in 1832. The principal interest of the scene lies in its lively crowd of fashionably dressed women who wait for a pleasure boat on the Seine; Turner obviously delighted in recording their exaggerated *haute couture*, and may have implied a mildly satirical comparison with the more modestly white-clad English picnickers that he showed on the grass by the Thames in his *England and Wales* view of *Richmond Hill and Bridge* (W. 833). A colour study of the *Marly* subject is TB CCLXIII-30 (repr. *Turner in the British Museum* p. 103).

64

Tancarville *c.*1840

Watercolour and bodycolour with scraping-out 344 × 477 mm

Coll: Swinburne family; by descent to Julia Swinburne;
H. E. Hayman; Messrs Agnew, 1912; R. W. Lloyd, who bequeathed it to the British Museum, 1958
1958-7-12-423 (W. 1379)

Stylistically this view of Tancarville on the Seine appears to have been executed rather later than those of *Saumur* and *Marly* (plates 50 and 63) which also derive directly from Turner's work for the *Annual Tours* of French rivers. Its warm golden colouring and coruscating light are reminiscent of oil paintings of the later 1830s such as the *Mercury and Argus* of 1836, now in the National Gallery of Canada, Ottawa (B/J 367). The return to an idealised Claudean atmosphere, after the lively realism of the years around 1830, is common to a number of water-colours that can be dated about 1840; see also the *Lake Nemi*, plate 87. Nevertheless, this sumptuous landscape is based on a rough colour study among the notes on blue paper in the artist's Bequest (TB CCLIX-169) which must belong to the time when Turner was preparing his views along the Seine; and two rather sombre studies – one concentrating on

the trees, the other on the figures and buildings (TB CCLXIII-17, 77) – may also have been done closer to 1830, for they are similar in type to the large colour studies of those years (see plate 40).

65

The Castle of Beilstein on the Moselle ? 1834

Bodycolour on blue paper 141 × 190 mm

TB CCXXI-J

While the *Annual Tours* along the Seine and the Loire were in preparation, Turner was also planning further celebrations of European rivers: in 1833 and 1835 he went far afield gathering material, apparently, for the project. This was added to an already sizeable group of studies gleaned from tours in 1825, 1826 and 1828. Among these we can distinguish in particular the scenery of the rivers Meuse and Moselle; of both of these he had assembled enough material to fill several 'Annuals' if Heath had wished. Why the landscape of the Ardennes and the Moselle should have inspired him to flights of chromatic fantasy even more splendid than those prompted by the Mediterranean (see plates 44–6) it is difficult to say; but many of these drawings are of exceptional originality as essays in pure colour. The subject of this study is not securely identified (it reappears in another bodycolour drawing, on brown paper, TB CCCLXIV-305, which is known simply as *On the Rhine*); but it is perhaps unique in Turner's output in displaying the complete spectrum of colours, each placed separately and unmixed: starting at the top and reading clockwise we have red, orange, yellow, green, blue, indigo and violet. Ruskin never-theless asserted that 'Such things *are*, though you mayn't believe it'.

66

Namur *c.*1834

Bodycolour with some pen on blue paper 142 × 190 mm

TB CCLIX-151

Commanding the junction of the rivers Meuse and Sambre, Namur had always been a town of strategic importance, repeatedly involved in European wars. It had been held by the French from 1794 until the fall of Napoleon; but for English travellers its most exciting associations were with the siege of 1695, when William III of England captured it from Louis XIV. Charles Campbell, in his revised guide to Belgium of 1817, quoted the Augustan poet Matthew Prior on the subject, pointing out that 'The taking of Namur by William, and some circumstances attending it, as related by Prior, must forcibly remind the historic reader of some more recent advantages obtained by the British arms'.

> Europe freed, and France repell'd.
> The hero from the height beheld:
> He spoke the word, that war and rage should cease;
> He bid the Meuse and Rhine in safety flow.
> And dictated a lasting peace
> To the rejoicing world below.
> To rescued states and vindicated crowns
> His equal hand prescrib'd their antient bounds;
> Ordain'd whom every province should obey,
> How far each monarch should extend his sway;
> Taught them how clemency made power rever'd
> And that the prince belov'd, was truly fear'd.

> (Prior, *Carmen Seculare for the year 1700*)

The defeat of Napoeon was thus the occasion of a renewed consciousness of the English role in Europe, very much as Addison had expressed it at the opening of the eighteenth century.

67

Dinant on the Meuse: looking upstream *c.*1826

Bodycolour on blue paper 138 × 188 mm

TB CCXX-U

Dinant is perhaps the most picturesque of the Meuse towns, with its curious onion-spired thirteenth-century church and impressive citadel, dating from the middle of the eleventh century. Turner made several drawings of it, evidently enjoying the contrast of the delicate church spire with the solid mass of the fortress above. Here he also includes the ruins of the castle of Crèvecoeur on the cliffs to the north of the town. He was always attracted to places in which the works of man seem about to be overwhelmed by the forces of nature, and Dinant, on its narrow ledge between river and cliff, is just such a spot. This and plate 68, another view of Dinant, illustrate the expressionistic extremes to which Turner takes his use of colour in the 'Rivers of Europe' drawings.

68

Dinant on the Meuse: looking downstream *c.*1826

Bodycolour with some pen on blue paper 137 × 189 mm

TB CCXX-V

A number of the views on the Meuse make use of this hot yellow – here enveloping the whole subject in the light of a 'bronzed sunset', as Ruskin calls it. Turner includes here the splinter of rock known as the Rocher de Bayard, which stands in the river upstream from the town. Legend relates that it was kicked out of the cliff by the heel of Bayard's horse, while the '*chevalier sans peur et sans reproche*' was fighting for François I against the forces of the Emperor Charles V at Mézières.

69

Luxembourg *c.*1834

Bodycolour on blue paper 137 × 190 mm

TB CCXXI-M

Of all the fortified towns in the region of the Meuse and Moselle which Turner so thoroughly explored for his views on the 'Great Rivers of Europe', none was more nobly situated and strongly walled than Luxembourg. The rivers Alzette and Petrusse create natural moats around it, which were strengthened by the successive defence works of Spanish, Austrian, French and Dutch rulers. Turner's drawings of it, which are numerous, accentuate the organic unity of natural and man-made bastions, forming huge geometric patterns in the landscape.

70

Luxembourg *c.*1834

Bodycolour on blue paper 139 × 193 mm

TB CCXXI-O

In Ruskin's opinion this is 'probably the grandest drawing of this date', and even allowing for his incurable tendency to use superlatives it is difficult to think of any more impressive evocation of sheer scale in the range of the 'Rivers of Europe' designs. Nowhere does Turner more completely and grandly suggest the sheer military strength of a city. As Charles Campbell observed in his *Traveller's Complete Guide*, 'These naked rocks may be said to form the glacis of the place, the approaches to which are thus rendered extremely difficult. They constitute a part of an immense bank of solid marble, extending as far as Namur. Out of this solid rock the fortifications and the batteries have been cut, most of which are of course bomb proof . . . this place, generally supposed to be impregnable, was entered by the French, after starving out the garrison, in *1795*'.

71

Luxembourg *c.*1834

Bodycolour on blue paper 139 × 189 mm

TB CCXXI-P

Even more than at Dinant and Namur, Turner found at Luxembourg the dramatic juxtaposition of buildings with high precipices of rock that were always irresistible to him and which he was to draw again at Fribourg (plates 92–4). 'Nothing is more singular than its picturesque situation', wrote Charles Campbell, 'upon two solid rocks running along each bank of the little river Else. One of these is of an elevation sufficient to turn the strongest head that could venture to look down upon the river and the Lower Town, where the people appear the size of puppets'.

72

Passau 1833–5

Pencil and watercolour 212 × 278 mm

TB CCCXL-3

In 1833 or 1835, probably in search of subject-matter for his series of 'Annual Tours' of the Great Rivers of Europe, Turner made his most far-ranging journey; one that took him through the Baltic to Berlin, Dresden and Prague, then to Vienna and along the Danube to Passau. In all these cities he visited the public galleries of painting and sculpture, and drew the architecture – from the medieval monuments of Prague to the neo-classical masterpieces which had been recently built in Berlin. The tour resulted in few colour studies (though precisely how many of the 'Rivers of Europe' sketches on blue paper relate to Eastern Germany and Austria has yet to be determined); but he made a small group of atmospheric watercolours along the Danube, including this sheet. The pale washes over their delicate but precise skeleton of pencil-work constitute a *tour de force* in the economical yet concrete evocation of space and atmosphere.

73

The Walhalla near Regensburg on the Danube 1840

Watercolour 245 × 305 mm

TB CCCLXIV-316

Turner's tour to Venice in the early autumn of 1840 took him, on the return journey, to Munich, and Regensburg along the Danube. In a small sketchbook, the *Venice, Bamberg, Coburg* book, he made a pencil drawing of the Walhalla, outside Regensburg. This neo-classical Temple of Fame, built by Leo von Klenze for Ludwig I of Bavaria, was not opened until 1842, so Turner was presumably unable to see the vast interior, a room 155 ft long, decorated with paintings by Schwanthaler and sculptures by Wagner, and destined to contain over a hundred marble busts of eminent Germans. He was, in any case, perhaps more interested in the idea behind the building than in the details of its

contents, and he expressed his sense of its grandeur in this mysteriously beautiful study, which anticipates to some degree the misty golden light in which he bathed the landscape of his large painting of *The Opening of the Walhalla*, shown at the Royal Academy in 1843 (B/J 401).

74

Rosenau 1840

Pencil and watercolour 243 × 306 mm

TB CCCLXIV-49

In the spring of 1840 Queen Victoria married Albert of Saxe-Coburg, a young man well known for his interest in the arts, and for his patronage of artists. After a lifetime of royal indifference, Turner may have felt that at last he could hope for patronage from that quarter. There can be little doubt that when he toured Europe that autumn he deliberately included Coburg on his itinerary, and planned a 'portrait' of the Prince's family home for exhibition at the Royal Academy. The painting duly appeared there, in 1841, carefully titled *Schloss Rosenau, seat of H.R.H. Prince Albert of Coburg, near Coburg, Germany* (B/J 392), but although he may have felt that it was almost inevitable that Albert should want to acquire such a picture from the acknowledged *doyen* of English landscape, Turner was disappointed. This was no doubt largely due to the wide stylistic disparity between his work and the glossy, crisply drawn work of the medievalising German artists that Albert admired, and the fashionable contemporary manner that English artists had adopted from them – the manner of Maclise and Landseer, which must have made Turner's pictures seem old-fashioned as well as obscure. The unusual existence of a study in watercolour for the view of Rosenau indicates, perhaps, a special concern on Turner's part to do justice to his subject; but it is just possibly to be interpreted as evidence that he planned a watercolour of it as well. In the circumstances he would not have been encouraged to produce such a drawing. On the other hand, it is arguable that his treatment of the *Opening of the Walhalla*, exhibited two years later, was a renewed bid for Albert's interest (see plate 73 and Introduction, pp. 26–8).

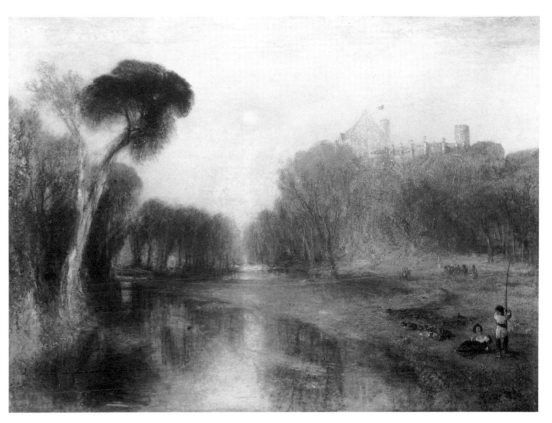

J. M. W. Turner, *Schloss Rosenau, Seat of H.R.H. Prince Albert of Coburg, near Coburg, Germany*, RA 1841. Oil on canvas. 970 × 1248 mm. Walker Art Gallery, Merseyside County Art Galleries, Liverpool (309) B/J 392

75

Ehrenbreitstein ? 1840

Watercolour 243 × 304 mm

TB CCCLXIV-285

76

Ehrenbreitstein ? 1840

Watercolour 242 × 295 mm

TB CCCLXIV-319

The fortress that commands the junction of the Rhine and the Moselle opposite Coblenz had figured in several of Turner's Rhine views of 1817; by that date it was already a ruin, in the process of being demolished. Two finished watercolours of Ehrenbreitstein are known, one of about 1820 (W. 687), the other dating from the early 1830s (W. 1051). It was not until about 1840, however, that Turner produced his long series of colour studies of the fortress from different viewpoints and in changing conditions. Here the remains of the citadel glow with a pearly radiance in sunset light, indicating that the romantic associations that Byron had lent it were still echoing in Turner's mind:

> Here Ehrenbreitstein with her shatter'd wall
> Black with the miner's blast, upon her height
> Yet shows of what she was, when shell and ball
> Rebounding idly on her strength did light;
> A tower of victory! from whence the flight
> Of baffled foes was watch'd along the plain:
> But peace destroy'd what War could never blight,
> And laid those proud roofs bare to Summer's rain
> On which the iron shower for years had poured in vain.

> (*Childe Harold*, canto III, stanza LVIII)

77

Mainz 1840

Pencil, watercolour and bodycolour with pen on grey paper
192 × 280 mm

TB CCCLXIV-293

The Turner Bequest includes a series of drawings on grey paper of this format among which are some subjects drawn at Venice and along the route north into Austria, as well as on the Rhine. They therefore accord

with the itinerary of Turner's journey to Venice and back in 1840 and are generally thought to belong to that year. It is possible that they should be placed with the other studies on blue or grey paper which he made in the early 1830s for the 'Rivers of Europe' project (see plates 47–62); but in style and technique they perhaps fit more comfortably with the later dating. The free calligraphic use of a pen dipped in colour which we find in many of them was to become an increasingly conspicuous feature of the Continental drawings of the 1840s (see plates 88, 116, 123 and 124).

78

A ruined tower on a crag ? 1836

Watercolour 240 × 305 mm

TB CCCLXIV-361

In the second half of his career Turner habitually used soft-covered sketchbooks when he travelled abroad: these he could roll up and carry in a pocket, and they provided him with a larger surface of paper than the smaller board-bound books in which he made his quick pencil notes. In the 'roll sketchbooks' he made a long stream of studies in both pencil and watercolour which he often extracted later for reference or, sometimes, for sale. The disbound sheets of these numerous books were jumbled together in his studio and it has proved difficult to establish the subjects of many of them. In the 1830s he produced drawings on a succession of European tours which are frequently indistinguishable from the fruits of journeys made in the 1840s; both the dating and the identification of many of them are therefore matters largely of speculation.

This richly coloured sketch would seem, on stylistic grounds, to belong to the 1830s when, as in the 'Rivers of Europe' drawings, Turner was preoccupied with the expressive power of colour in its own right; thus it can probably be assigned to a tour that he made in western Switzerland and the Val d'Aosta in 1836, in company with his friend and patron H. A. J. Munro of Novar. Its subject, however, may be the ruins of the Hohenrätien at the mouth of the Via Mala near Thusis in the Grisons, which Turner is not known to have seen until 1843.

79

Venice: sunset 1840

Watercolour 220 × 323 mm

TB CCCXV-17

The large number of Turner's Venetian studies in colour that survive from the later part of his life, both in the artist's Bequest and elsewhere, have been assigned to various visits to the city, documented and otherwise. It is now fairly certain that, in spite of a stream of paintings with Venetian subjects exhibited or planned between 1833 and 1846, he only went there in 1833 (after the first pictures had been shown at the Royal Academy; see note to plate 29) and 1840. Whether any colour studies were produced in 1833 is uncertain; some may have been, but the bulk of those we have seem most appropriately dated to around 1840, and so were probably done either in Venice in that year or at some time shortly afterwards. A letter from Turner dated 23 November 1843 refers to a trip 'to the Tyrol and parts of northern Italy' that year; but there is no reason to suppose that this means more than the circuit of Lake Maggiore and Lake Como which he is known to have made then. But although there is a thread of unity running through all, or many, of the late studies of Venice, they certainly display a variety of technique and approach remarkable in one visit. The examples reproduced here give some idea of the range of Turner's resources in dealing with the open, brilliantly lit spaces of Venice even within the circumscribed medium of the rapid watercolour sketch. Some are amplified with pencil outline, or with touches of pen; but many, like this one, are notes of the greatest simplicity and directness, relying only on exquisitely suggestive washes of a few colours. The intangible magic of these drawings may have been a discouragement to Turner from developing any of them into more elaborate watercolours, as he was to do later in Switzerland; but it is nevertheless surprising that a place which obviously caught his imagination so powerfully, and gave rise to many of his most luminous and personal late canvases, should not apparently have inspired a single finished drawing.

80

Venice: looking down the Grand Canal towards the Casa Corner and the Salute 1840

Watercolour 221 × 323 mm

Inscribed lower left: *BAIDI* (?)
TB CCCXV-6

The consummate ease with which the architectural topographer in Turner could render, with a few strokes of pencil or brush, the essence of a group of buildings gives even the most direct records of Venetian houses and *palazzi* an airy inevitability that denotes their special place in his output. Ruskin observed that this sketch showed 'the strong impression on the painter's mind of the opposition of the warm colour of the bricks and tawny tiles to the whiteness of the marble, as characteristic of Venice'.

81

Venice: a campanile and other buildings, with a fishing boat 1840

Watercolour 221 × 321 mm

TB CCCXV-9

In their division of the Venetian drawings between two or three different visits, both Ruskin and Finberg agreed that on the whole the work of 1840 was decidedly inferior to that produced in the 1830s. They found Turner's studies of that year tired, indecisive and slight. Even if we do not follow their segregation of the drawings so that the best are assigned to one year and the less good to another, we can agree that some display a greater degree of industry than others. But to argue that Turner was no longer able, in 1840, to make colour studies of real vigour is to overlook the long succession of such works that were to appear from the Swiss tours of the next five years. And to imagine that Turner had lost interest in Venice is surely mistaken. Even in a very

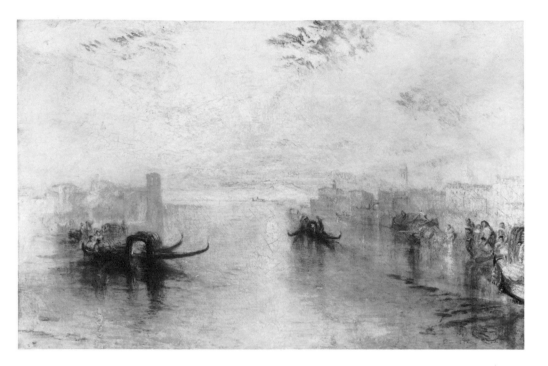

J. M. W. Turner, *St Benedetto, looking towards Fusina*, RA 1843. Oil on canvas. 615 × 920 mm. The Tate Gallery, London (534) B/J 406

82

Venice: the Giudecca, looking towards Fusina 1840

Watercolour and coloured chalks 221 × 321 mm

TB CCCXV-13

Ruskin spoke of this drawing as the 'original sketch' for Turner's oil painting, shown at the Academy in 1843, of *St Benedetto, looking towards Fusina* (B/J 406). It is a rare example of a watercolour study being used directly as the model for a painting; the view of *Rosenau* illustrated here (plate 74) is another. A rather less exact correspondence exists between another Venetian study, now in the National Gallery of Scotland (W. 1374) and the painting of *The Sun of Venice going to Sea* also exhibited in 1843 (B/J 402). These pictures are among the seventeen canvases of Venetian subjects that Turner showed between 1841 and 1846. All presumably derive from his observations of the city during the visit of 1840, the last time he is recorded as having been there. He had already executed eight paintings of Venice between 1833 and 1840, exhibiting the first some fourteen years after he first saw the city, and went on producing views of it six years after his final stay there.

83

Venice: distant view of the entrance to the Grand Canal 1840

Watercolour 230 × 303 mm

TB CCCXVI-13

Among the Venetian studies in Turner's Bequest are a few – only five – on what Finberg described as 'a slightly yellowish coarse paper' (TB CCCXVI-11 to 15). The sketches that Turner made on this unusual support are in themselves unusual: without pencil, they are exceptionally broad and allusive, and make use of the extra absorbency of the paper to create hazy, imprecise images that suggest the shimmering air of a hot evening. They are rich in colour but extremely economical of means, evoking the wide level waters of the Bacino di San Marco with a minimum of touches.

generalised study such as this one, in which the buildings have not been identified (though the campanile is possibly that of S. Giuseppe di Castello), the atmosphere of an ecstatic dream is almost palpable; the boat seems enchanted as it floats past coral palaces beneath a tender dawn sky.

84

Venice: the Salute from S. Giorgio Maggiore 1840

Watercolour and pen 241 × 303 mm

TB CCCXVI-19

A small group of the Venice studies make use of a characteristic contrast of honey-amber and turquoise in an opposition of warm and cool colour that is frequently to be found in Turner's later works. Here the composition is divided precisely into two areas dominated by these colours, a formal and purely structural system which underlines how very far these apparently direct 'notes' of Venetian views are from being spontaneous – and, indeed, how the principle of reorganisation for aesthetic ends that was evident in the *Grenoble* sketchbook drawings of 1802 (see note to plate 4) is as much in evidence at the end of Turner's career.

85

Venice: a storm 1840

Watercolour with some pen 218 × 318 mm

Coll. William Quilter; sale Christie 8 April 1878 (240); Rev. J. C. Sale, who bequeathed it to the British Museum, 1915
1915-3-13-50 (W. 1354)

Turner made a group of six studies of Venice in a storm; they were probably not all executed on the same occasion, and they deal with varying effects seen in different parts of the city and the Lagoon. Perhaps on account of their particularly impressive subject-matter, all of them were extracted from the artist's studio and acquired by private collectors, presumably through the artist's agent, Thomas Griffith. They are now widely dispersed (W. 1352-5, 1358, 1371).

86

Bedroom in Venice 1840

Bodycolour on grey-buff paper 227 × 300 mm

Inscribed verso: *J M W T Bedroom at Venice*

TB CCCXVII-34

Despite his preoccupation with the brilliance of diffused daylight in Venice, Turner did not confine his studies there to works on white paper, but made a series of remarkable drawings in bodycolour on a brown or grey-brown paper as well. This should not surprise us, since he was perennially fond of changing his ground tone, as we have seen earlier in Italy and elsewhere. There also exist a few Venetian studies on grey paper (see note to plate 77). But he did reserve the brown or buff sheets for subjects of a special kind: night scenes, often with fireworks; sketches of theatrical performances; and architectural interiors. This one is, as Turner's note tells us, a view of his own bedroom at the Hotel Europa. He made drawings from its windows of the roofscapes of Venice, and obviously considered its old painted ceiling and curtained bed worth recording on this final visit, which lasted for three weeks.

87

Lake Nemi *c*.1840

Watercolour with scraping-out 347 × 515 mm

Coll: B. G. Windus; J. E. Fordham; Sir John Fowler, sale Christie 6 May 1899 (29) bt Vokins; William Cooke, sale Christie 8 June 1917 (66); R. W. Lloyd, who bequeathed it to the British Museum, 1958
1958-7-12-444 (W. 1381)

In its iridescent warmth and sparkle, this drawing approaches even closer than the view of *Tancarville* (plate 64) to those golden visions which Turner was committing to canvas in the late 1830s, and by virtue of its Italian subject-matter reaffirms the 'classical' element in his work as a watercolourist, after his long concern with modern 'sublime'

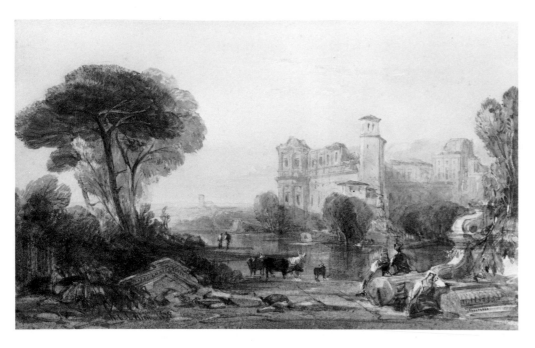

William Leighton Leitch, *Ideal landscape with palace, c.*1840. Watercolour.
151 × 242 mm. (1948-10-9-7)

topography in the *England and Wales* series. Turner is no doubt
engaged here in a private response to the current popular school of
Italian viewmakers in watercolours – William Leighton Leitch, James
Duffield Harding and Penry Williams, for example; but his rarefied
and intense restatement of the tradition of Claude and Wilson is as far
removed from their work as great poetry from prose.

88

Geneva 1841

Pencil and bodycolour with some pen 228 × 292 mm

TB CCCXXXII-20

It has been said that for Turner, unlike Byron or Shelley, Geneva was
little more than a stage on the route over the Alps to Italy. We are
perhaps justified in thinking that the city did not attract Turner in the
way that, say, Fribourg did (see plates 92–4); but he nevertheless made
several drawings of the city and its environs during his tour of
Switzerland in the late summer of 1841. He had visited Geneva quite
recently, during his tour of 1836, and had, of course, made some
important drawings of it in 1802. He no doubt recalled Hakewill's
advice to him in 1819: 'Best view of Geneva, said to be from Secheron';
and he made a number of studies of the town as a whole, crowded into
the narrow plain where the Rhône flows out at the foot of the lake. But
although the great peaks of Mont Blanc and its neighbours are close by,
they and the Jura do not provide the sharp contrasts and dramatic
juxtapositions that Fribourg in its gorge offers the artist; nor does the
situation of Geneva afford the expansive views of the lake that he could
find at Lausanne (see plate 91).

89

Geneva: the Mole and the Savoy hills 1841

Watercolour 228 × 295 mm

TB CCCXXXII-8

This drawing and that reproduced in plate 88 illustrate a recurrent
feature of the late roll sketchbooks: Turner's repeated use of the same
palette with quite different results. Both of these studies are built up on
a system of blue, yellow and grey; but whereas the panorama of the city
is brilliantly lit with a white light that merely reflects these colours in
sparkling touches, this serene view of the lake is evoked by means of
broad, smooth washes of the identical hues, without the aid of pen
outline. There can be little doubt that the pair of drawings were
executed almost together; yet their moods are quite distinct, the
colours serving separate expressive ends.

90

Lausanne 1841

Pencil and watercolour with some pen 232 × 332 mm

TB CCCXXXIV-3

91

Lausanne and Lake Geneva 1841

Pencil and watercolour with some pen 232 × 332 mm

TB CCCXXXIV-4

Among the many scenes in Switzerland to which Turner repeatedly returned in his old age, Lausanne on its steep hill beside Lake Geneva with a broad view of the Savoy mountains must be counted one of his greatest favourites. The lake seen from the heights of its northern shore at Lausanne or Vevey is famous for its serene brilliance, and for its subtle changes of light. As Thomas Roscoe wrote in 1836: 'Nothing can equal the magnificence of a summer's evening in this part of Switzerland, when the sun descends beyond Mont Jura; the Alpine summits reflect for a long time the bright ruddy spendour, and the calm, smooth lake assumes the appearance of a sheet of liquid gold. Rousseau lays the scene of his too enchanting romance [*La Nouvelle Heloïse*] near these delicious retreats, and he makes his hero burst into a strain of eloquence, on beholding the majestic beauties of an Alpine heaven – all mingling in glory at the close of a brilliant day' (*Views of Cities and Scenery in Italy, France and Switzerland*, 1836). Rousseau's novel was inevitably associated with Lausanne, as was the composition of Gibbon's *Decline and Fall of the Roman Empire*, which had taken place actually in the town, in a summer-house regularly visited by tourists.

The long sequence of studies that Turner made at Lausanne, especially in 1841, includes meditations on the splendours of the natural setting and lively evocations of the cultured middle-class life of the town which found its highest expression in the work of the writers especially associated with it by romantic travellers.

92

Fribourg 1841

Pencil and watercolour 229 × 332 mm

TB CCCXXXV-16

93

Fribourg: moonlight 1841

Pencil and watercolour 321 × 332 mm

TB CCCXXXV-3

While Turner's views of Lausanne are almost invariably associated with the human life of the place, Fribourg, to which he seems to have been equally attracted in the early 1840s, is nearly always a silent city of awe-inspiring precipices that threaten the very existence of man, whose huddled and ancient dwellings cluster together beneath them. The theme of man against nature had, of course, always preoccupied him, and in Fribourg it was given particularly vivid and direct expression.

94

Fribourg 1841

Watercolour 235 × 335 mm

TB CCCXXXV-19

In making drawings, like this one, of the new suspension bridge across the gorge at Fribourg, Turner registers his love of the new as well as of the old. The achievements of the roadmakers, and all who facilitated travel, were of lively interest to him; he did not see them as desecrations of somehow sacrosanct 'beauty-spots'. Here the presence of a piece of audacious engineering can only increase the powerful impression given by the dramatic site of the city.

95

Martigny 1841

Pencil and watercolour with some pen 228 × 288 mm

TB CCCXXXII-23

This is a sheet from Turner's *Fribourg, Lausanne and Geneva* sketchbook, used on the tour of 1841. The ruined castle of La Bastiaz, at Martigny, was a subject that Turner had drawn several times; here, he subsumes it in its surrounding landscape, so that it becomes little more than a shadow among blue shadows, which sweep in an exhilarating diagonal combining the fall of light with the steep slope of the mountainside, a favourite device of his later years.

96

Splügen: sample study 1841-2

Watercolour 242 × 305 mm

TB CCCLXIV-277

On 21 October 1841 Turner got back to London from a visit to Switzerland which had been of unusual importance in inspiring in him a wholly new response to the Swiss mountains and lakes – a response so deep and passionate that he returned to the same spots in the three ensuing years. From these four Swiss journeys twenty-six finished watercolours emerged – works of supreme importance in Turner's output, presenting an entirely novel, intensified communion with nature which took his art into a new sphere altogether. The mass of colour studies that come from these tours forms a picture of incredible energy and impassioned involvement. From them Turner selected a few, presumably examples he felt particularly rich in pictorial possibilities, which he gave his agent, Thomas Griffith, in the hope that clients would commission finished watercolours based on them. The first set of these, ten in number, appeared in 1842. Griffith succeeded in getting only nine commissions, but Turner, who had determined on a set of ten, completed the last as 'commission' for Griffith. Four of the subjects he worked up fully, so that Griffith's clients might see what to expect. The *Splügen* was one of these 'signs for his re-opened shop', as Ruskin phrased it; 'the noblest Alpine drawing Turner had ever made till then', he said.

97

Lake Lucerne: the Bay of Uri from Brunnen: sample study 1842

Pencil and watercolour 236 × 299 mm

TB CCCLXIV-354

From this study Turner developed the finished watercolour of 1842, bought by Munro of Novar from the group of four 'shop-sign' water-colours (see note to plate 96). Another of the 1842 watercolours is of a similar view, and two more showing the prospect from Brunnen appeared in 1845. Both this study and its finished watercolour are among the most magical of Turner's many renderings of the scene. In returning so often to the theme, Turner no doubt recalled the lines of Samuel Rogers's poem *Italy* relating to Lake Lucerne, which he had illustrated:

> That sacred Lake withdrawn among the hills,
> Its depth of waters flanked as with a wall
> Built by the giant race before the flood –
> Where not a cross or chapel but inspires
> Holy delight, lifting our thoughts to God
> From God-like men, men in a barbarous age
> That dared assert their birth-right, and display'd
> Deeds half-divine, returning Good for Ill;
> That in the desert sowed the seeds of life,
> Framing a band of small republics there,
> Which still exist, the envy of the world!

From Brunnen can be seen not only the spot at which William Tell made his famous leap ashore to freedom from his captors' boat, but also the site of the three springs that miraculously welled out of the ground at Grütli, on the opposite shore, marking the place where representatives of the three Cantons of Uri, Schwytz and Unterwalden

swore to free their countrymen from the tyranny of Austria. These historic moments in the progress of European Liberty were very much to the forefront of the Romantic tourist's mind when he visited the Bay of Uri.

98

Zurich: sample study 1842

Watercolour 242 × 302 mm
Inscribed verso: *J A Munro Esq^re; 16*

TB CCCLXIV-291

The 'sample' from which Munro of Novar commissioned the finished watercolour of 1842, plate 99. Turner has already established the exhilarating blue and white colour structure on which the final design is to be founded, though, as is usually the case with the 'sample studies', the sheet gives little sign of the expansive rhythms and the explosive vortex of light that animate the larger drawing.

99

Zurich 1842

Watercolour and scraping-out 300 × 456 mm

Coll: H. A. J. Munro of Novar, sale Christie 6 April 1878 (87); J. Irvine Smith; Messrs Agnew 1907; Sir George Drummond; sale Christie 26 June 1919 (129); C. Morland Agnew; R. W. Lloyd, who bequeathed it to the British Museum, 1958
1958–7–12–445 (W. 1533)

The two finished watercolours of Zurich that Turner made in 1842 and 1845 represent, perhaps, the climax of his life's work as a portrayer of cities. His vision of the communal life of a metropolis, swarming with the activity of fête or market in its context of crowded buildings and surrounding landscape affected by sunshine and storm, can be traced back to his early work as a topographer, which involved an awareness of

all aspects of the place to be depicted: architectural, geographical, social, economic and historical. Whereas the view of *Lucerne from the Walls* (see plate 100) is homely and, as it were, mundane, this panorama of Zurich is ecstatic and suggests, perhaps, the apotheosis of city life – the perfect and joyful union of men and their works with the all-embracing forces of nature that surround them.

100

Lucerne from the walls: sample study 1842

Watercolour 233 × 311 mm

Inscribed verso: *J Ruskin Jun^r Esq^re; 17*

TB CCCLXIV-290

If the views of Zurich that Turner painted in 1842 and 1845 (plates 98, 99, 121) represent the utmost extremity of his development of the cityscape as a type of sublime landscape, this study of Lucerne and the finished watercolour that he made from it for Ruskin show how, at the same time, he retained with remarkable fidelity the topographical interests of his youth. Few of his late watercolours give us such a 'literal' rendering of a particular place as this, which is enhanced, not by brilliant bursts of light, nor by the expansive and transcendental calm that seems to speak of a more exalted state of consciousness, but rather by the natural sunshine of a fine summer day, under which the town lies basking quietly. It is not convulsed in activity, like Zurich, nor buried under rubble, like Goldau (plate 108); it tranquilly pursues its business – a business, in Turner's day, very much taken up with entertaining the tourists who came to enjoy the picturesque cluster of old buildings, walled round with medieval watch-towers, and encircled by lake and mountains, with the Rigi immediately opposite (see plates 102 and 104). But in the years that Turner visited Lucerne, it was the centre of growing unrest, which led to the formation of the *Sonderbund* in 1845, and the brief war in which it was suppressed, in 1847. The foreground vignette that Turner includes in his view, showing men doing target-practice in a shooting range, perhaps hints at this violent undercurrent in contemporary Swiss life.

101

Coblenz Bridge: sample study 1842

Watercolour 234 × 294 mm

Inscribed verso: *J Ruskin Jun* *Esq*

TB CCCLXIV-286

Turner's special interest in Coblenz, and the junction there of the rivers Moselle and Rhine overlooked by the fortress of Ehrenbreitstein, is witnessed by numerous drawings and colour studies, among which this view of the Moselle bridge occurs repeatedly. It is indeed remarkable in itself that the subject should appear in a set of watercolours which are otherwise all of Swiss views. The 'sample' was selected by Ruskin and a watercolour based on it was drawn for him; but it is now untraced (W. 1530).

102

The Red Rigi: sample study 1842

Watercolour 228 × 303 mm

TB CCCLXIV-275

According to Ruskin, Turner stayed at Lucerne in the 'Schwan' Inn, which was, as Murray's *Handbook* of 1838 noted, 'a new house, in the best situation, and good' – though it had been considered expensive in 1837. Edward Dillon, however, thought Turner more likely to have stayed in the Hôtel des Balances, 'an old-established house, good, clean and *moderate charges*'. The 'situation' of the Schwan was one that Turner could hardly have resisted, and would have thought well worth the cost: the inn stood at the edge of the water, looking across the northern arm of Lake Lucerne to the Rigi immediately opposite, and it was from here that he made a long series of drawings of the mountain. No fewer than three views of the Rigi were finished for the 1842 set of ten watercolours; this subject, which came to be known as 'The Red Rigi', showing the mountain at sunset, was one of the four 'shop-sign' watercolours and bought by Munro of Novar.

The ascent of the Rigi was an essential part of any visitor's programme, and the view from its summit was 'a panorama hardly to be equalled in extent and grandeur among the Alps' (Murray). This is not so much on account of its height, a mere 5,700 ft, but, as Murray explains, because of 'its isolated situation: separated from other mountains in the midst of some of the most beautiful scenery of Switzerland, which allows an uninterrupted view from it on all sides, and converts it into a natural observatory'. It is surprising, therefore, that Turner seems never to have made a drawing of the view, though a letter to one of his patrons, Francis McCracken, written in November 1844, suggests that he contemplated it: '. . . the more I read your words "I will wait readily another year" which implies the top of the said Riggi only – if therefore it is to be done this season I think I can do it by the means of the Swiss Panoramic Prints and knowing tolerably well the geography all round the neighbourhood'.

103

Constance: sample study 1842

Watercolour 244 × 309 mm

TB CCCLXIV-288

Although Turner did not make any finished watercolours of Venice in the 1840s, the view of Constance that he based on this 'sample' at the request of Ruskin (W. 1531) gives us, perhaps, some idea of what such a work might have looked like. At Constance, he found a town perched on the rim of a vast expanse of water rather as Venice stands in her Lagoon, and he painted the broad flood of direct and reflected light in a composition dominated by a firm horizontal emphasis similar to many of his Venetian studies. Edward Dillon described the 'sample' as 'a mere hasty blot of an effect seen in one of Turner's early morning prowls, washed in either on the spot or rapidly noted on his return to the inn. The time can hardly be later than 5 a.m. We are looking upstream to the spot where the river – which behind us soon broadens out into the lower lake, the Untersee – flows out from the lake under a long wooden bridge'. Oddly enough, no other drawing of Constance is known to have been made by Turner.

104

The Dark Rigi: sample study 1842

Watercolour 230 × 322 mm

Inscribed verso: *J A Munro Esq* ; *31*

TB CCCLXIV-279

While the *Red Rigi* (see plate 102) shows the mountain at sunset, this view portrays it 'in the dawn of a lovely summer's morning,' as Ruskin says; 'a fragment of fantastic mist hanging between us and the hill'. Like the other Rigi views of 1842, it was taken from the 'Schwan' Inn. Munro of Novar commissioned the finished watercolour from this study (W. 1532). Another of the ten drawings of 1842 was a dawn view of the mountain – *The Blue Rigi*, finished as one of the four 'shop-sign' drawings, and purchased by Elhanan Bicknell (W. 1524). It was based on a further study, TB CCCLXIV-330.

105

Arth, on the lake of Zug: sample study 1843

Watercolour 227 × 289 mm

Inscribed verso: *Art – Lake of Zug No 9: X 810* and *Mr Munro*

TB CCCLXIV-280

Despite the lack of commissions for Turner's 1842 set of ten finished watercolours based on Continental studies (see note to plate 96), he determined to make a similar set under similar conditions in the following year. Presumably the 'sample' studies that he presented to Griffith on this occasion were gathered from his tour of 1842, although they could have been derived from the 1841 trip. 'But now', as Ruskin recorded, '– only five commissions could be got. My father allowed me to give two: Munro of Novar took three. Nobody would take any more'. In fact, as he mentions elsewhere, a sixth subject was executed, apparently on the same terms – *Bellinzona from the road to Locarno* (see plate 111). These drawings of 1843 maintain the supreme quality of the 1842 set, but are rather different in feeling, and broader in conception; their subjects are closer to the paintings of the same period in being

focused on one boldly handled idea, rather than comprehending a wide variety of ideas within the unity of the whole composition. The elaborate panoramas and townscapes of that set are replaced by grandly stated meditations on themes that have become almost abstract in their generalisation. So this view of Arth on Lake Zug was worked up into a finished watercolour (in the Metropolitan Museum of Art, New York; W. 1535) that is a more generalised, we might say a more idealised, Swiss summer morning than either of the two morning views of the Rigi (see plate 104). Ruskin goes so far as to suggest that the subject forms a complement to the terrible sunset of *Goldau* (see note to plate 108): 'the sunrise gilds with its level rays the two peaks [the Mythen] which protect the village that gives its name to Switzerland [Schwytz]; and the orb itself breaks first through the darkness on the very point of the pass to the high lake of Egeri, where the liberties of the Cantons were won by the battle-charge of Morgarten'.

106

Kusnacht: sample study 1843

Watercolour 229 × 291 mm

Inscribed verso: *Kusnacht and Tell's Church and Gessler's Castle – Lake of Lucerne No. 2* and *Mr Munro*

TB CCCLXIV-208

The note on the back of this study, which was used as the basis for a finished watercolour of 1843 (W. 1534), gives an indication of the range of associations that the subject carried with it for Turner and his contemporaries. By tradition, the ruined castle that stands above the village of Kusnacht was the stronghold of the captor of William Tell, who shot him nearby after his escape from Gessler's boat. Tell's Chapel at Kusnacht (not to be confused with the small chapel on the edge of the Bay of Uri; see note to plate 97) was originally dedicated to Christ, the Virgin and the Apostles, the 'fourteen helpers in need'; but, as Murray sardonically remarks, it 'now commemorates a deed of blood, which tradition, and its supposed connexion with the origin of Swiss liberty, appear to have sanctified in the eyes of the people, so that mass is periodically said in it, while it is kept in constant repair, and adorned with rude fresco, representing Gessler's death and other historical events'.

107

The Pass of Faido: sample study 1843

Pencil and watercolour with some pen 228 × 304 mm

Inscribed verso: *Pass Piolano* (or *Piottino?*) *Tessin No. 14*

TB CCCLXIV-209

This 'sample' study from Turner's 1842 tour of Switzerland was used as the basis for one of the most dramatic of the 1843 set of finished drawings – the *Pass of Faido, St Gothard* commissioned by Ruskin and now in an American private collection (W. 1538). It is unusual among the late Swiss watercolours in the constriction of the view: this is no exultant panorama, but rather a study of the very rocks of which Switzerland is made. No doubt it was this geological content that appealed to Ruskin; indeed, he used to show visitors to his home a specimen of rock from Faido 'in order that they might compare it with the drawing'. He also pointed out the importance in the design of the carriage, inconspicuously placed in the finished work, to indicate the road through the pass which is what makes the sublime experience of the mountains possible to the traveller.

108

Goldau: sample study 1843

Pencil and watercolour with some pen 228 × 286 mm

Inscribed verso: *Goldau – Rigi, and Lake of Zug/No 7*

TB CCCLXIV-281

Of all the 1843 set of Swiss subjects, the *Goldau* is most emphatically a work with a single theme. Its huge scarlet sunset is enough to announce that. Everything else in the design is subordinated: most significantly of all, the figures, which take on the colour of the rocks, and which seem a part of them as they sit fishing in statuesque silence. The finished watercolour is now in an American private collection (W.1537). The study for it lacks the breadth of its rhythms and, above all, the almost overpowering red of its sunset; but the elements of its subject-matter

are otherwise there. It is clear that Turner has already in mind the germinal idea of the finished work. Like every tourist, he knew that Goldau was a village that had been destroyed by an avalanche in 1806, and his watercolour is a celebration of that catastrophe in terms which Ruskin interpreted as tragic, but which it is perhaps more appropriate to see as a reaffirmation of the unity of man and nature. This is suggested, superficially, by the rock-coloured anglers in the foreground, and more deeply by the place of *Goldau* in a sequence of works, like the Rigi and Zurich views, which propose other aspects of the same theme. We may further conclude that Turner wished to make an almost religious statement by the sheer grandeur of the design, which contrasts markedly with the alarming realism of his earlier treatment of an avalanche in the *Cottage destroyed by an Avalanche* of 1810 (B/J 109). There is nothing in the watercolour or its study to bring to mind, as Turner could well have done had he so chosen, the physical horror of the event itself, which was reported in detail by an eyewitness account published at length by Murray, who deemed it fit matter for his *Handbook*:

The summer of 1806 had been very rainy, and on the 1st and 2nd September it rained incessantly. New crevices were observed in the flank of the mountain [the Rossberg], a sort of cracking noise was heard internally, stones started out of the ground, detached fragments of rocks rolled down the mountain; at two o'clock in the afternoon on the 2nd of September, a large rock became loose, and in falling raised a cloud of black dust . . . soon, a fissure larger than all the others, was observed; insensibly it increased; springs of water ceased all at once to flow; the pine-trees of the forest absolutely reeled; birds flew away screaming. [When Turner composed the verses to accompany his apocalyptic painting of the *Evening of the Deluge* in 1843, he seems to have remembered this passage: 'The birds forsook their nightly shelters screaming, And the beasts waded to the Ark'.] A few minutes before five o'clock, the symptoms of some mighty catastrophe became still stronger; the whole surface of the mountain seemed to glide down, but so slowly, as to afford time to the inhabitants to go away . . . The most considerable of the villages overwhelmed in the vale of Arth was Goldau, and its name is now affixed to the whole melancholy story and place . . . Nothing is left of Goldau but the bell which hung in its steeple, and which was found about a mile off . . .

Murray adds that

Five minutes sufficed to complete the work of destruction. The inhabitants of the neighbouring towns and villages were first roused by loud and grating sounds like thunder: they looked towards the spot from which it came, and beheld the valley shrouded in a cloud of dust – when it had cleared away they found the face of nature changed. The houses of Goldau were literally crushed beneath the weight of superincumbent masses. Lowertz was overwhelmed by a torrent of mud. Those who desire a near view of the landslip should ascend the Gnypenstock, whose summit may be reached in three hours from Arth.

109

Lucerne: moonlight: sample study 1843

Watercolour 234 × 323 mm

TB CCCLXIV-324

The set of Swiss watercolours that Turner completed in 1843 includes some subjects which give particular emphasis to one colour; and none is more decidedly monochromatic than the moonlight view of Lucerne (plate 110), for which this is the preparatory study. Indeed, the design harks back to a much earlier treatment of the same subject in the more explicitly monochromatic medium of brown wash, for a plate in the *Liber Studiorum* (plate 15), and Turner may have had that drawing in mind when he drew this sheet.

110

Lucerne: moonlight 1843

Watercolour and scraping-out 290 × 476 mm

Coll: H. A. J. Munro of Novar, sale Christie 2 June 1877 (34); J. Irvine Smith; R. E. Tatham, by whom bequeathed to W. G. Gibbs; Messrs Agnew, 1920; R. W. Lloyd, who bequeathed it to the British Museum, 1958
1958-7-12-446 (w. 1536)

This finished watercolour is founded on the 'sample' study illustrated here, plate 109. The drawing was commissioned by Munro of Novar, who purchased no fewer than four of the six finished Swiss watercolours of 1843. This is one of the most economical of the series, a tranquil study of moonlight expressed in a subtly varied monochrome that creates a symphony in black and silver worthy of Whistler. It is nevertheless a work that adheres in some measure to the topographical tradition that lies behind all these late watercolours. The bridge it portrays is the most picturesque of the Lucerne bridges, and has also been seen as 'a great staging-point in the development of the country'. Built in 1333, and decorated at the beginning of the seventeenth century with over 150 paintings hung on the timbers of its roof, showing scenes from Swiss history and from the lives of Lucerne's patron saints, Leger and Maurice, the bridge formed 'part of an elaborate defence-system . . . it served, in fact, as a kind of water-borne rampart, and a defence against such naval forays as had been attempted in 1332 by the fleet of the Forest'. The year previous to its construction saw the admission of the canton of Lucerne to the militant anti-Habsburg alliance of Uri, Schwytz and Unterwalden, which had recently gained a signal victory over the Austrian régime. And so 'the building of the Kapellbrücke, at once bridge and rampart, may be said to symbolise the renascence of Lucerne as an important and independent town' (John Russell, *Switzerland*, 1950).

111

Bellinzona from the road to Locarno: sample study 1843

Watercolour 228 × 287 mm

Inscribed verso: *Bellinzona No 12; Mr Munro*

TB CCCXXXII-25

The finished watercolour that Turner worked up from this study (Aberdeen Art Gallery; W. 1539) shares its striking 'vortex' composition, with a long receding perspective that takes the eye deep into the landscape. It is a formula that he was using at almost exactly the

same moment to create the spatial recession of *The Evening of the Deluge*, a painting exhibited at the Royal Academy in this year, 1843 (B/J 404).

112

Bellinzona from the South 1842 or 1843

Pencil and watercolour with some pen 227 × 324 mm

TB CCCXXXVI-15

A page from the *Bellinzona* sketchbook which Turner probably used in 1843, but which perhaps belongs to his tour of 1842, this view of the town which Ruskin thought 'on the whole, the most picturesque in Switzerland' shows the two larger of its three castles, and the castellated wall, with the Porto Lugano. A bridge over the Dragonato is at the left. The military architecture which lends so much of its character to Bellinzona was maintained in functioning order until the mid-nineteenth century, for the town stands in a strategic position at the entrance to both the St Gothard and the San Bernardino passes.

113

Bellinzona from the North: a procession ? 1843

Pencil, pen and watercolour 230 × 288 mm

TB CCCLXIV-343

Like the view of Bellinzona from the road to Locarno (plate 111) this study makes use of an emphatic perspective that leads us into the design. Here it is central, and given additional weight by the two lines of people flanking the road on either side. In the road itself, a religious procession with banners is making its way through the fields towards the Collegiate Church with the castles of San Michele, Montebello and Corbario to left and right. Ruskin noticed the elaborate conception of this subject; it was perhaps one which Turner might have made use of as a 'sample' study, but it lacks the development both of colour and detail which is usual in those studies.

114

Lake Lucerne from Brunnen: sample study 1845

Watercolour 246 × 305 mm

Inscribed verso: *Lucerne*

TB CCCLXIV-385

In 1845 Turner's health seriously deteriorated – so much so that Ruskin considered that year effectively the last of his career. But despite illness, his output remained substantial, and he even made yet another set of Swiss watercolours, this time achieving his stipulated ten commissions as he had failed to do in 1843 (see note to plate 105). Ruskin and Munro of Novar accounted for most of them, but two drawings were ordered by another important late patron, B. G. Windus of Tottenham. The finished watercolour based on this study (now in the Indianapolis Museum of Art; W. 1547) was one of Windus's two. The subject is a return to that of two of the 1842 set, though Turner places himself higher above Brunnen, and instead of looking south down the Bay of Uri, he contemplates the shore immediately opposite and the stretch of the lake to the north. The expansive topography of the 1842 set also returns in these drawings, after the more concentrated and single-minded group of 1843; but these are loosely handled, with more startling manipulations of scale. The change in handling can certainly be partly attributed to Turner's ill-health; but it may indicate, too, a desire on his part to alter, quite deliberately, his mode of discussing subjects which, after all, were not new to him. Indeed, we must suppose that, while he repeated some of his old compositions such as the *Bay of Uri* (plate 122) and *Zurich* (plate 121) fairly closely, he surely wished to express new ideas about them. This he did by means of a considerably coarser, broader application of his familiar hatching, and a consequent increase in the dynamism of light that pervades these late subjects.

115

Lucerne from the lake: sample study 1845

Watercolour 232 × 322 mm

Inscribed verso: *Lucerne*

TB CCCLXIV-386

The 1842 view of Lucerne from the walls (plate 100) shows the town in full noon sunlight; the 1843 watercolour is a moonlight study of one of its old bridges; this subject completes Turner's contemplation of the town by presenting it as it is seen from the lake, at twilight. Thus it is a necessary addition to what he has already told us, and perhaps helps to explain why the 1845 set of drawings was executed. The finished watercolour (W. 1544) is in a German private collection.

116

Schaffhausen town and castle: sample study 1845

Pencil and watercolour with some pen 237 × 295 mm

Inscribed verso: *Munro; Schaffhausen; 30*

TB CCCLXIV-337

This general view of Schaffhausen, with the fort of the Munot with its oblique walls discernible at the right, is unusual among the studies that Turner presented to his patrons as 'samples' in that it is very slight, lacking the characteristic elements of detail and texture which he normally added to help in choosing subjects. But the final watercolour, acquired by Munro of Novar, is as fully wrought and elaborately detailed as any of this set; it is now in the Toledo Museum of Art, Toledo, Ohio (W. 1540).

117

The First Bridge above Altdorf: sample study 1845

Watercolour 236 × 296 mm

Inscribed verso: *Altorf*

TB CCCLXIV-283

The stormiest of the late Swiss subjects, this study and its finished watercolour (now in the Whitworth Art Gallery, Manchester; W. 1546) continue the ideas presented in the *Faido* of 1843 (see plate 107), but with greater breadth of light and shade and a more open composition compatible with the rest of this set. The subject was chosen from this 'sample' by Ruskin, who however disliked it: 'I having unluckily told him that I wanted it for the sake of the pines, he cut all the pines down, by way of jest, and left only the bare red ground under them. I did not like getting wet with no pines to shelter me, and exchanged the drawing with Mr. Munro . . .' It will be noticed that Ruskin frequently responded to Turner's Continental drawings with a vivid sense of their relationship to travel and the plight of the stranger in the places they depict. This seems to reflect an important aspect of their significance.

118

Fluelen: looking towards the Lake: sample study
1845

Watercolour 237 × 302 mm

Verso: pencil sketches and notes and *Lucerne; Munro; Mr M*

TB CCCLXIV-282

The finished watercolour based on this sketch is now in the Yale Center for British Art (W. 1541). It is conspicuous among the 1845 set for its extremes of distortion, especially in the relation of the little village of Fluelen to the cliff that towers behind it.

119

Fluelen: looking from Lake Lucerne: sample study
1845

Watercolour 240 × 293 mm

Inscribed verso: *Altorf; Windus*

TB CCCLXIV-381

This subject may perhaps be thought of as a 'pendant' to the view of Fluelen looking towards the lake (plate 118). As the inscription on the back of the study tells us, it was chosen for 'realisation' by B. G. Windus (see note to plate 114). The finished watercolour is in the Cleveland Museum of Art (W. 1549).

120

Brunnen: sample study 1845

Pencil and watercolour 239 × 294 mm

Verso: sketches and notes in pencil and, perhaps in another hand, *Lucerne looking towards Schwitz; Ruskin*

TB CCCLXIV-375

Turner's attachment to Brunnen must have been great, for he drew the view of Lake Lucerne from its quay, or from the slopes above, on innumerable occasions. It was therefore natural that, if only as a souvenir of the spot, he should make a drawing of the village itself. This study was offered as one of the 'samples' for the set of ten watercolours of 1845, and a finished subject was commissioned, as the note on the back of this sheet testifies, by Ruskin, who admired the study, describing it as 'very elaborate and beautiful, the dark slope of the hills on the right especially'. Unfortunately, Ruskin reckoned without Turner's keen sense of obligation, as it were, to the place that had offered him so much hospitality: the artist used the finished watercolour to celebrate his special relationship with Brunnen as tourist. 'In the sketch', Ruskin says, 'there were no ugly hotels; in the drawing he put them in and spoiled his subject'.

121

Zurich: sample study 1845

Watercolour 232 × 326 mm

Inscribed verso: *Windus; Zurich; 38*

TB CCCLXIV-289

At first sight this subject is very similar to that of the view of Zurich that Turner made in 1842 (see plates 98 and 99), and Edward Dillon, among others, thought that it was a study for the same work. But in fact it is the 'sample' from which a second panorama of the city was made for B. G. Windus in 1845 (the finished watercolour is now in the Kunsthaus, Zurich; W. 1548). Dillon thought he saw in both subjects a division of soldiers marching along the road in the foreground; and his observation that 'Turner must always have associated Switzerland with revolutions and military movements' may well reflect the truth. But in neither of these Zurich views is any military activity perceptible; Turner presents us, on the contrary, with two accounts which leave us in no doubt that he thought of the city as one of festivity and rejoicing. The 1842 subject shows the preparations for the Vintage festival while the 1845 drawing has always been known by the title *Zurich: fête*.

122

Lake Lucerne: sunset: sample study 1845

Watercolour 243 × 331 mm

Inscribed verso: *Ruskin; Lucerne*

TB CCCLXIV-338

This, one of the last of Turner's views down the Bay of Uri from Brunnen, is suitably valedictory in its mellow sunset light and ineffable tranquillity – a vision of natural splendour from which all suggestion of the rugged turbulence of Switzerland's past is subsumed in roseate contentment. In the finished watercolour, now in a private collection

(W. 1543), Turner introduced yet again the lake steamer which symbolised for him the advent of a nobler age – an age in which wars have given place to peaceful travel, and the tourist has unrestricted access to all the wonders of nature and of history.

123

A castle near Meran 1844

Pencil and watercolour with pen 229 × 327 mm

TB CCCXLIX-24

Like plate 124, this is a sheet from the *Rheinfelden* sketchbook, watermarked 1844 and used by Turner on his tour of that year, which took him, as in the three preceding years, to Lucerne. He had planned to go further, but, as he explained to Hawkesworth Fawkes in his letter of 28 December 1844, he was frustrated by the climate: 'The rains came on early so I could not cross the Alps, twice I tried, was set back with a wet jacket and worn-out boots and after getting them heel-tapped I marched up some of the small valleys of the Rhine and found them more interesting than I expected'. These studies are the outcome of those unplanned excursions.

124

View on the Rhine: Rheinfelden? 1844

Pencil and watercolour with pen 228 × 329 mm

Inscribed, upper centre: *blue* and upper right: *Town against the sky*(?)

TB CCCXLIX-20

In the sketchbooks that Turner used on his last journey to Switzerland and back we encounter a technique that he had developed over a long period, especially for the drawing of large groups of buildings, towns and cities seen in panorama, in its full maturity of expressive force. The rapid outlines sketched with a pen dipped in colour with which he delineated Geneva and Fribourg in 1840 or 1841 (plates 88, 89, 91–4) have become integrated into delicately washed watercolours, so that the pen lines have the character of fragmented applications of wash, sharpening local colour and heightening detail while remaining part of the chromatic structure of the whole sheet. The pen stroke which defines outline takes on the function of the hatched brush-stroke which gives colour and atmosphere. By this remarkable system of 'shorthand' Turner created in 1844 a sequence of views along the Neckar and the Rhine which seem to mark a new departure in his art. It was to have a significant effect on the finished watercolours that he produced in the last five years of his life. Here, despite the great economy of his draughtsmanship, Turner vividly suggests the rainy weather that in 1844 prevented him from pursuing his planned itinerary across the Alps.

125

Heidelberg: looking down on the castle 1844

Pencil and watercolour with pen 230 × 328 mm

TB CCCLII-8

The *Heidelberg* sketchbook from which this sheet comes was, like the *Rheinfelden* book (see plates 123 and 124), in use during Turner's last tour to Switzerland, but Heidelberg cannot be counted among those places that he found 'more interesting' than he expected, for he had visited the old city in 1833 and already executed two finished watercolours showing the view from the opposite bank of the Neckar. Turner's large canvas of *Heidelberg* (B/J 440), showing the castle surrounded by crowds in seventeenth-century costume, can also perhaps be placed in the mid-forties.

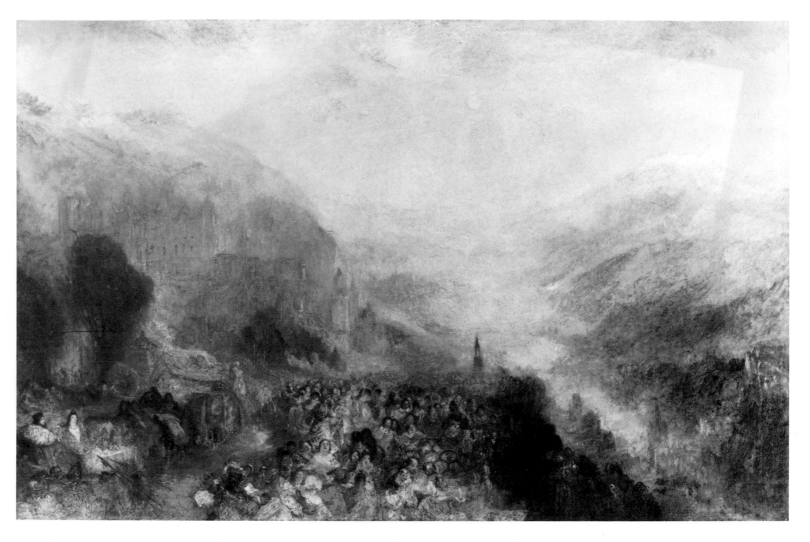

J. M. W. Turner, *Heidelberg, c.*1840–5. Oil on canvas. 1320 × 2010 mm. The Tate Gallery, London (518) B/J 440

126

Eu, with the Cathedral and Louis Philippe's Château
1845

Watercolour 231 × 325 mm

Inscribed in sky with notes, and lower right: *farmer looking about[?] in corn, bl[ack] dog*

TB CCCLIX-6

In 1845 Turner's failing health prevented him from making the journey to Switzerland as he had done for the past four years. A relatively modest stay on the coast of Normandy and Picardy formed his autumn tour this year, but it seems to have been enlivened by the visit of Queen Victoria and Prince Albert to the French King, Louis Philippe, at the Château d'Eu in early September. Louis Philippe was an old acquaintance of Turner, for the two men had been near neighbours at Twickenham in 1815; and Turner probably visited the King on this trip. Drawings of a grand dining-room lit by chandeliers occur in one of his sketchbooks, and it has been suggested that he was either present at or able to see the preparation for the entertainment for Victoria and Albert on 8 September (see the *Dieppe* sketchbook, TB CCCLX). A number of views of Eu with the Château and Cathedral prominent occur in the *Eu and Tréport* sketchbook from which this leaf comes.

127

The Cathedral at Eu 1845

Pencil and watercolour 231 × 327 mm

TB CCCLIX-16

This subject is a very late example of the way Turner occasionally reverted, throughout his life, to the low viewpoint close in front of a building which he had learnt to employ as a topographical draughtsman working under Thomas Malton in the late 1780s. Despite the rapid economy of his execution, Turner reveals his training in architectural drawing in the skilful and convincing way he assembles the elaborate gothic structure. Ruskin thought of it as seen 'by moonlight, in the sea fog', and discussed the architecture of the Cathedral as Turner presents it in some detail: 'The apse of Eu is one of the most interesting in France in its bold pyramidal structure, being surrounded by a double range of chapels, with corresponding pinnacles and double flying buttresses'.

128

White cliffs at Eu 1845

Pencil and watercolour with some pen 230 × 329 mm

TB CCCLIX-14

A sheet from the *Eu and Tréport* sketchbook, this vigorously drawn study (the detail of the foreground wall is indicated with the brush handle) records one of Turner's last views of the coast of Europe. He crossed back to England from Boulogne shortly after he had filled this book with drawings, and never returned. He planned 'my Summer's usual trip abroad' the following year, but illness and extra duties at the Royal Academy obliged him to forego it. From this time until his death in December 1851 he continued to execute finished watercolours of Continental subjects, and projected others which remained merely as studies. Many of the rough sketches in his Bequest that have been thought to belong to his late tours abroad are very possibly reminiscences at which he worked in London, after he had abandoned hope of seeing the places themselves again.

Topographical Index

(NB Modern spellings of place-names are given here, although traditional spellings are adhered to in the titles of the drawings themselves.)

Concordance

with Finberg's *Inventory* of the Turner Bequest, and with British Museum accession numbers.

	plate no								
	plate no	TB CCLIX-9	51	TB CCCXXXII-20	88	TB CCCLXIV-291	98	1958-7-12-431	1
TB LXXIV-4	3	TB CCLIX-86	57	TB CCCXXXII-23	95	TB CCCLXIV-293	77	1958-7-12-433	63
TB LXXIV-50	4	TB CCLIX-95	47	TB CCCXXXII-25	111	TB CCCLXIV-316	73	1958-7-12-444	87
TB LXXIV-74	2	TB CCLIX-97	48	TB CCCXXXIV-3	90	TB CCCLXIV-319	76	1958-7-12-445	99
TB LXXV-7	9	TB CCLIX-98	52	TB CCCXXXIV-4	91	TB CCCLXIV-324	109	1958-7-12-446	110
TB LXXV-23	7	TB CCLIX-105	58	TB CCCXXXV-3	93	TB CCCLXIV-337	116		
TB LXXV-24	6	TB CCLIX-114	59	TB CCCXXXV-16	92	TB CCCLXIV-338	122		
TB LXXX-B	8	TB CCLIX-117	53	TB CCCXXXV-19	94	TB CCCLXIV-343	113		
TB LXXX-C	5	TB CCLIX-118	54	TB CCCXXXVI-15	112	TB CCCLXIV-354	97		
TB LXXX-D	11	TB CCLIX-119	56	TB CCCXL-3	72	TB CCCLXIV-361	78		
TB CXVII-H	14	TB CCLIX-120	55	TB CCCXLIX 20	124	TB CCCLXIV-375	120		
TB CXVIII-b	15	TB CCLIX-121	60	TB CCCXLIX-24	123	TB CCCLXIV-381	119		
TB CLXXXI-4	26	TB CCLIX-133	62	TB CCCLII-8	125	TB CCCLXIV-385	114		
TB CLXXXI-5	27	TB CCLIX-138	46	TB CCCLIX-6	126	TB CCCLXIV-386	115		
TB CLXXXI-6	28	TB CCLIX-139	44	TB CCCLIX-14	128	1910-2-12-284	10		
TB CLXXXI-7	29	TB CCLIX-140	45	TB CCCLIX-16	127	1915-3-13-50	85		
TB CLXXXVII-6	30	TB CCLIX-145	49	TB CCCLXIV-49	74	1958-7-12-409	12		
TB CLXXXVII-13	31	TB CCLIX-150	43	TB CCCLXIV-208	106	1958-7-12-410	13		
TB CLXXXVII-32	32	TB CCLIX-151	66	TB CCCLXIV-209	107	1958-7-12-412	16		
TB CLXXXVII-43	33	TB CCLIX-161	61	TB CCCLXIV-275	102	1958-7-12-413	17		
TB CLXXXIX-21	34	TB CCLXIII-16	25	TB CCCLXIV-277	96	1958-7-12-414	21		
TB CLXXXIX-36	35	TB CCLXIII-350	39	TB CCCLXIV-279	104	1958-7-12-415	19		
TB CLXXXIX-39	37	TB CCLXIII-387	40	TB CCCLXIV-280	105	1958-7-12-416	18		
TB CLXXXIX-46	36	TB CCCXV-6	80	TB CCCLXIV-281	108	1958-7-12-417	20		
TB CCXX-G	42	TB CCCXV-9	81	TB CCCLXIV-282	118	1958-7-12-418	22		
TB CCXX-U	67	TB CCCXV-13	82	TB CCCLXIV-283	117	1958-7-12-420	23		
TB CCXX-V	68	TB CCCXV-17	79	TB CCCLXIV-285	75	1958-7-12-421	38		
TB CCXXI-J	65	TB CCCXVI-13	83	TB CCCLXIV-286	101	1958-7-12-422	24		
TB CCXXI-M	69	TB CCCXVI-19	84	TB CCCLXIV-288	103	1958-7-12-423	64		
TB CCXXI-O	70	TB CCCXVII-34	86	TB CCCLXIV-289	121	1958-7-12-426	41		
TB CCXXI-P	71	TB CCCXXXII-8	89	TB CCCLXIV-290	100	1958-7-12-430	50		

Select Bibliography

Books

Bacharach, A. G. H., *Turner and Rotterdam, 1817, 1825, 1841*, 1974

Butlin, M. and Joll, E., *The Paintings of J. M. W. Turner*, 2 vols, London–New Haven 1977

Borch, A. von der, 'Studien zu Joseph Mallord William Turners Rheinreisen (1817–1844)', Doctoral Thesis, Bonn 1978

Clifford, T., *Vues pittoresques de Luxembourg; dessins et aquarelles par JMW Turner 1775–1851*, Luxembourg 1977

Dillon, E., 'Turner's last Swiss watercolours', *Art Journal*, 1902, pp. 329, 362

Farington, J. *Diary*, ed. K. Garlick and A. Macintyre, 1978 *et. seq.* [see especially entries for 1 October and 22, 23 November 1802, giving Turner's account of his first Continental tour]

Finberg, A. J., *A Complete Inventory of the Drawings of the Turner Bequest*, 2 vols, by order of the Trustees of the British Museum, HMSO, 1909

— 'With Turner at Geneva', *Apollo*, January 1925, pp. 38–42

— *In Venice with Turner*, London 1930

— *The Life of J. M. W. Turner, R.A.*, 2nd edition, revised and with a supplement by Hilda Finberg, Oxford 1961

Finley, G., 'The Apocalypse and History: Angel and Undine', *The Burlington Magazine*, November 1979, pp. 685–96

Gage, J., *Turner – 'Rain Steam and Speed'*, London 1972

— ed. *Collected Correspondence of J. M. W. Turner, with an early diary and memoir by George Jones*, Oxford 1980

Gwynn, S., ed., *Memorials of an Eighteenth-Century Painter, James Northcote*, London 1898

Leslie, C. R., *Autobiographical Recollections*, ed. T. Taylor, 2 vols, London 1860

Pianzola, M., 'William Turner et Genève', in *Pour une histoire qualitative: études offertes à Sven Stelling-Michaud*, 1976

Rawlinson, W. G., *The Engraved Work of J. M. W. Turner, R.A.*, 2 vols, London 1908, 1913

— *Turner's Liber Studiorum*, 2nd ed. London 1906

Ritchie, L., *Liber Fluviorum; or River Scenery in France depicted in Sixty-one Line engravings from Drawings by J. M. W. Turner*, with a biographical sketch by A. A. Watts, London 1853

Russell, J., and Wilton, A., *Turner in Switzerland*, ed. W. Amstutz, with a checklist of Turner's finished Swiss watercolours, Zurich 1976

Ruskin, J., *Modern Painters*, London 1843–60; complete edition 6 vols, Orpington 1888

— *Notes on Pictures*, 2 vols, London 1902

Stader, K. H., *William Turner und der Rhein*, Bonn 1981

Thornbury, W., *The Life of J. M. W. Turner, R.A.*, 2 vols, 1862, rev. ed. London 1876

Wilton, A. *Life and Work of J. M. W. Turner*, Academy Editions, London 1979

Catalogues

J. M. W. Turner, Wallraf-Richartz-Museum, Cologne, October–November 1980

Turner en France, Centre Culturel du Marais, Paris, 7 October 1981–January 1982

Turner in the British Museum: Drawings and Watercolours, introduction and catalogue by Andrew Wilton. British Museum, May 1975–January 1976

Turner in Yorkshire, catalogue by David Hill, assisted by Stanley Warburton; Turner's Rhine drawings catalogued by Mary Tussey; ed. Richard Green. York City Art Gallery, 7 June–20 July 1980

The Plates

Now for my journey *home*. Do not think that any poor devil had such another, but quite satisfactory for one thing at least, viz. not to be so late in the season of winter again, for the snow began to fall at Foligno, tho' more of ice than snow, that the coach from its weight slide about in all directions, that walking was much preferable, but my innumerable tails would not do that service so I soon got wet through and through, till at Sarre-valli the diligence zizd into a ditch and required 6 oxen, sent three miles back for, to drag it out; this cost 4 Hours, that we were 10 Hours beyond our time at Macerata, consequently half starved and frozen we at last got to Bologna . . . But there our troubles began instead of diminishing – the Milan diligence was unable to pass Placentia. We therefore hired a voitura, the horses were knocked up the first post, Sigr turned us over to another lighter carriage which put my coat in full requisition night and day, for we never could keep warm or make our day's distance good, the places we put up at proved all bad till Firenzola being even the worst for the down diligence people had devoured everything eatable (Beds none) . . . crossed Mont Cenis on a sledge – bivouaced in the snow with fires lighted for 3 Hours on Mont Tarare while the diligence was righted and dug out, for a Bank of Snow saved it from upsetting – and in the same night we were again turned out to walk up to our knees in new fallen drift to get assistance to dig a channel thro' it for the coach, so that from Foligno to within 20 miles of Paris I never saw the road but snow!

Extract from Turner's letter to Charles Eastlake, February 1829

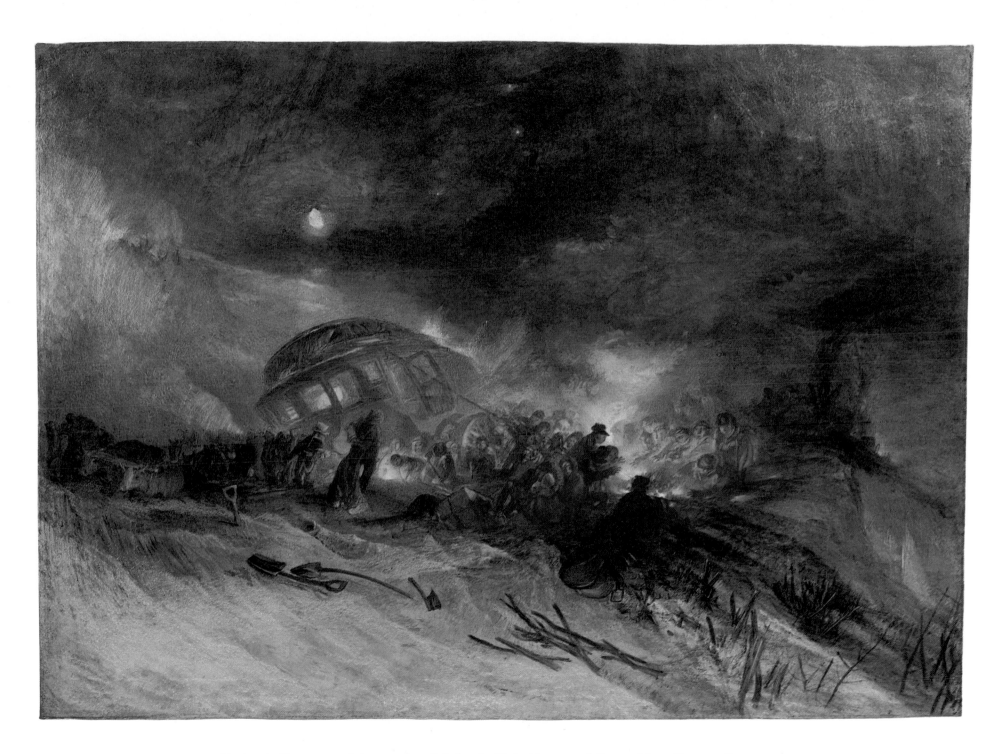

1 *Messieurs les Voyageurs* on their return from Italy (*par la diligence*) in a snow drift upon Mount Tarrar 1829

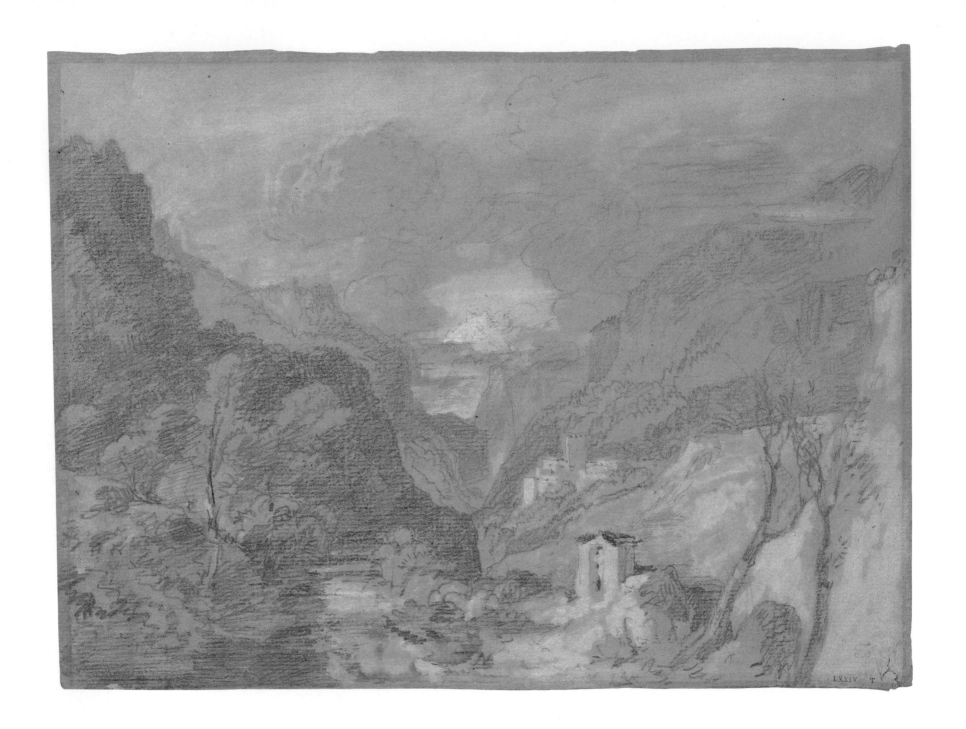

2 A Mountainous Valley 1802

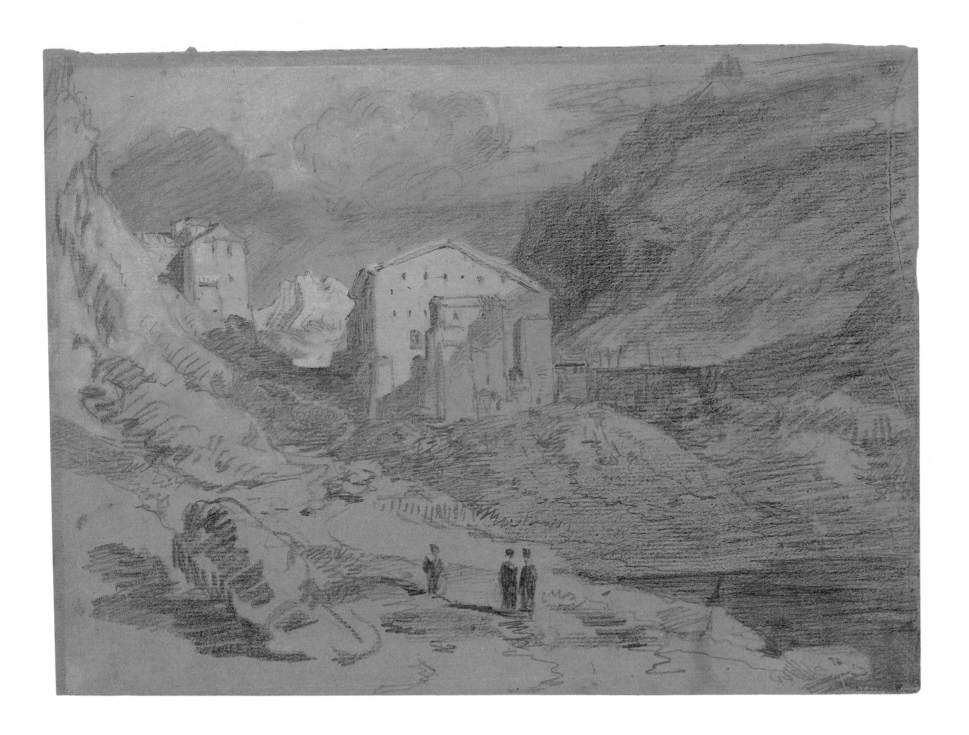

3 The Convent of the Great St Bernard 1802

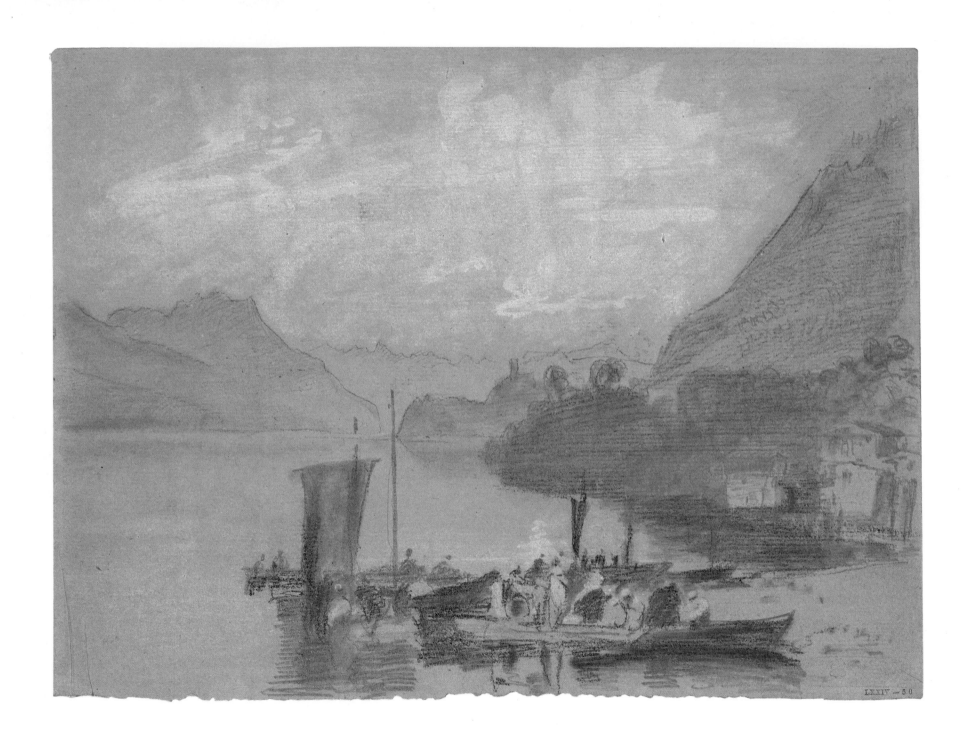

4 Lake Brienz 1802

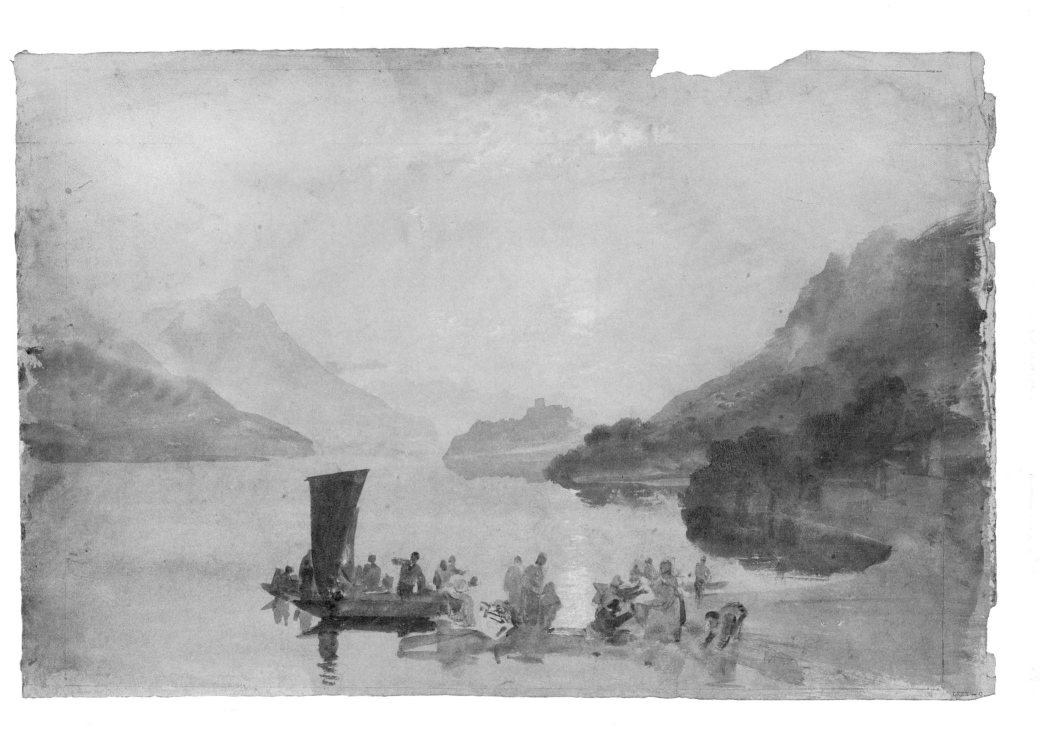

5 Lake Brienz ?c.1809

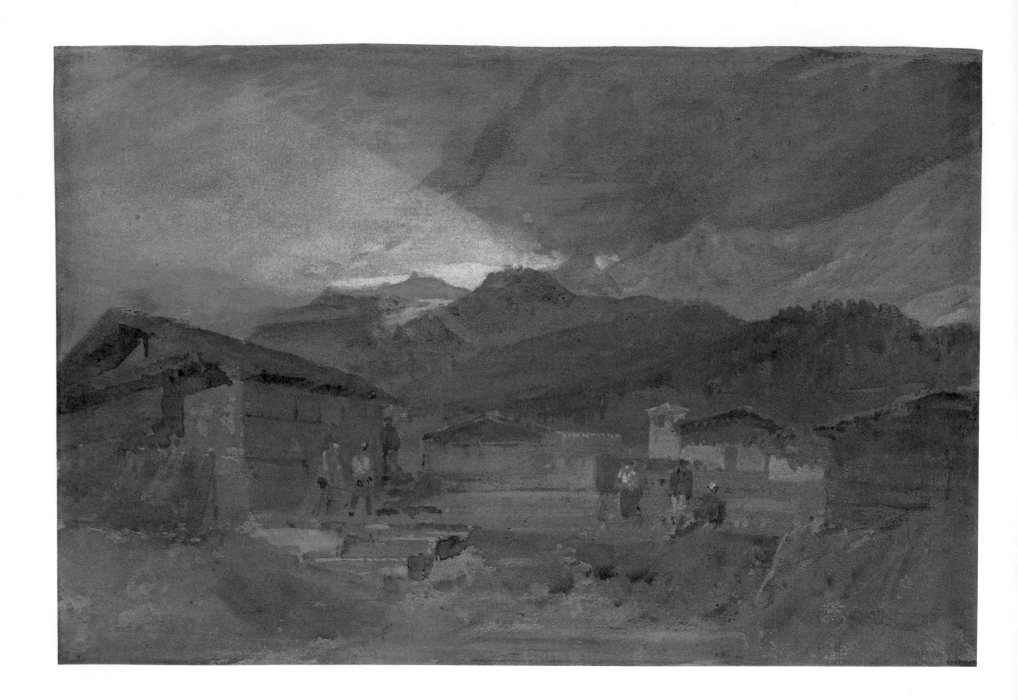

6 Contamines 1802

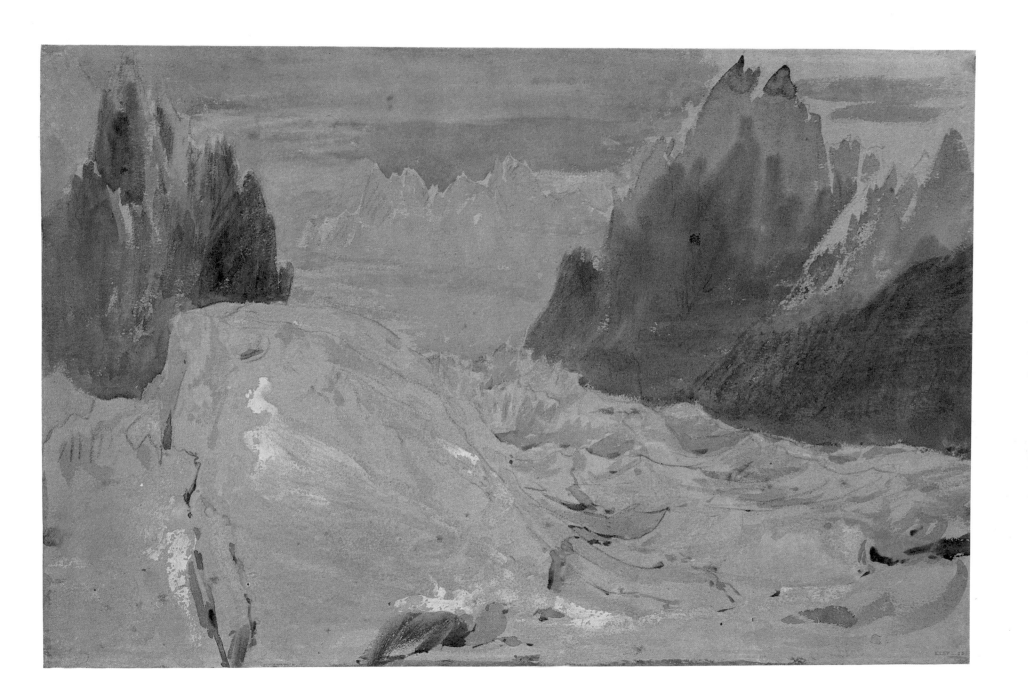

7 The Mer de Glace 1802

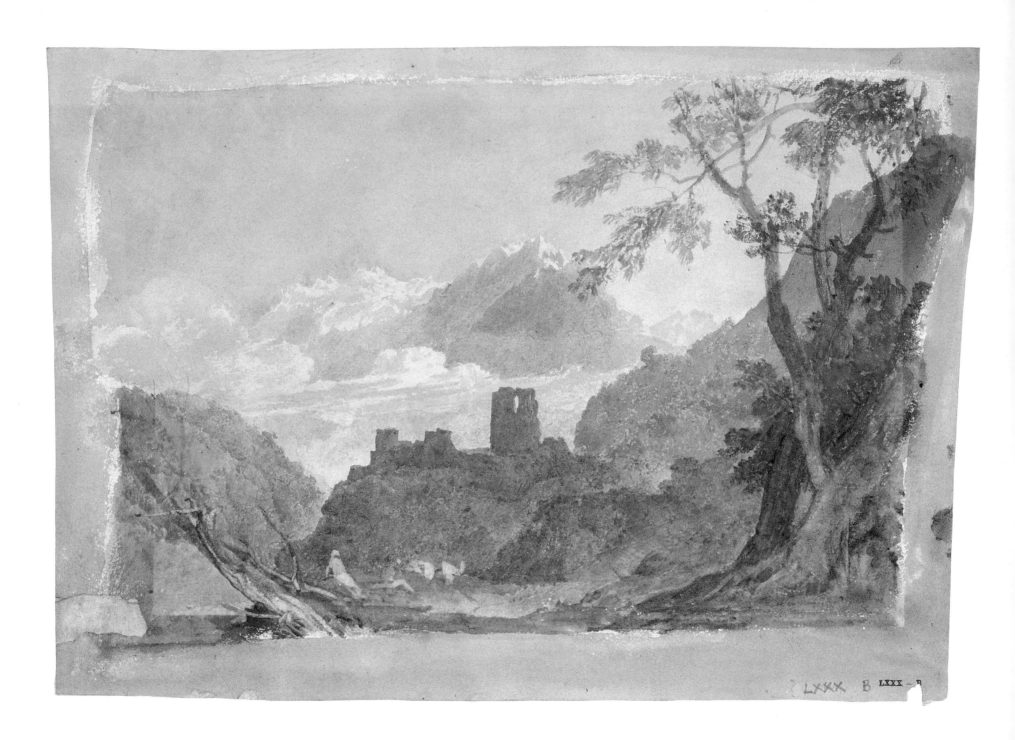

8 The Castle of Aosta *c*.1804

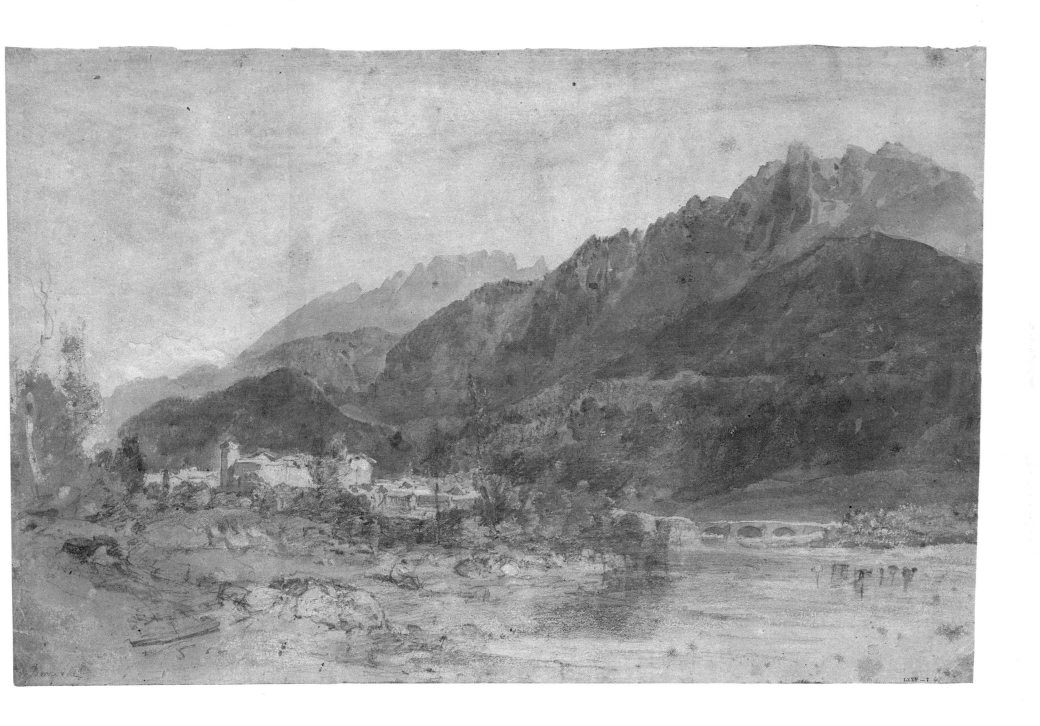

9 Bonneville 1802

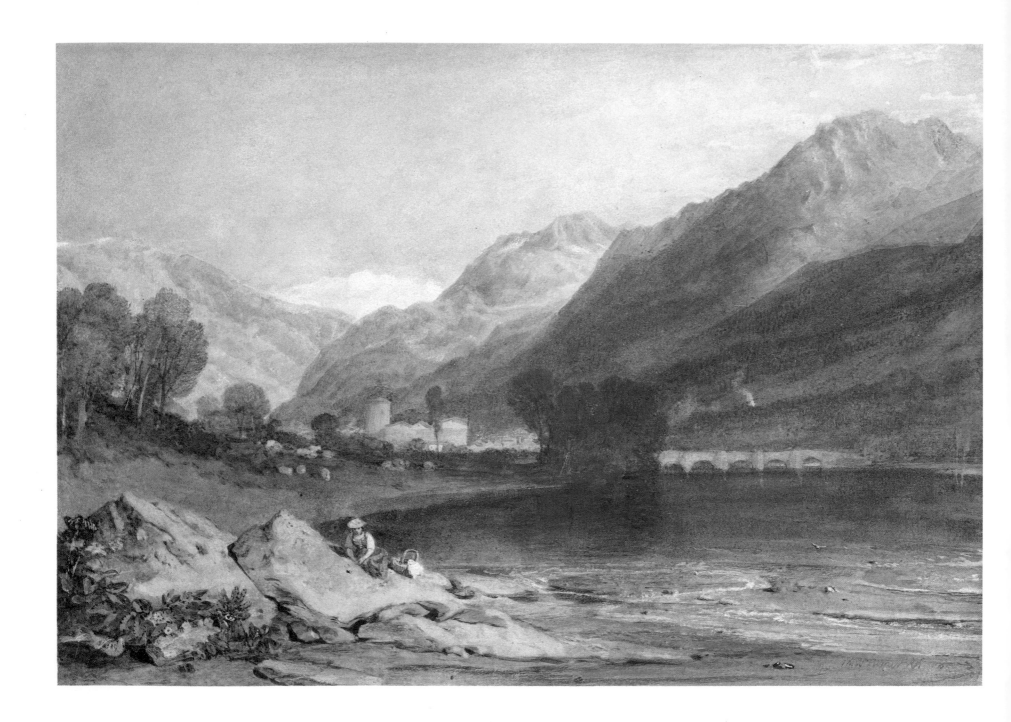

10 Bonneville *c*.1809

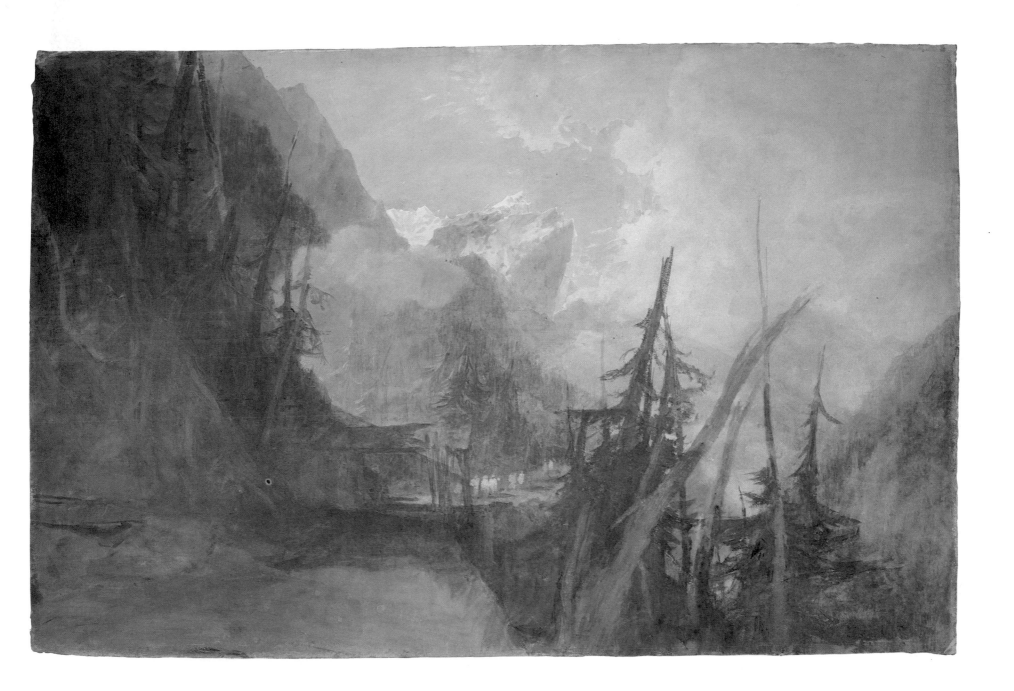

11 The Great St Bernard Pass ?c.1803

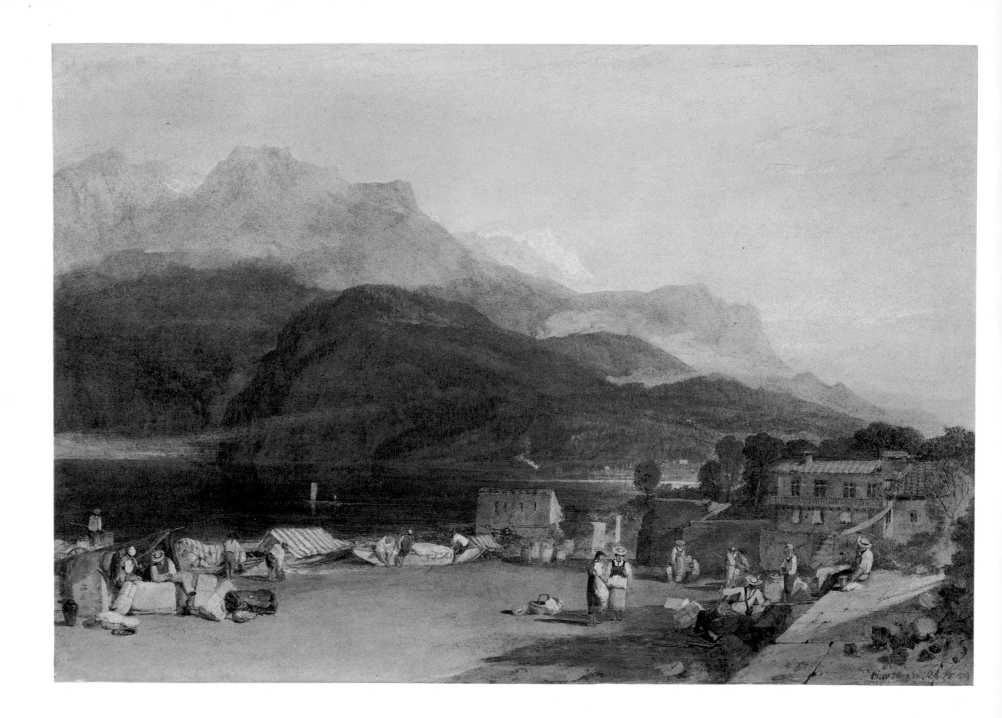

12　Lake Brienz　1809

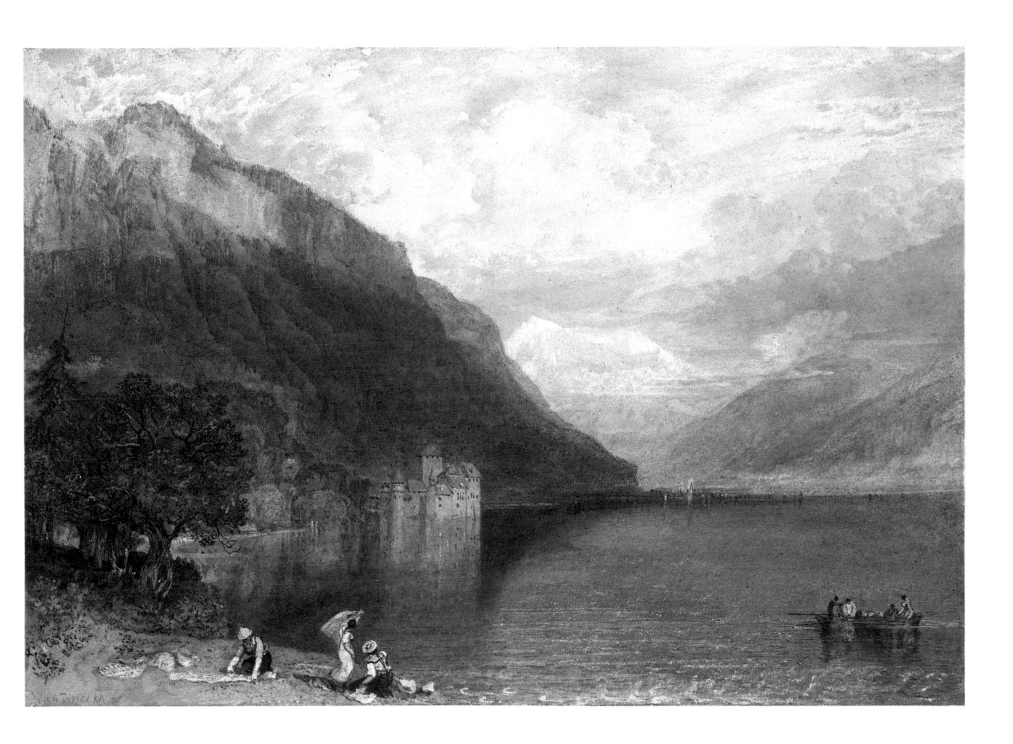

13 The Castle of Chillon *c*.1809

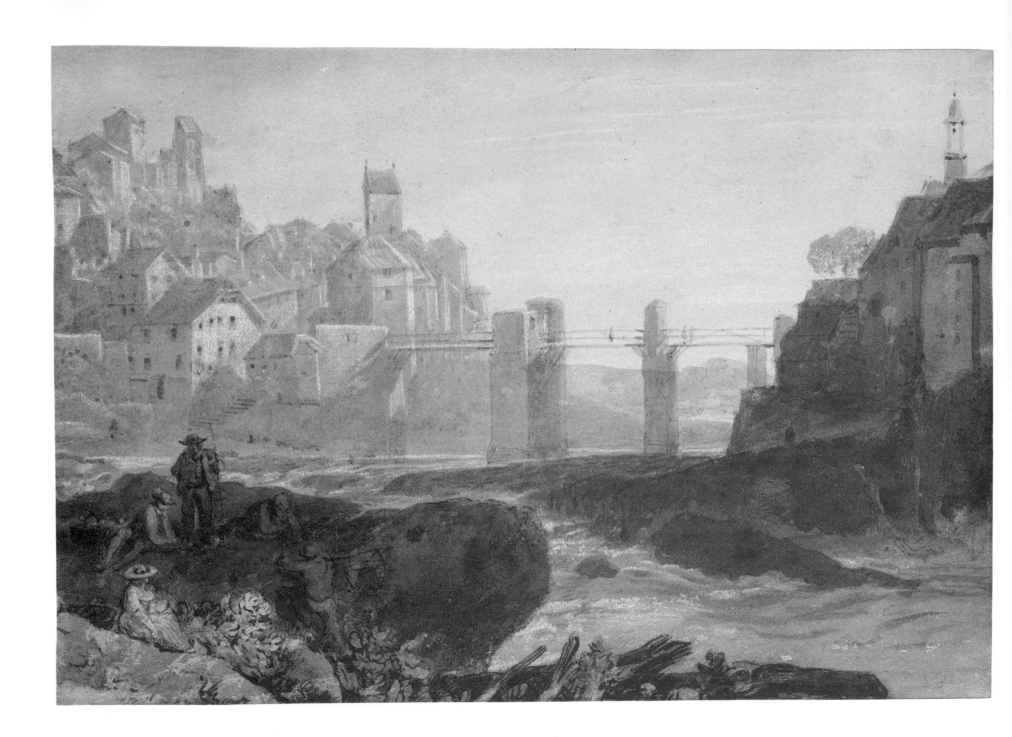

14 Lauffenbourgh on the Rhine *c.*1810

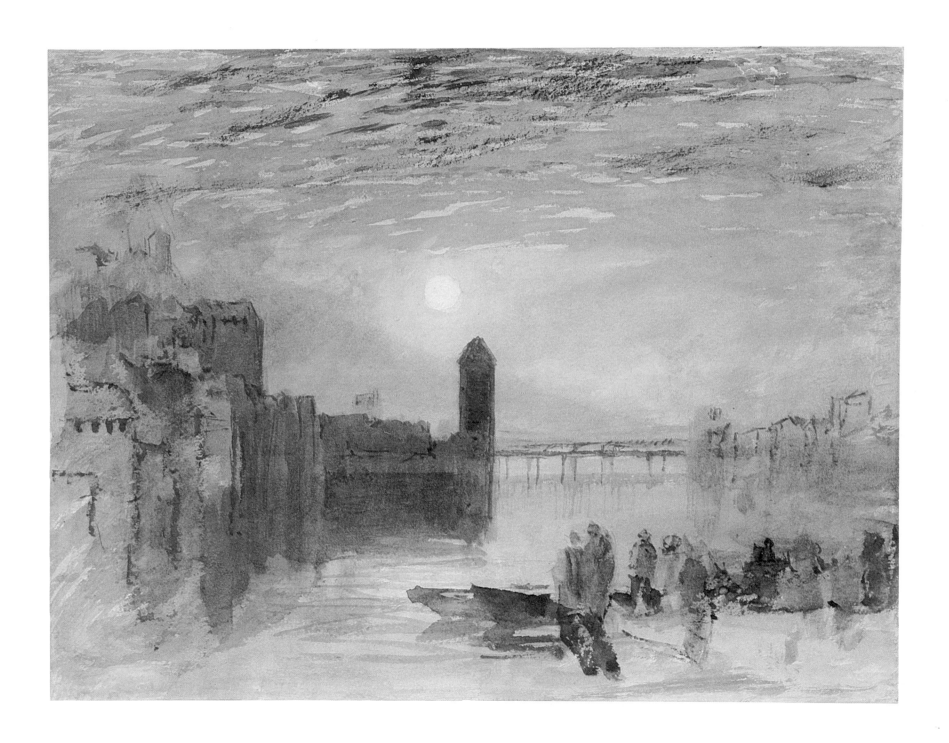

15 Lucerne: moonlight *c*.1815–20

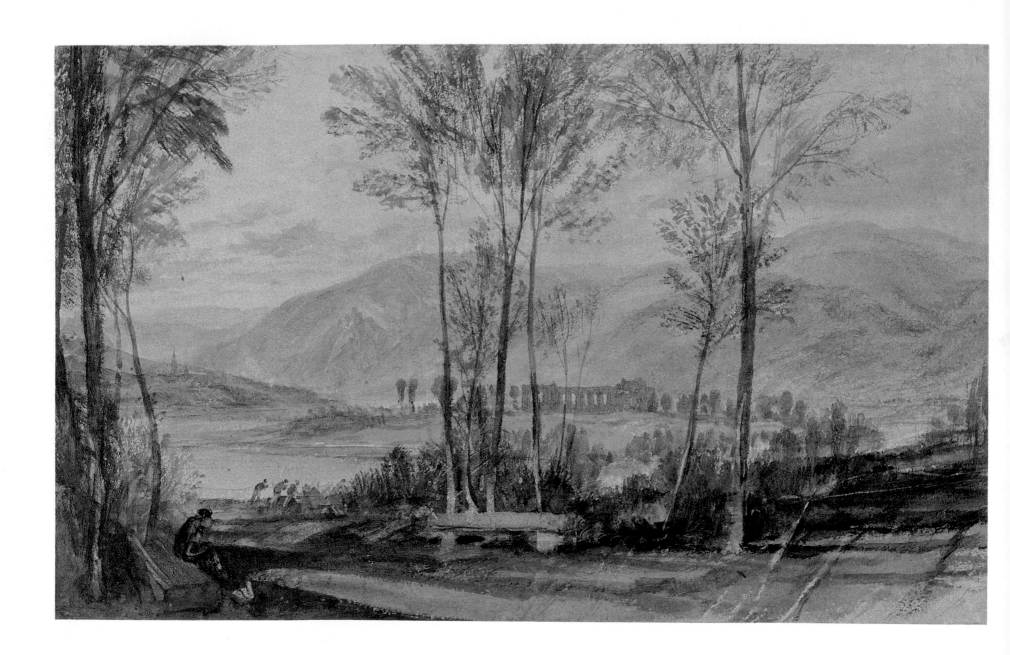

16 Abbey near Coblenz 1817

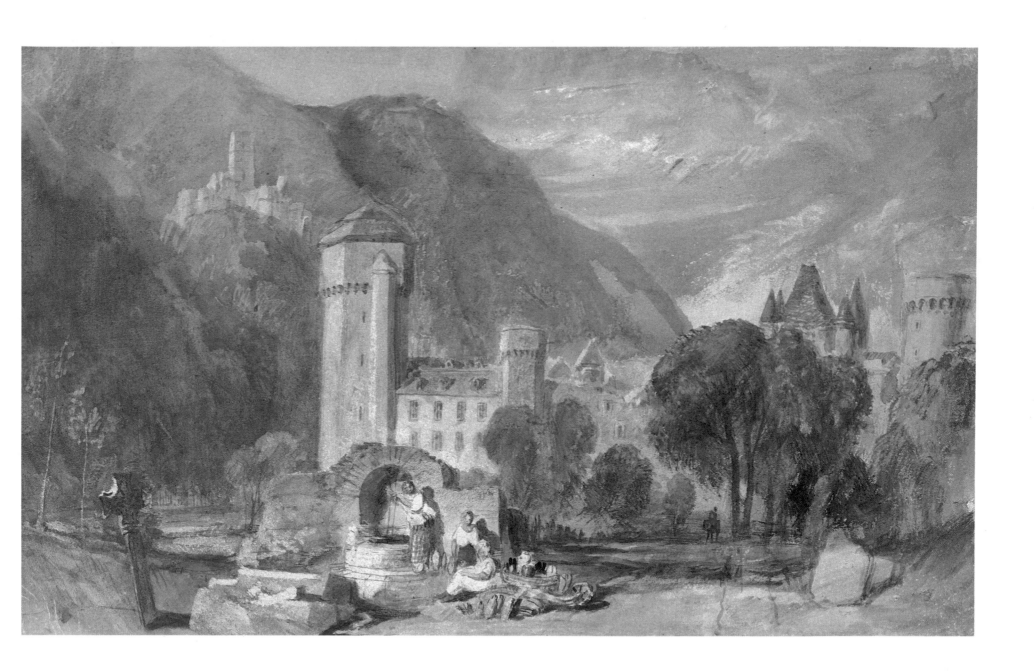

17 Oberlahnstein 1817

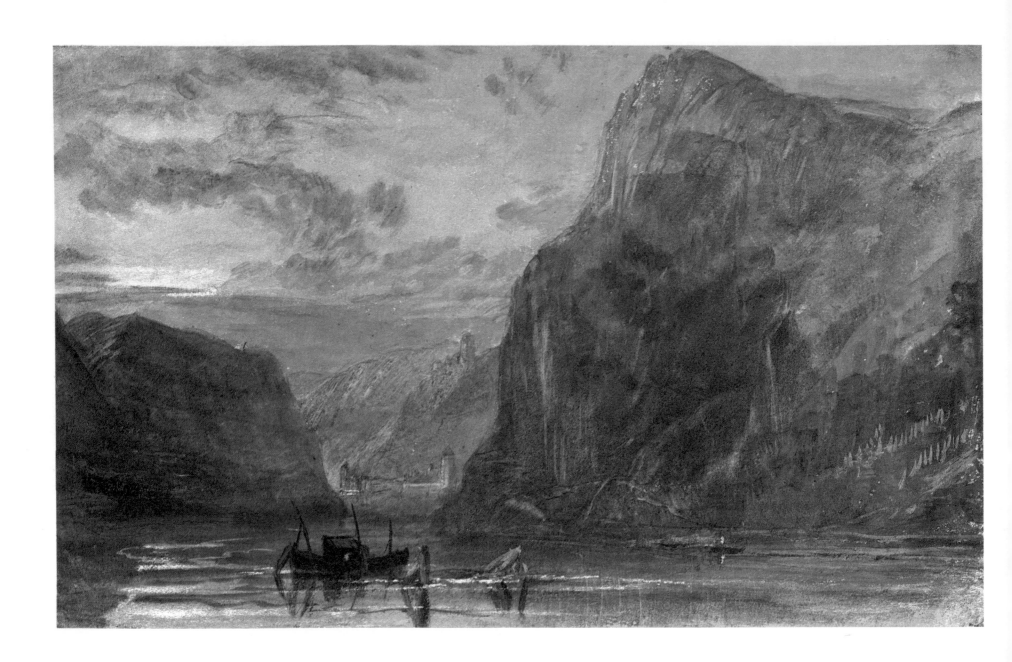

18 Lurleiberg and St Goarhausen 1817

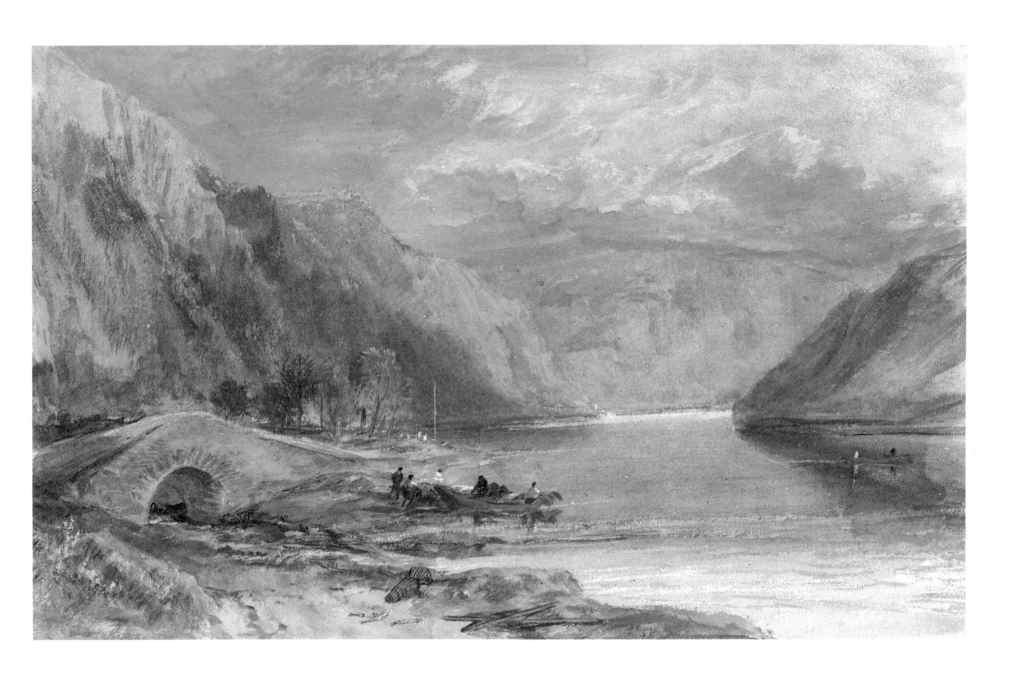

19 Hirzenach, below St Goar 1817

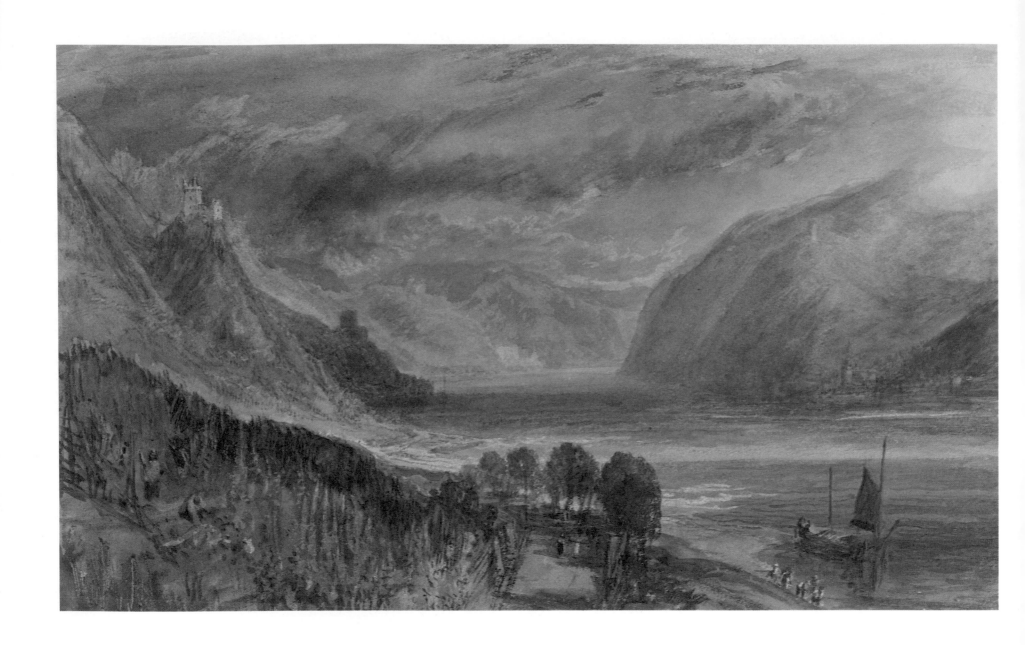

20 Sooneck with Bacharach in the distance 1817

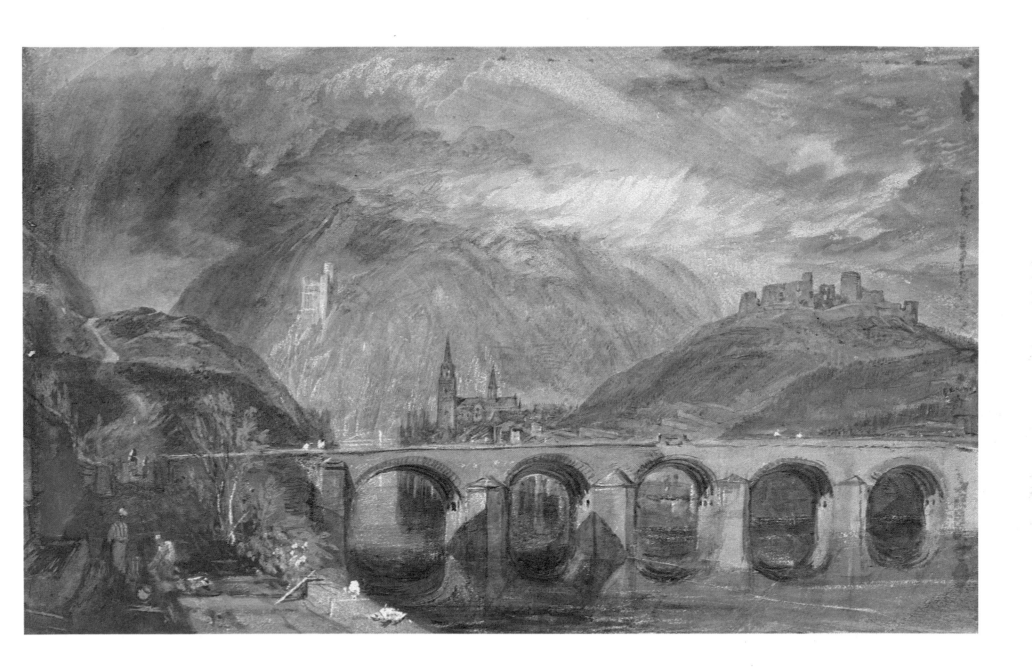

21 Bingen from the Lorch 1817

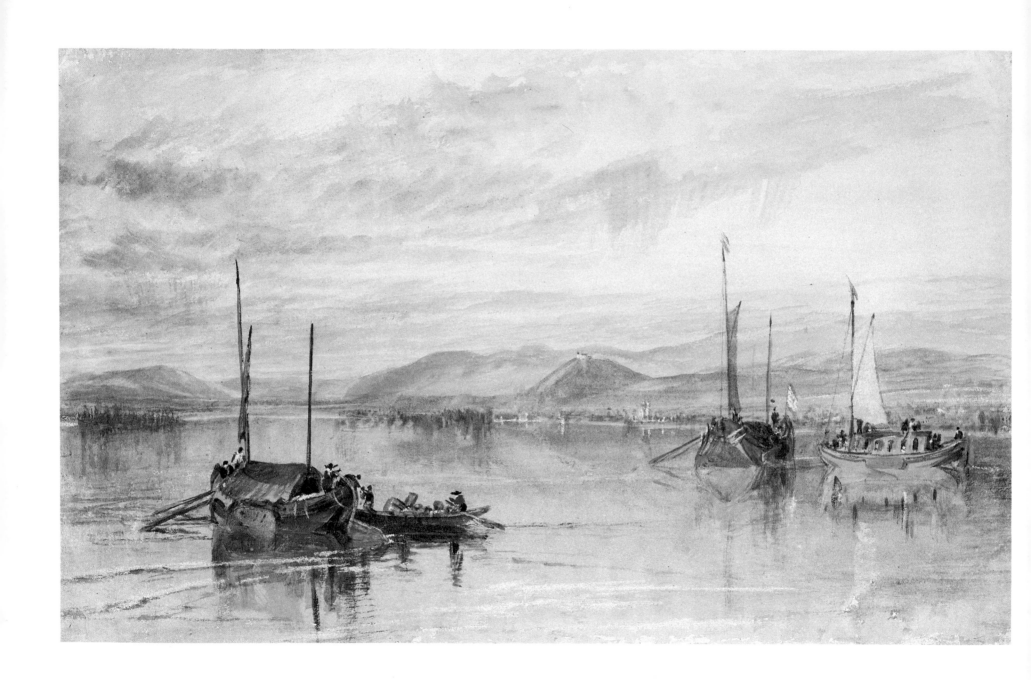

22 Johannisberg 1817

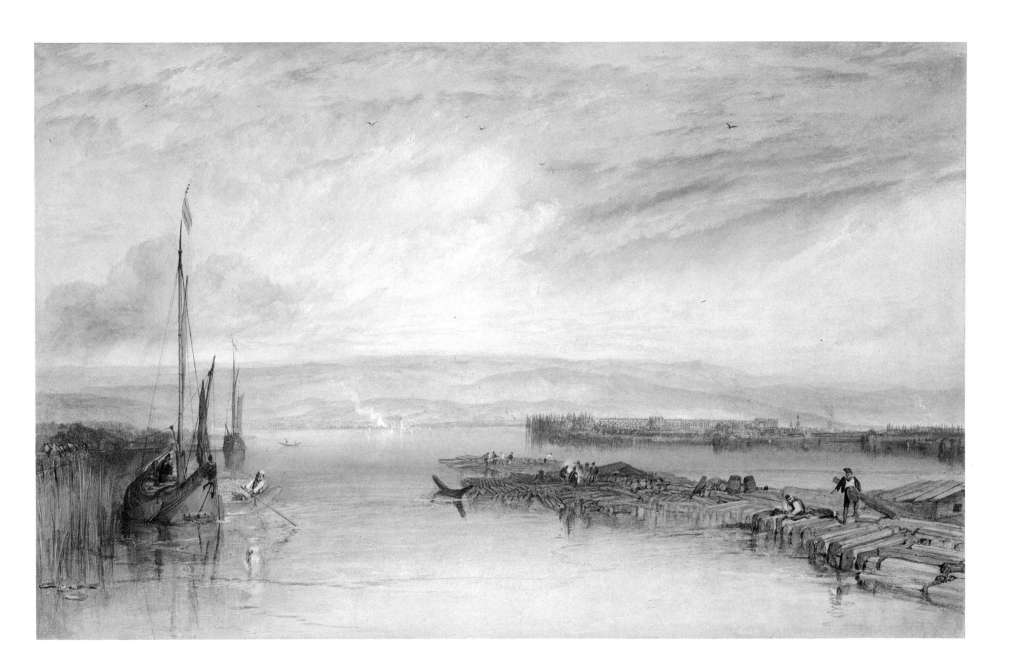

23 Schloss Biebrich 1820

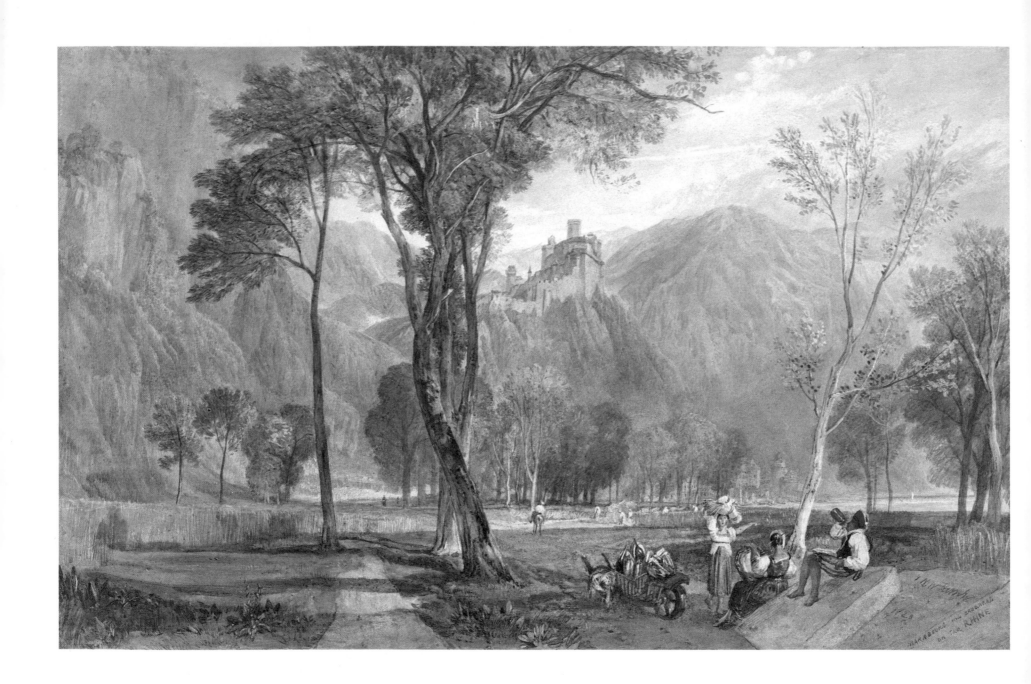

24 Marxbourg 1820

25 Caub and the Castle of Gutenfels on the Rhine *c*.1820–30

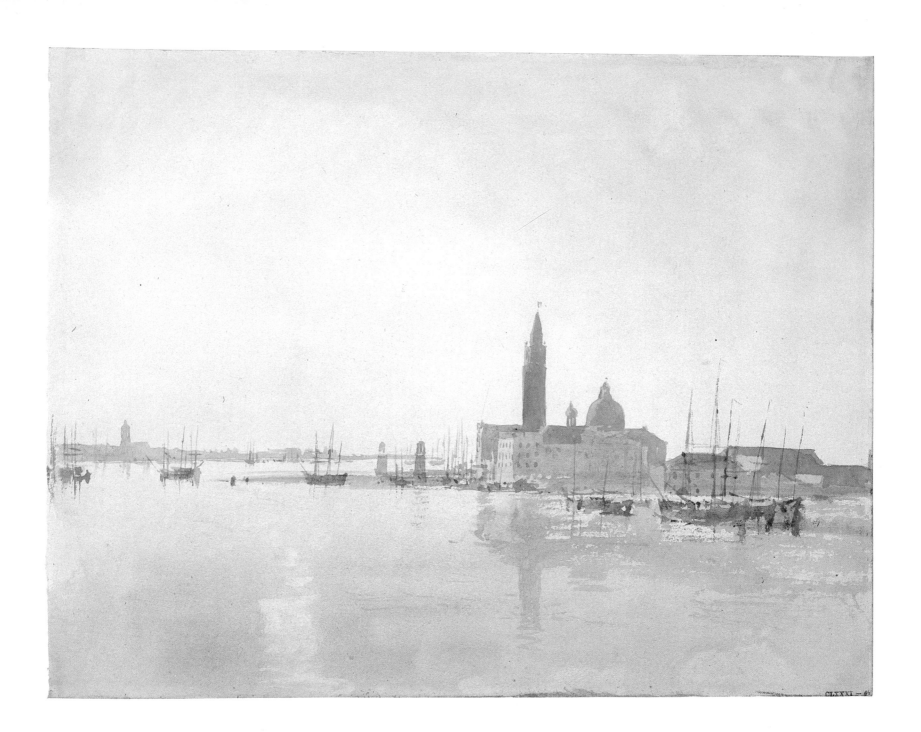

26 Venice: S. Giorgio Maggiore from the Dogana 1819

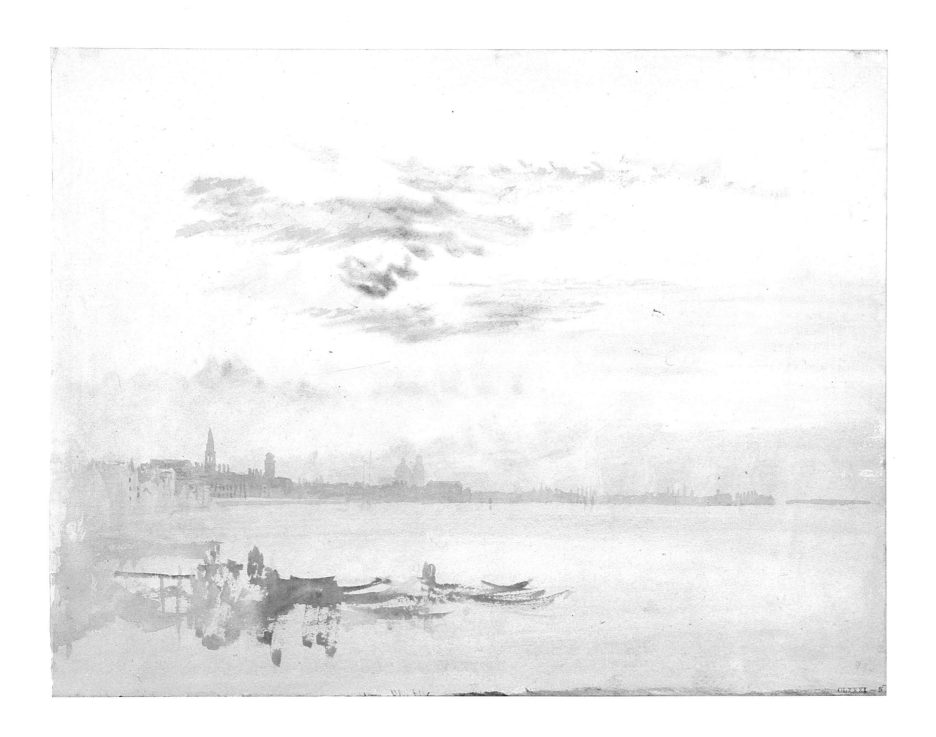

27 Venice: looking east from the Giudecca – sunrise 1819

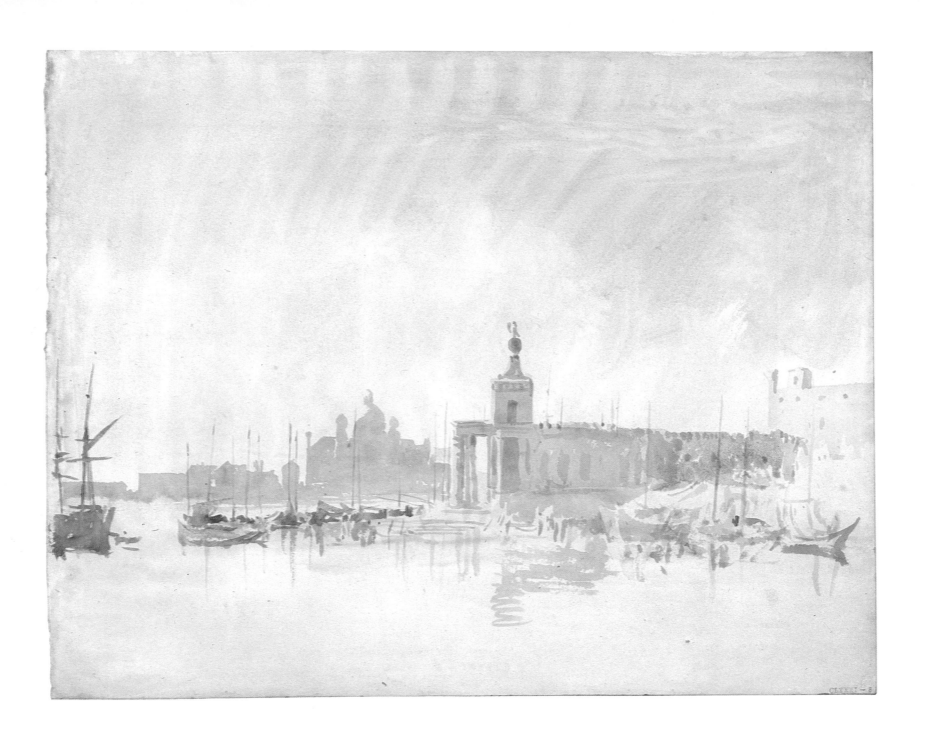

28 Venice: the Dogana from the Hotel Europa 1819

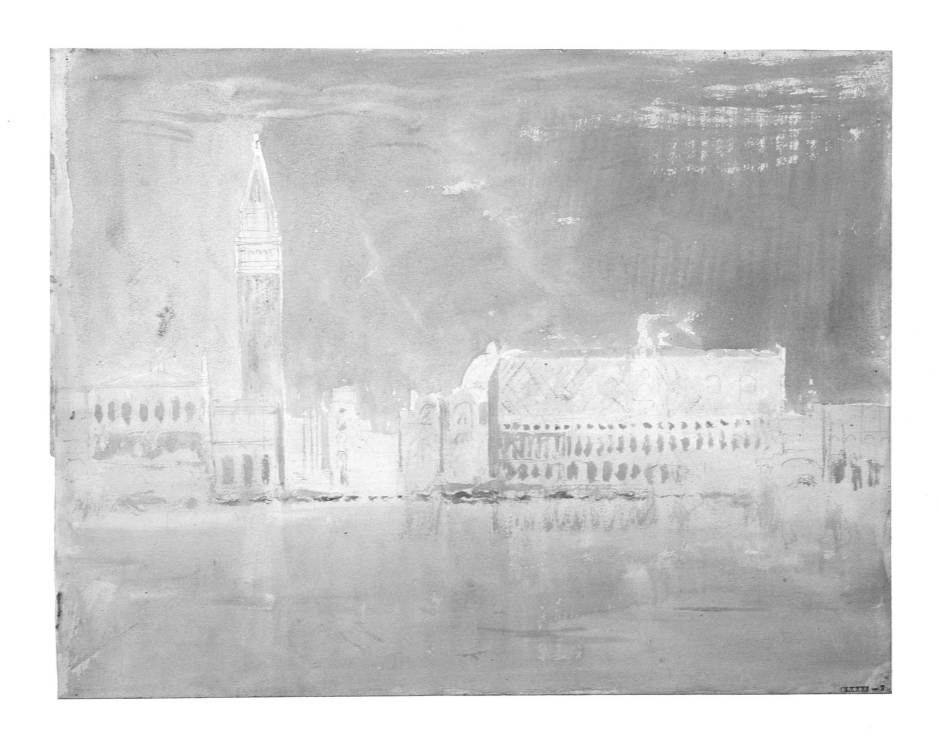

29 Venice: the Campanile of St Mark's and the Doge's Palace 1819

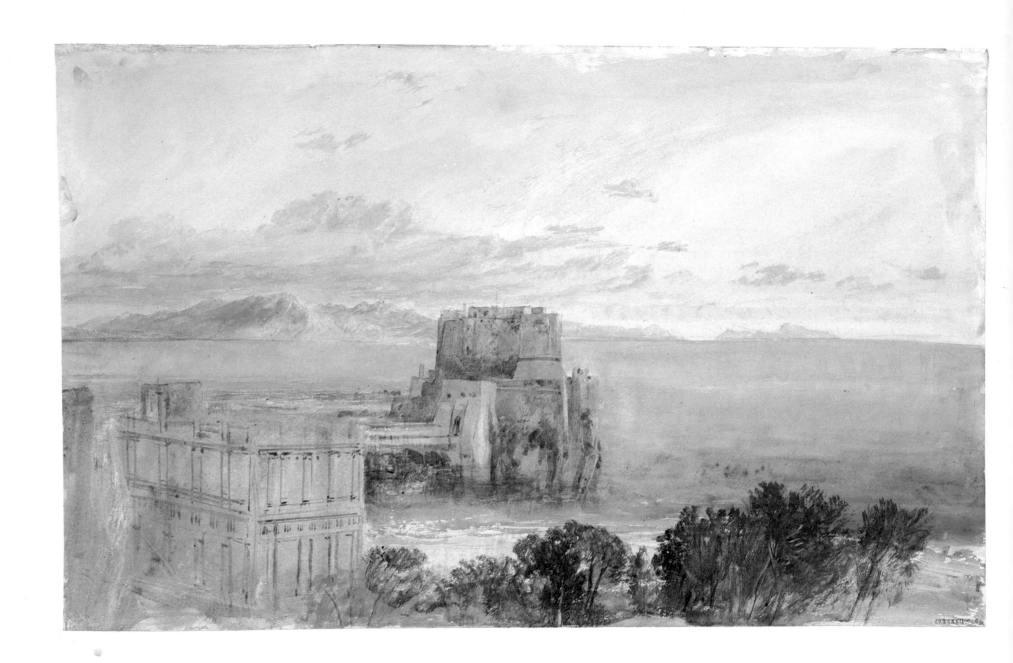

30 Naples: the Castel dell'Ovo, with Capri and Sorrento in the distance 1819

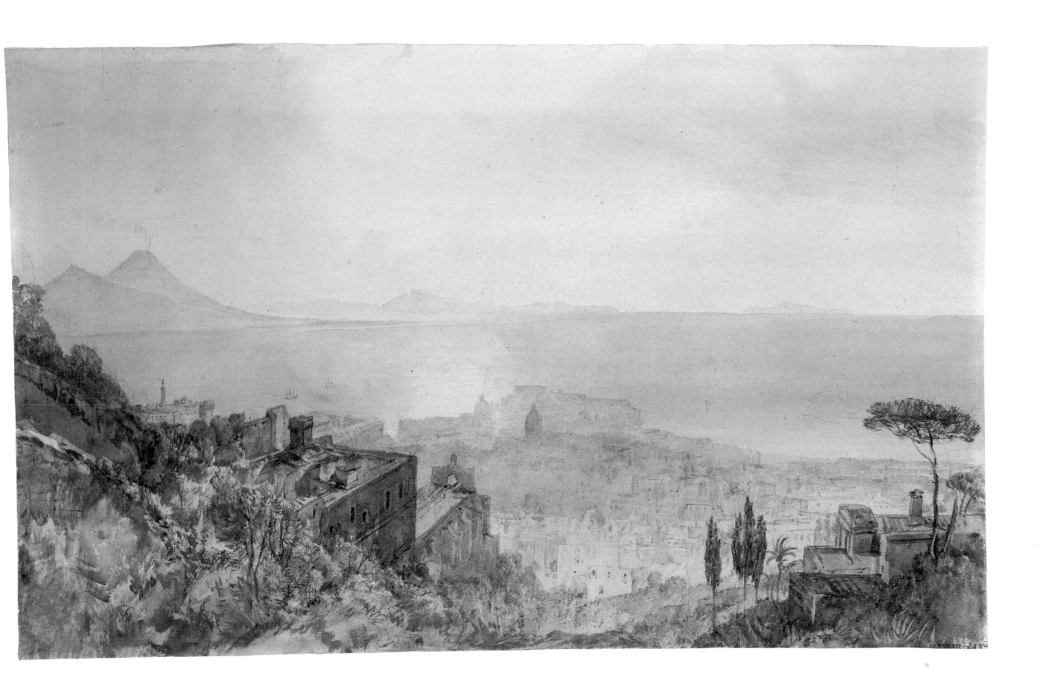

31　Naples from Capodimonte　1819

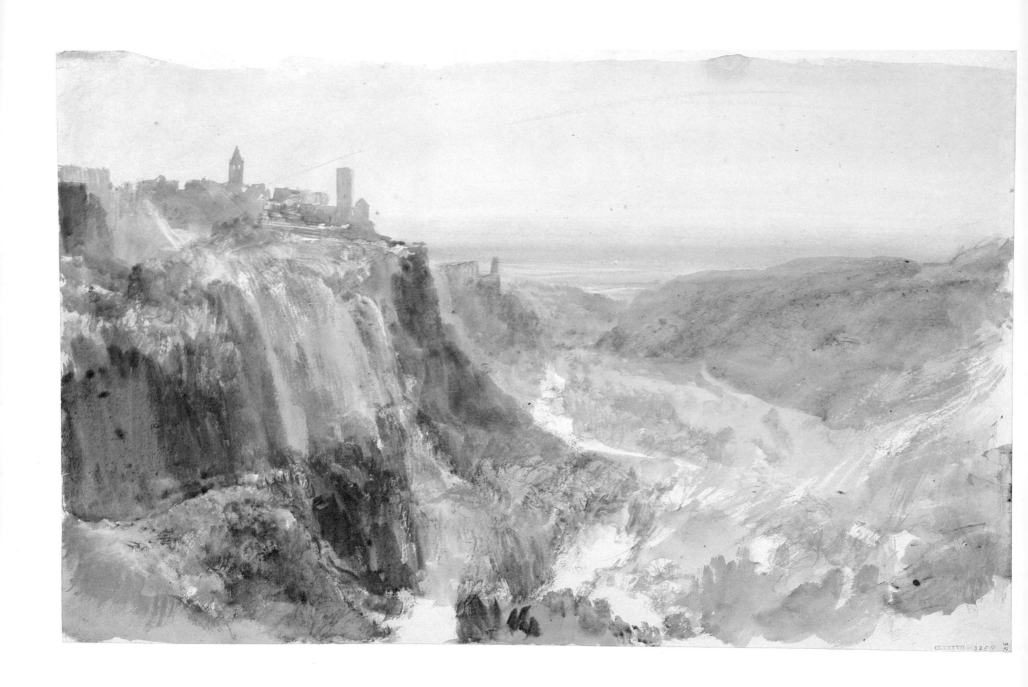

32 Tivoli 1819

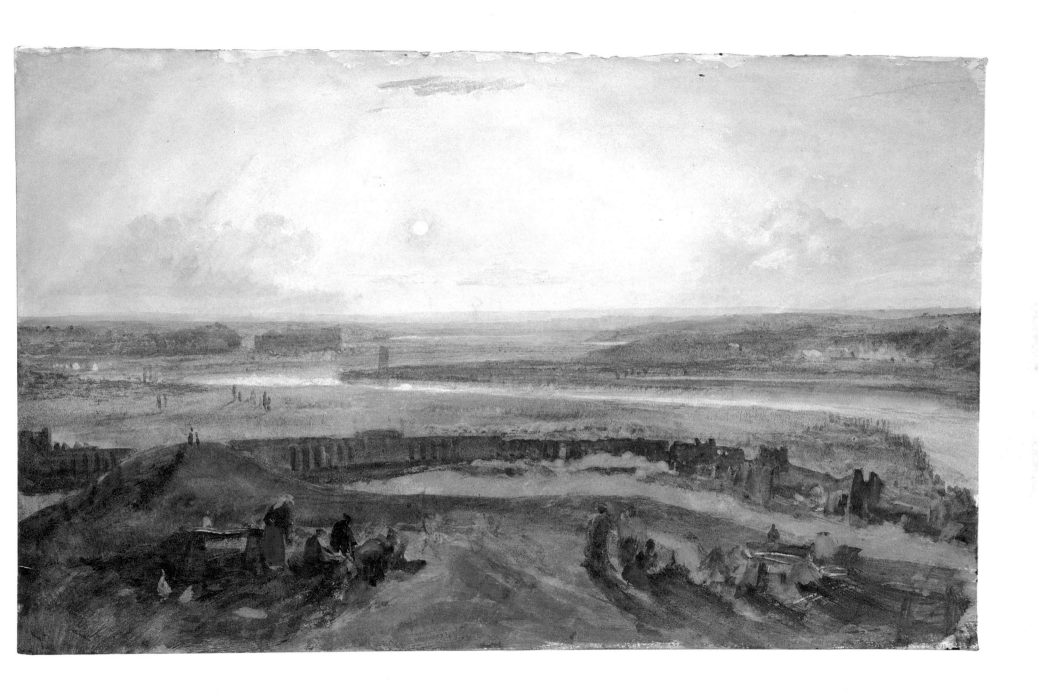

33 View across the Campagna with a low sun 1819

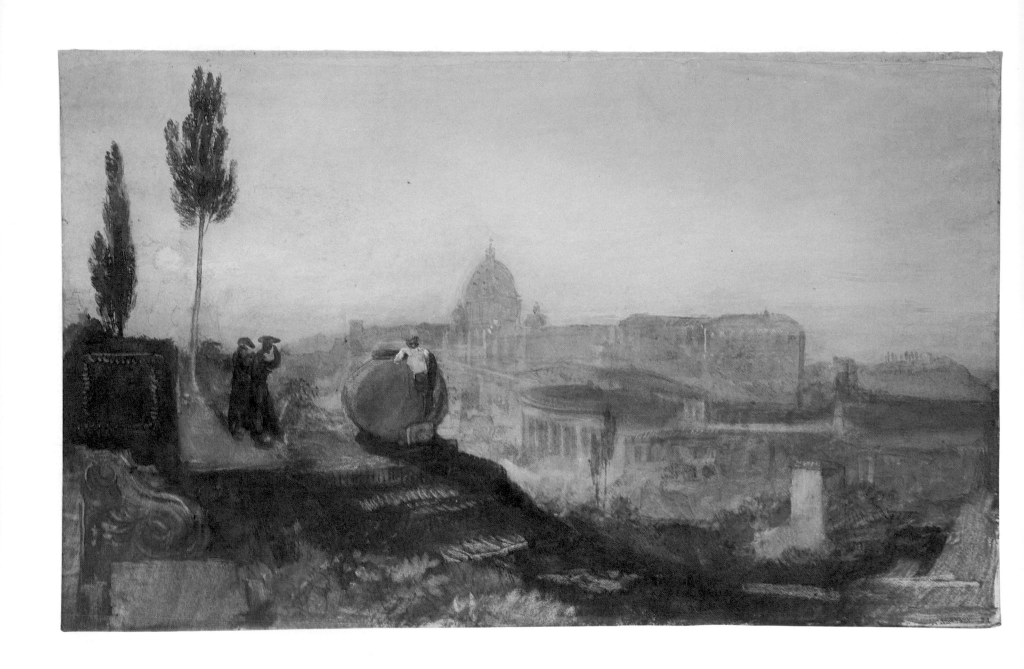

34 Rome: St Peter's from the Villa Barberini 1819

35 The Claudian Aqueduct 1819

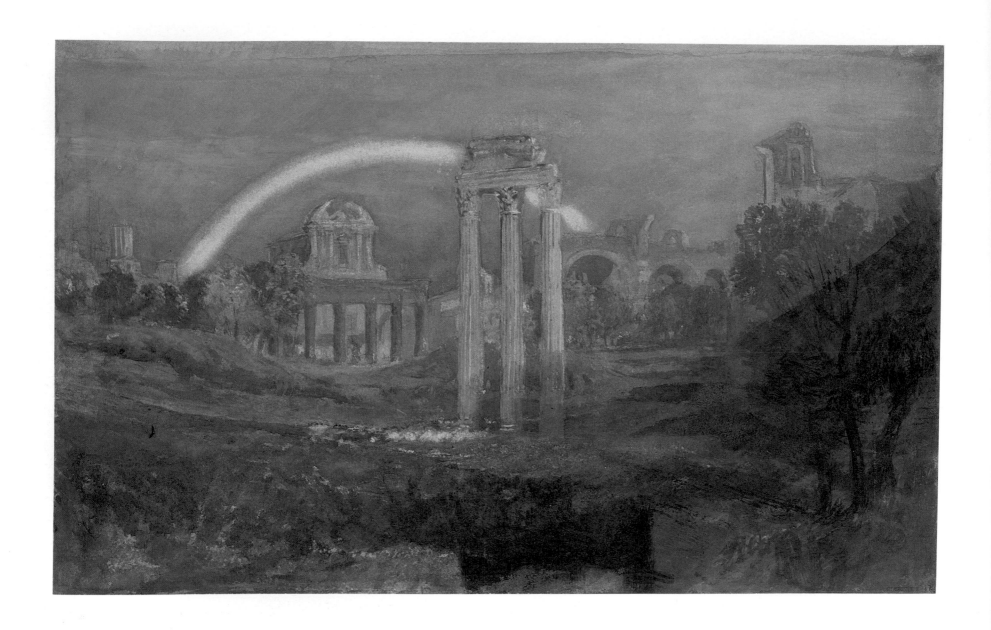

36 Rome: the Forum with a rainbow 1819

37 Rome: the Church of SS. Giovanni e Paolo 1819

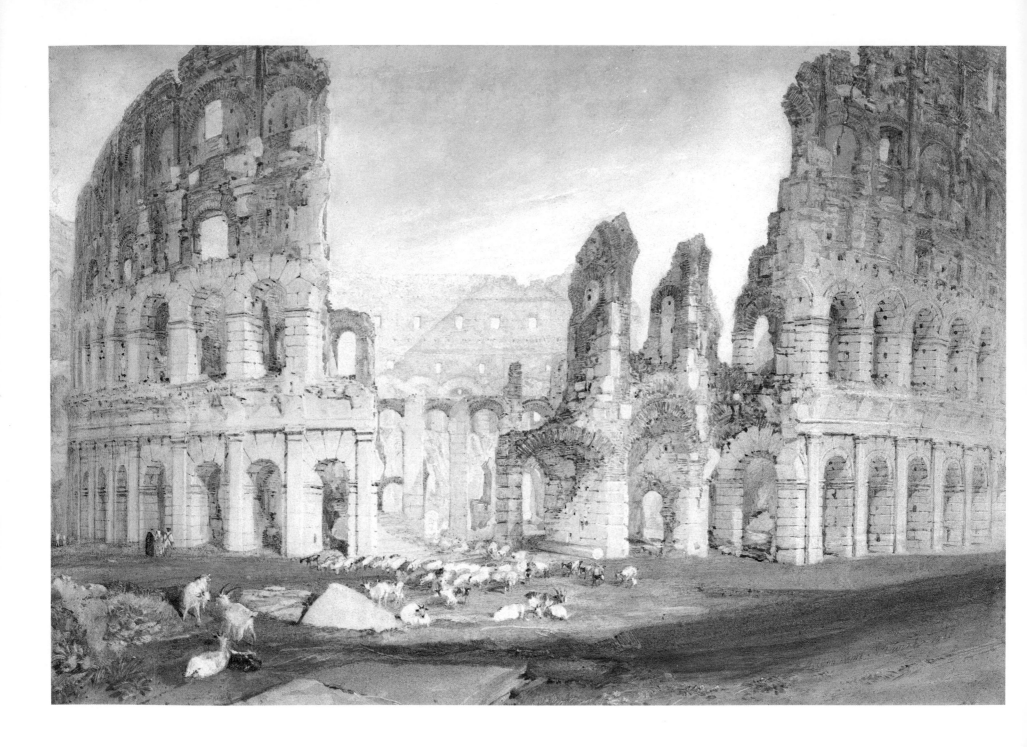

38 Rome: the Colosseum 1820

39 The Bay of Baiae *c.*1828

40　Florence　*c.*1828

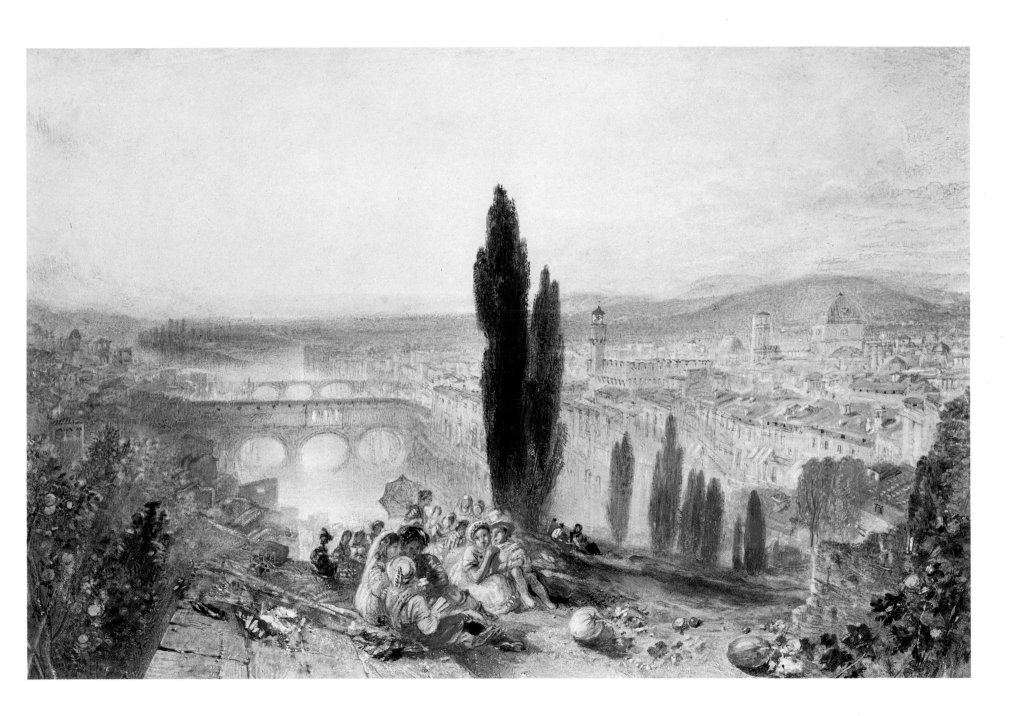

41 Florence from San Miniato *c*.1828

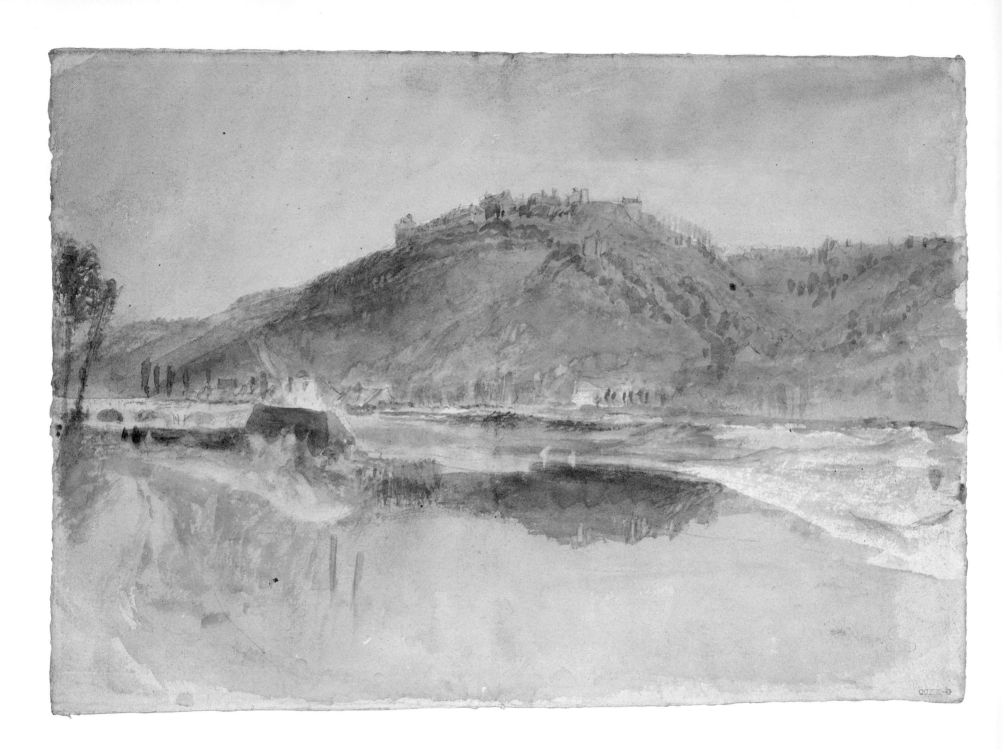

42 Domfront(?) *c.*1825

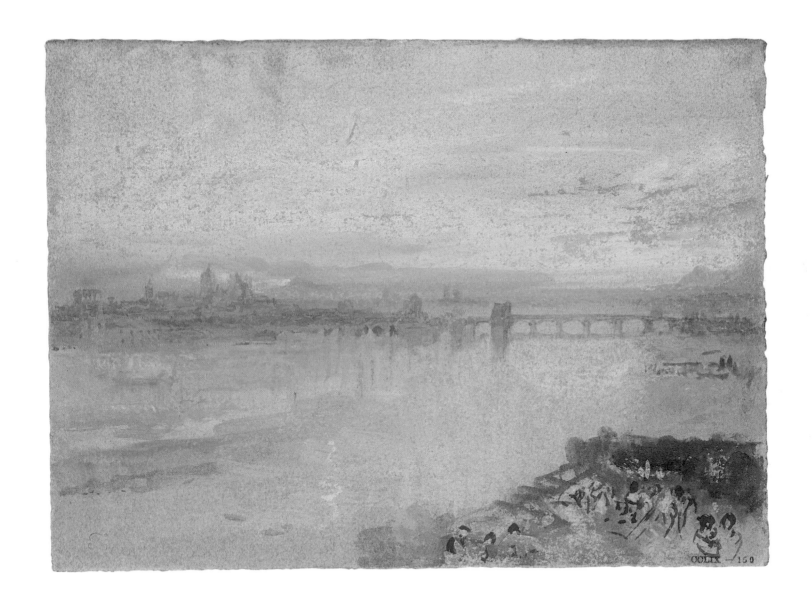

43 Avignon *c.*1828

CCLIX — 139

44 The lighthouse at Marseilles, from the sea *c.*1828

47 Beaugency *c.*1829

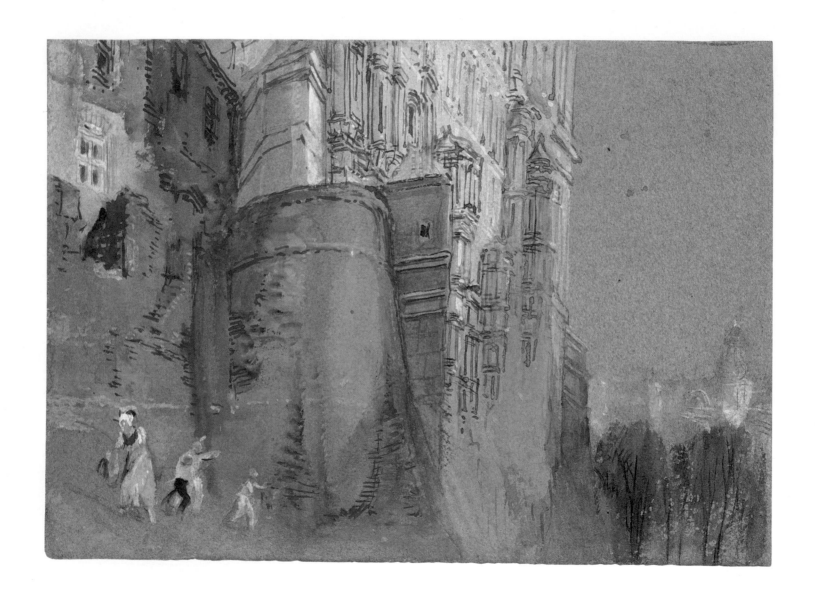

48 The Château de Blois c.1829

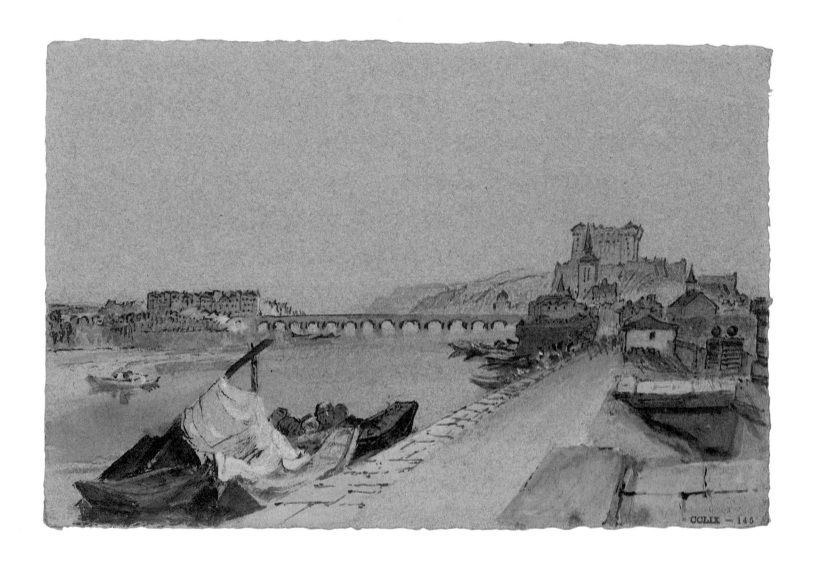

49 Saumur *c*.1829

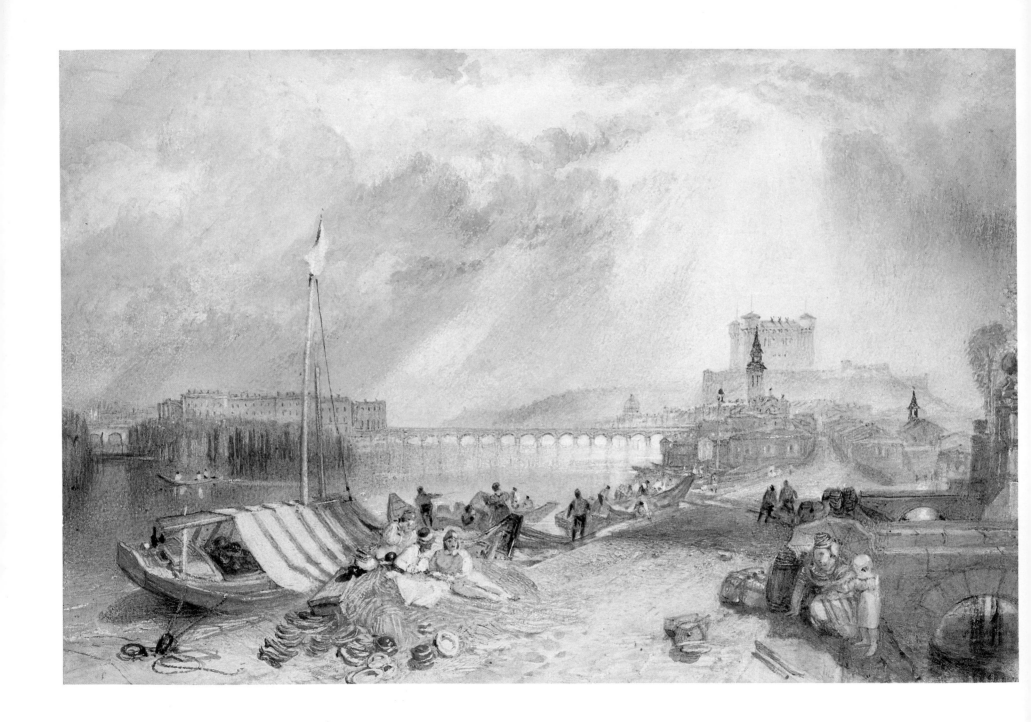

50 Saumur *c.*1830

51 St Florent le Vieil, Loire *c.*1829

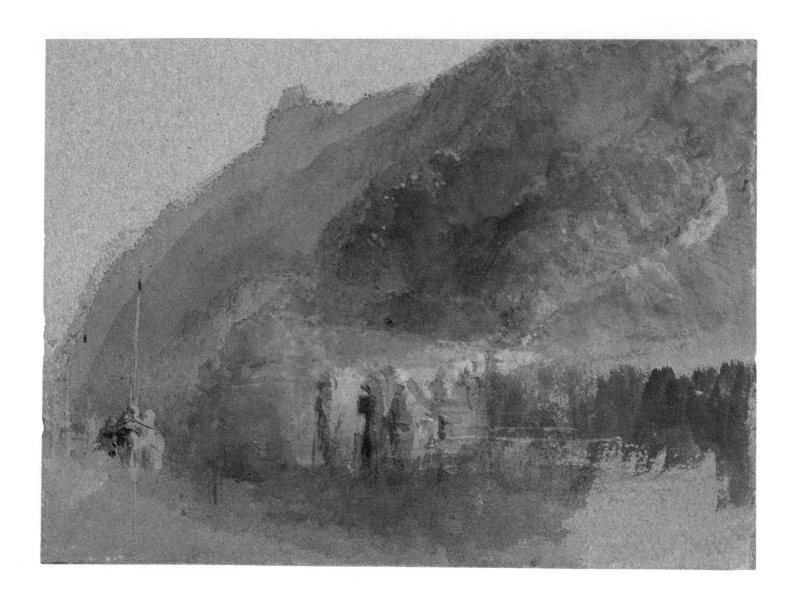

52　Château Hamelin, on the Loire　*c*.1829

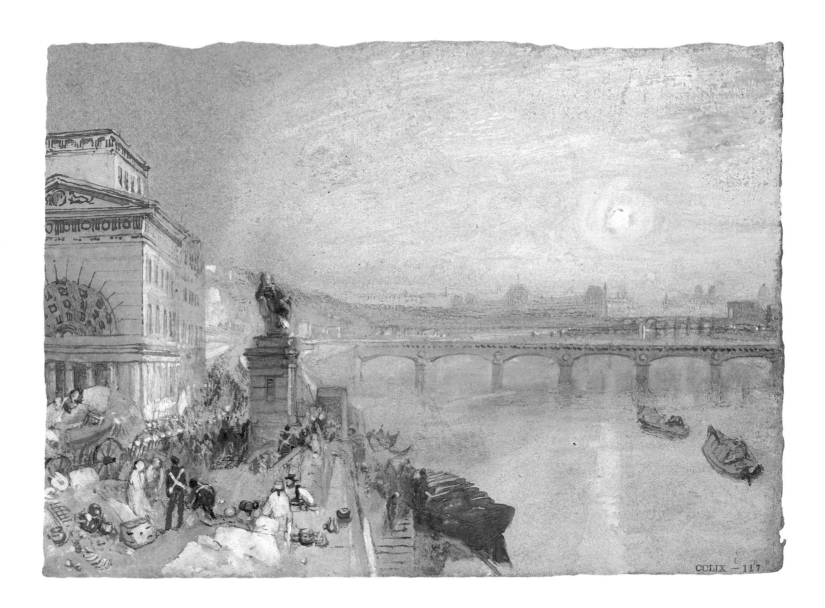

CCLIX — 117

53 Paris: view of the Seine from the Barrière de Passy, with the Louvre in the distance *c*.1832

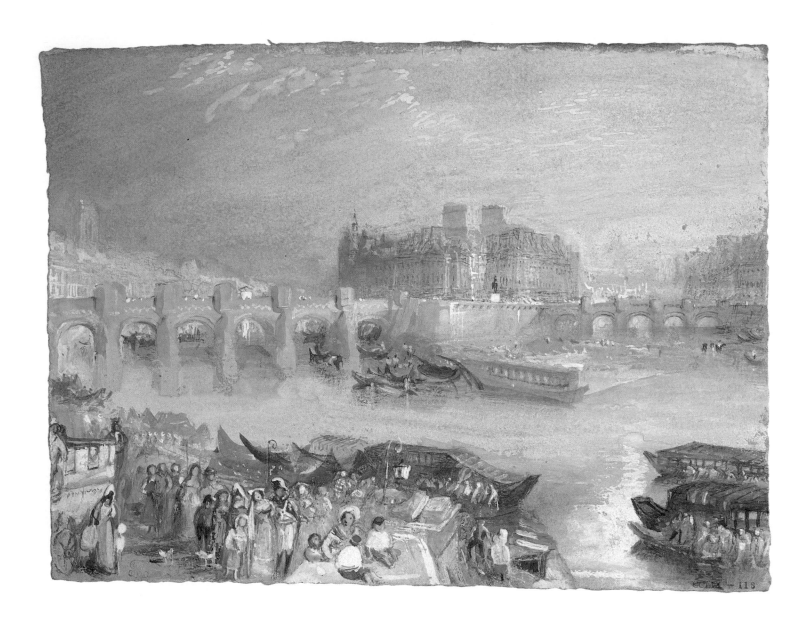

54 Paris: the Pont Neuf and the Ile de la Cité *c*.1832

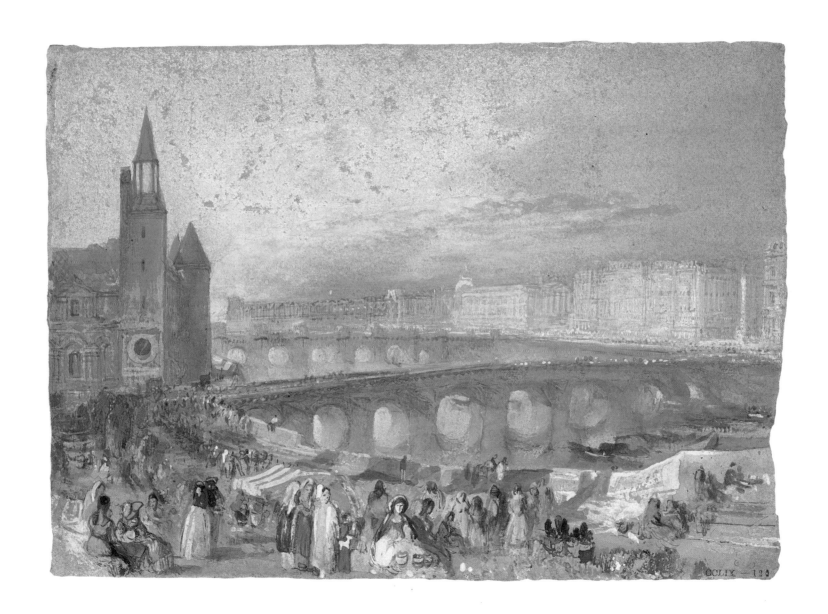

55　Paris: Marché aux fleurs and Pont au Change　*c.*1832

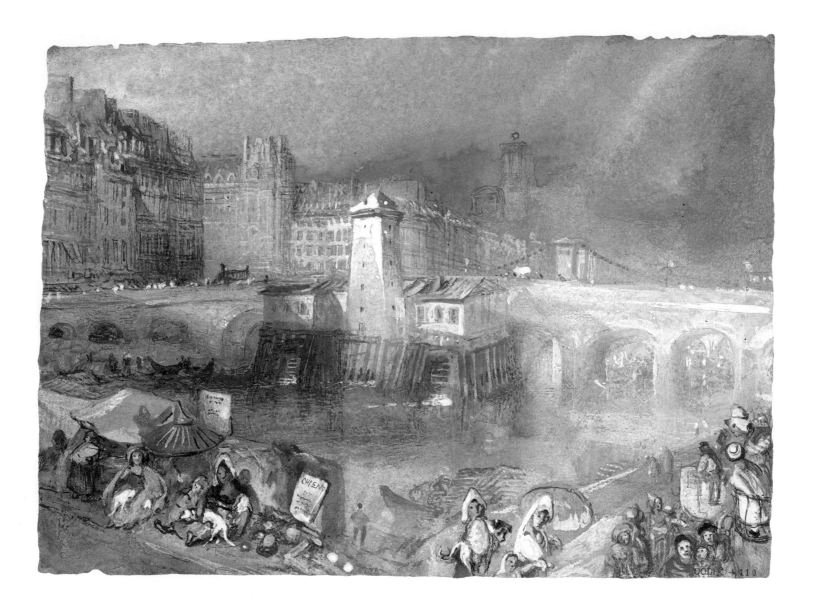

56 Paris: Hôtel de Ville and Pont d'Arcole *c*.1832

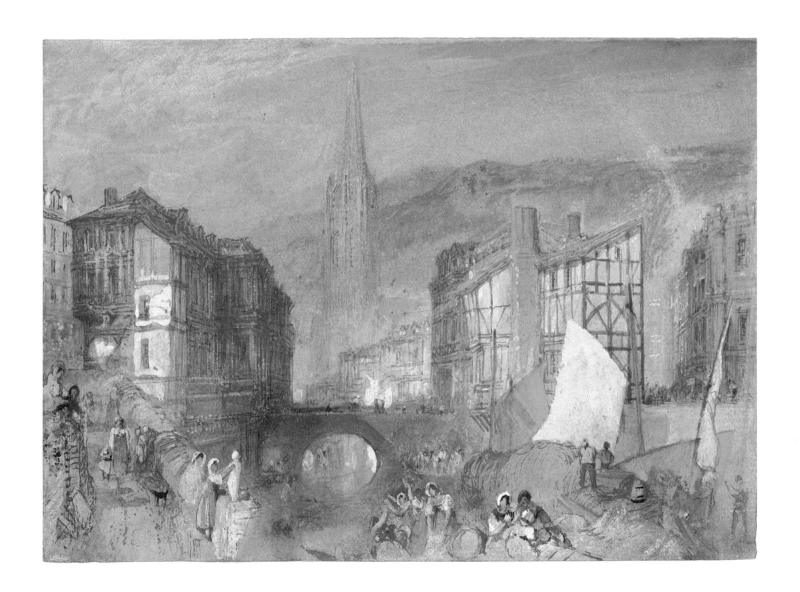

57 Harfleur c.1832

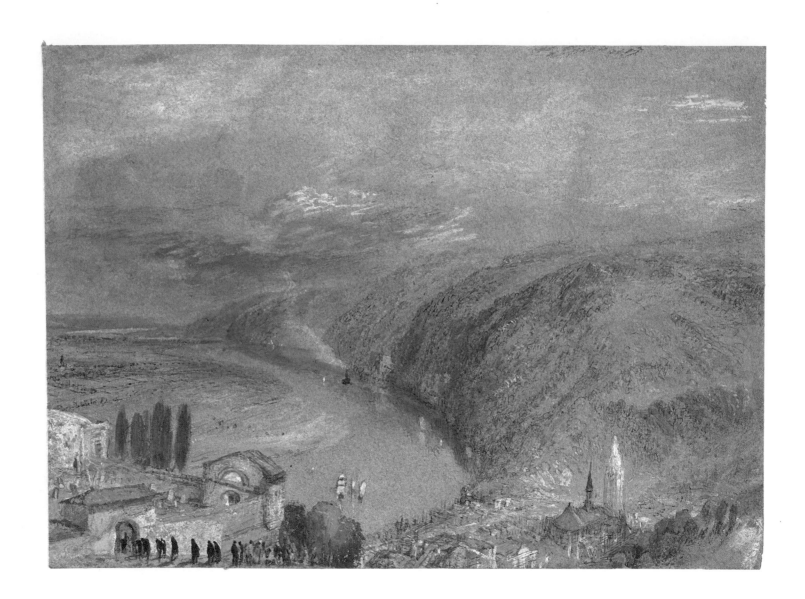

58 Caudebec *c*.1832

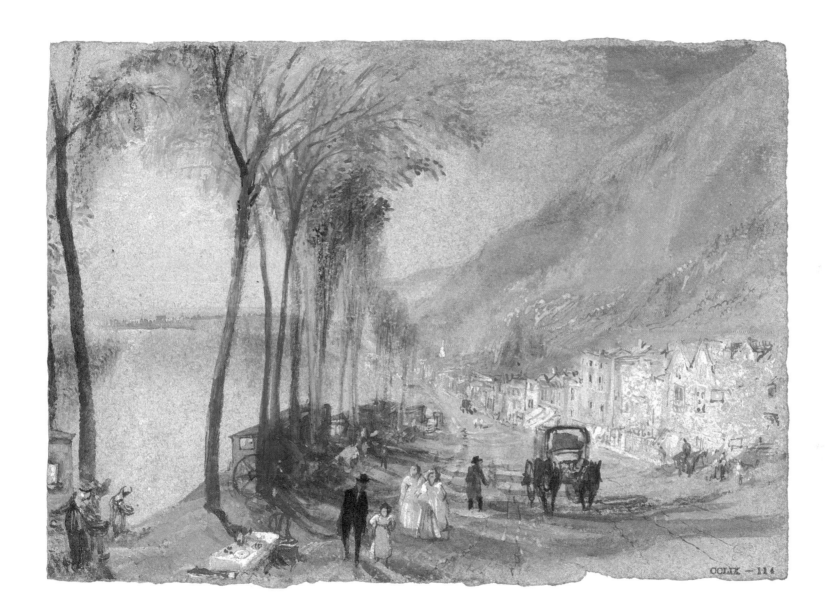

59 The Seine between Mantes and Vernon c.1832

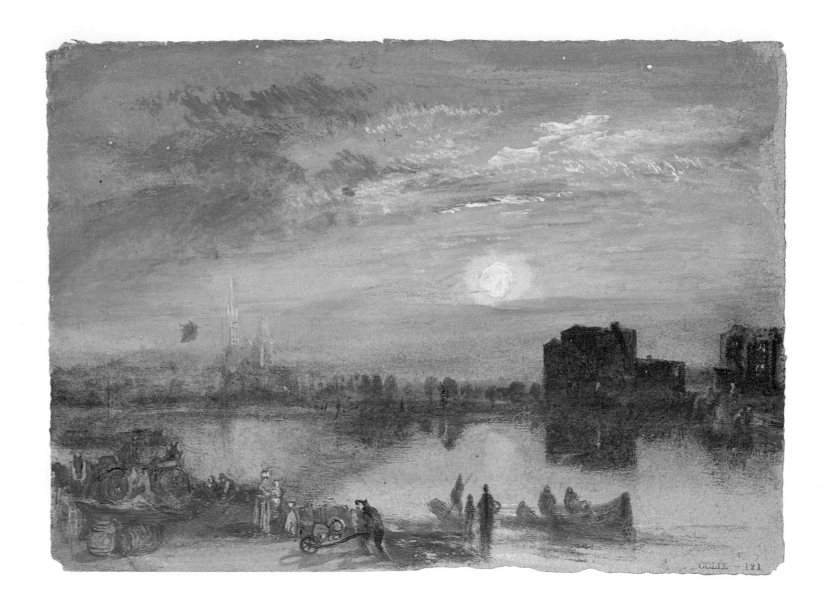

60 St Denis c.1832

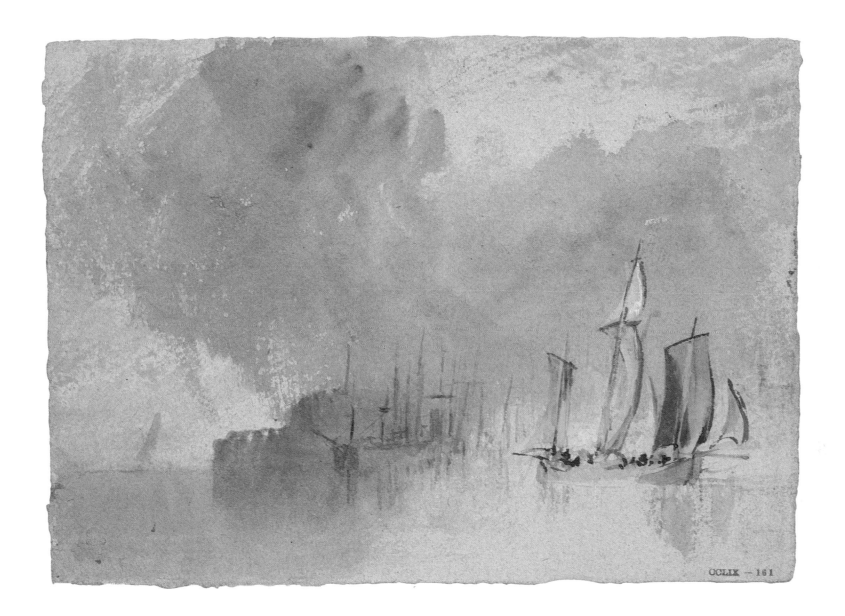

OCLIX — 161

61 Shipping off Havre *c*.1830

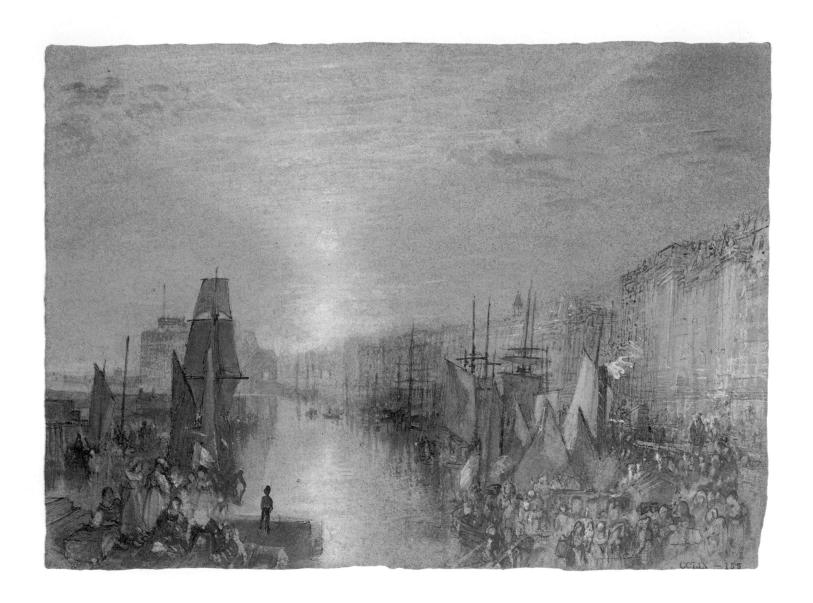

62 Havre *c*.1832

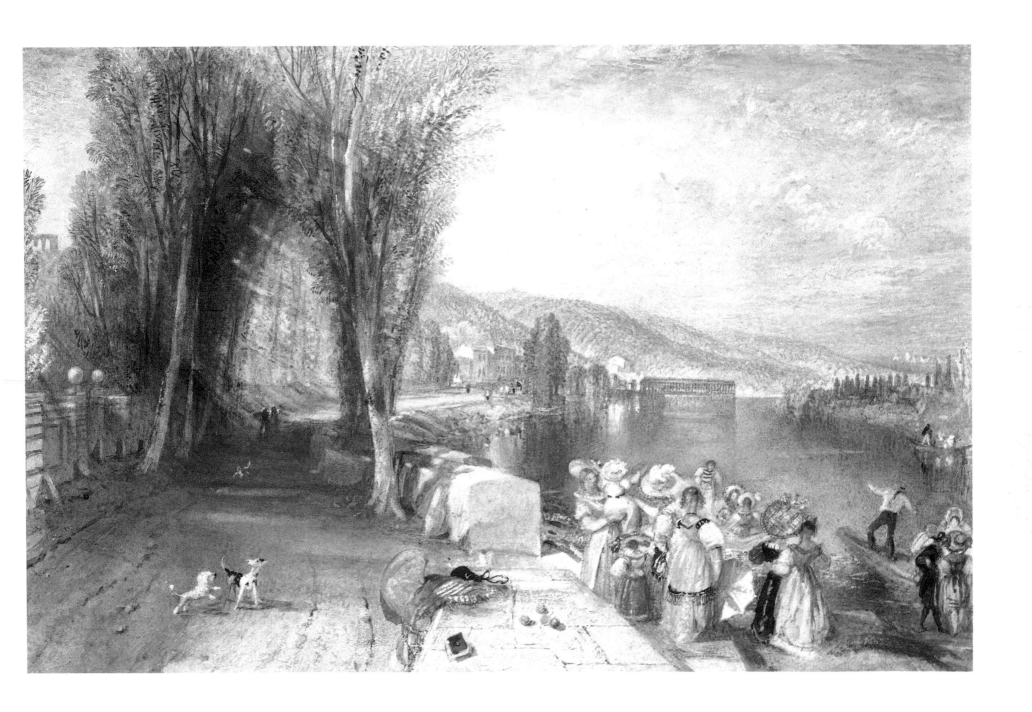

63 Marly-sur-Seine *c*.1831

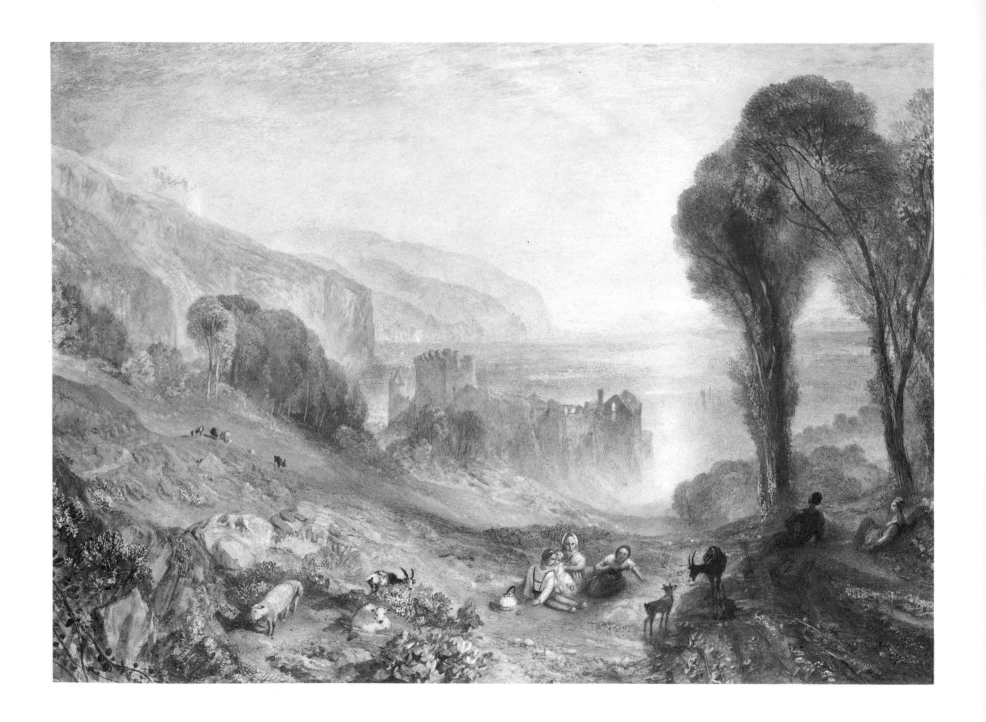

64 Tancarville *c*.1840

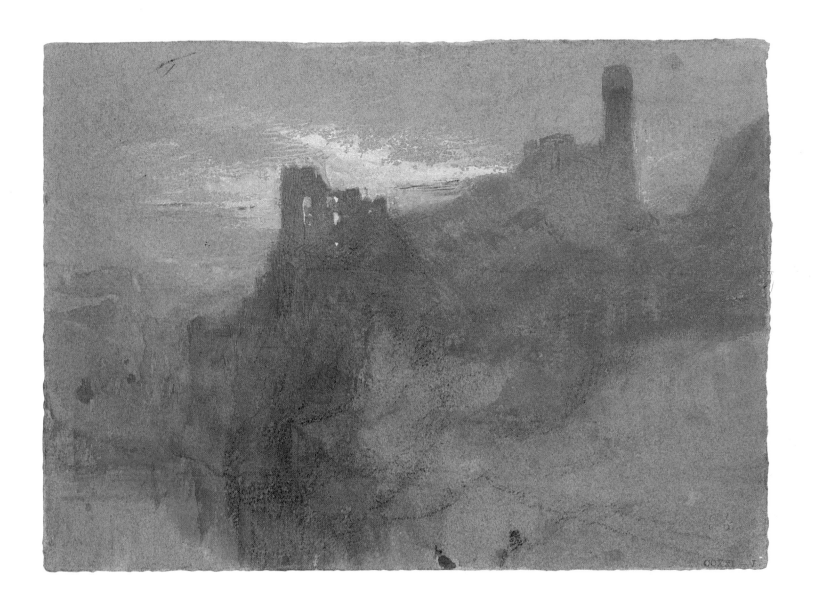

65 The Castle of Beilstein on the Moselle ?1834

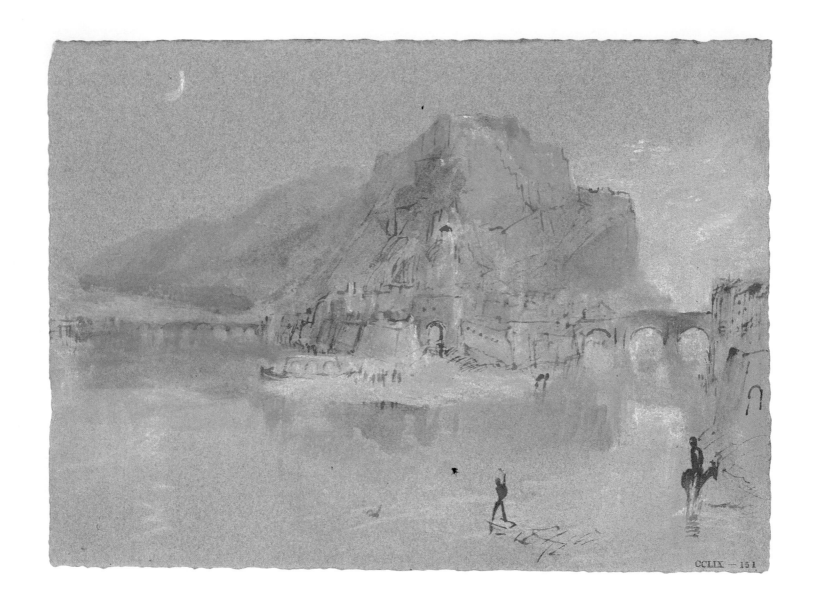

CCLIX—151

66 Namur *c.*1834

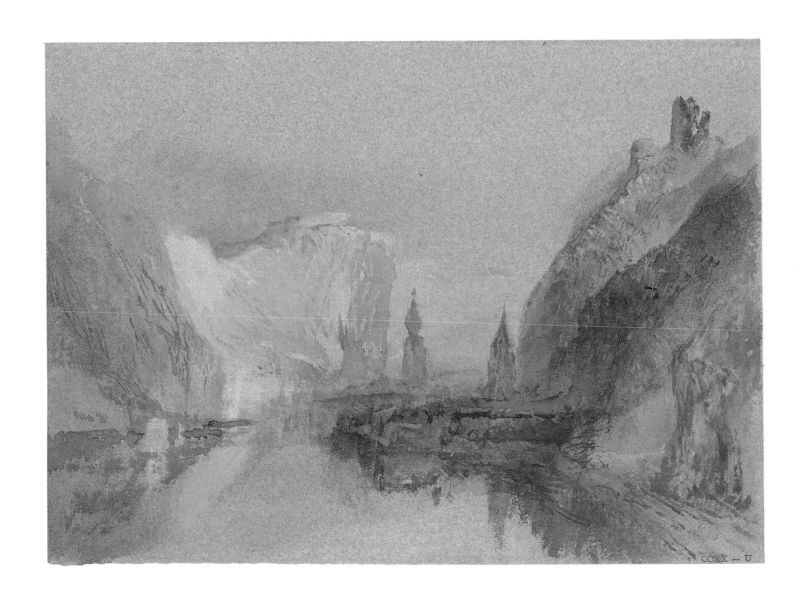

67 Dinant on the Meuse: looking upstream *c*.1826

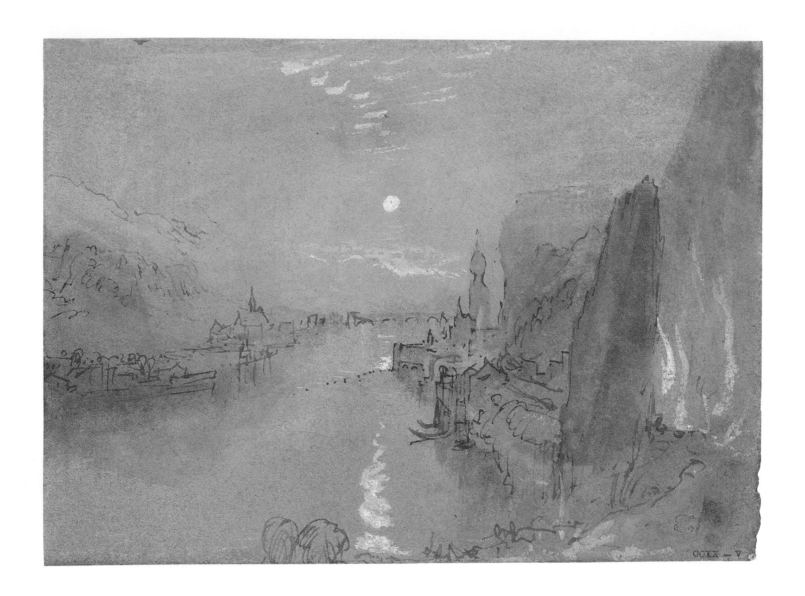

68 Dinant on the Meuse: looking downstream *c.*1826

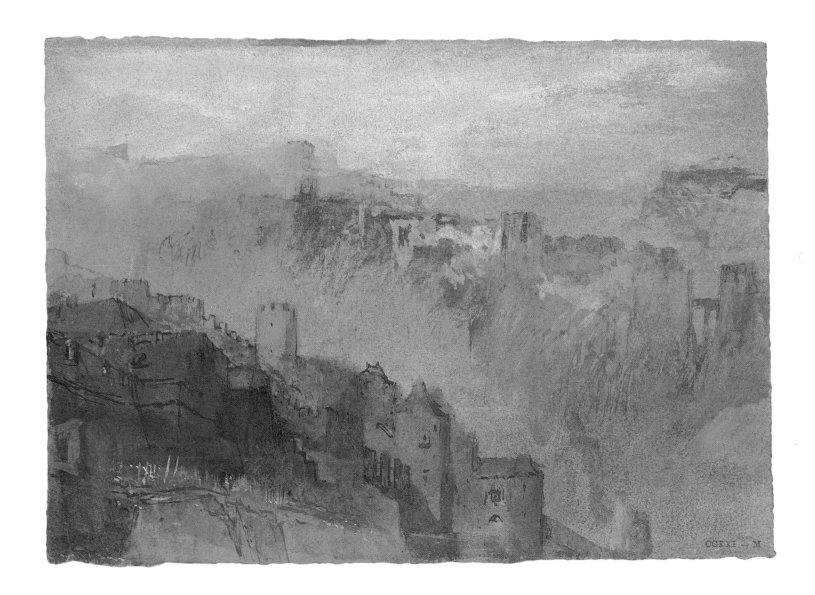

69 Luxembourg *c.*1834

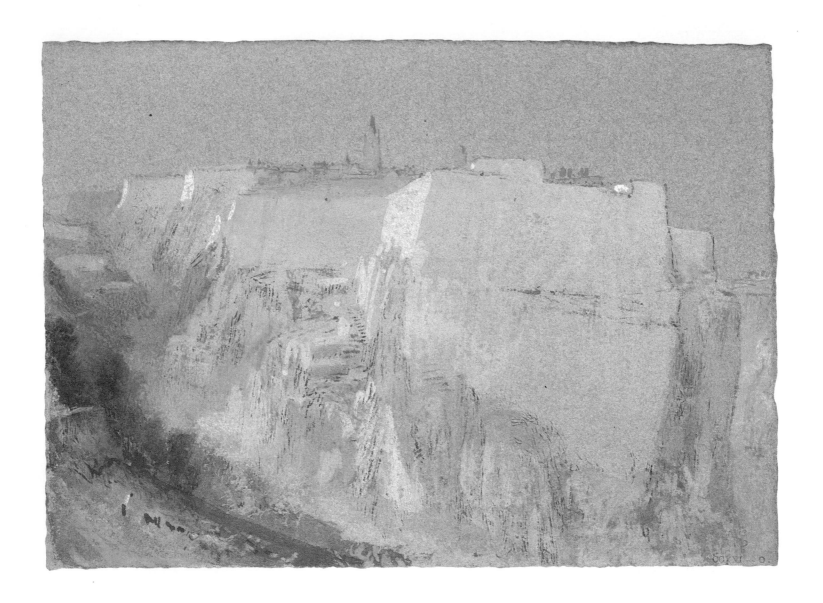

70　Luxembourg　*c*.1834

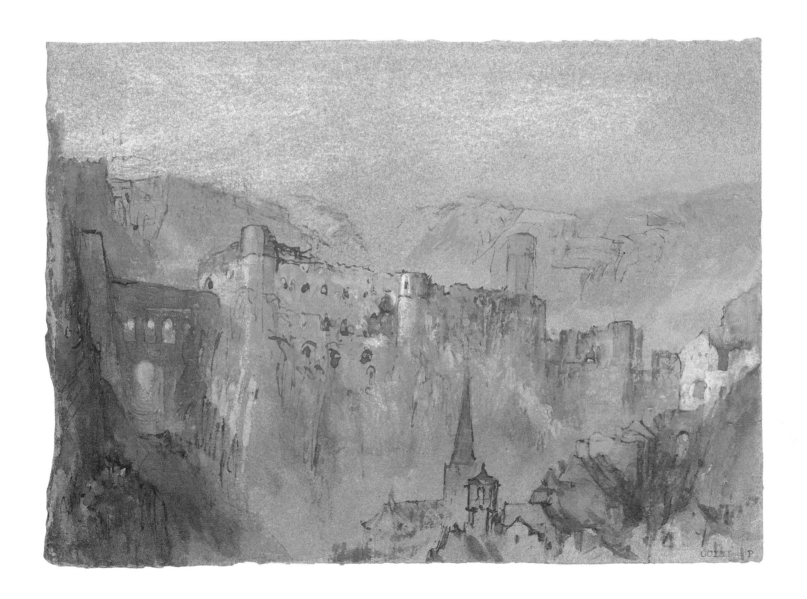

71 Luxembourg *c.*1834

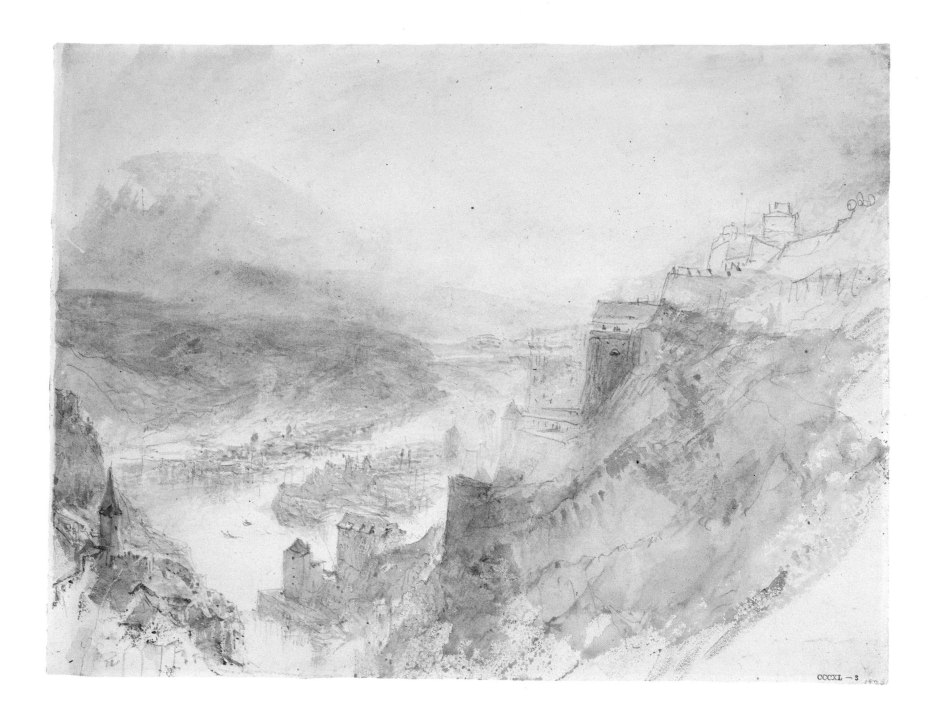

72 Passau 1833–5

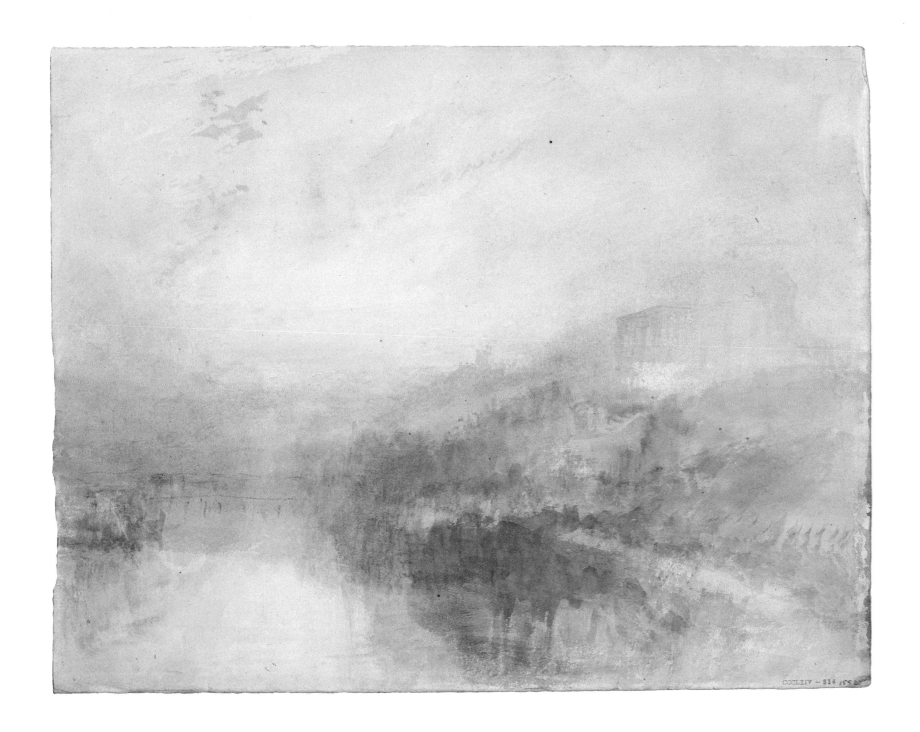

73 The Walhalla near Regensburg on the Danube 1840

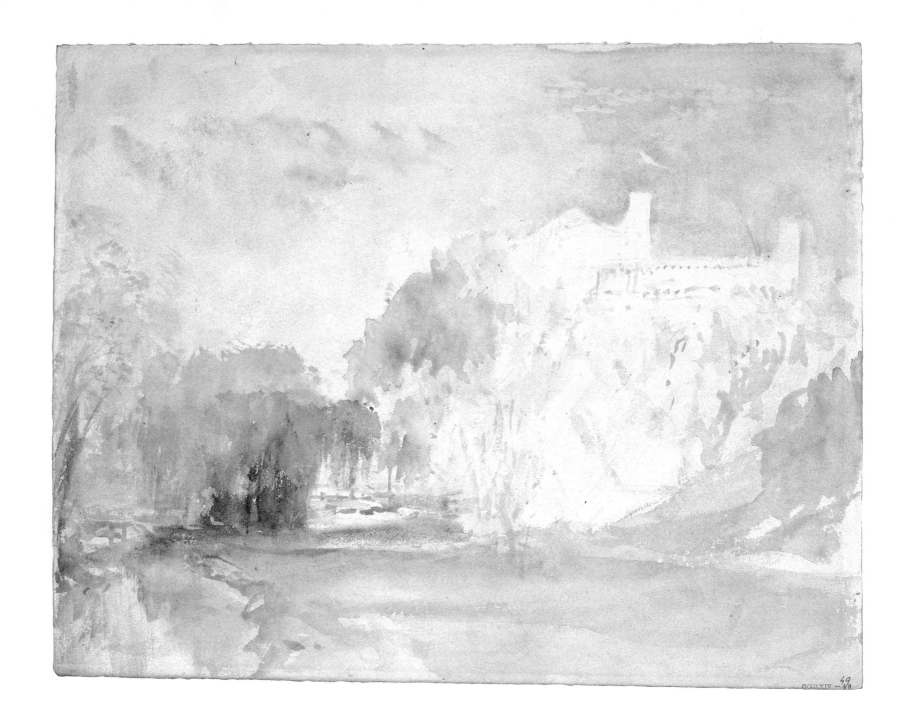

74 Rosenau 1840

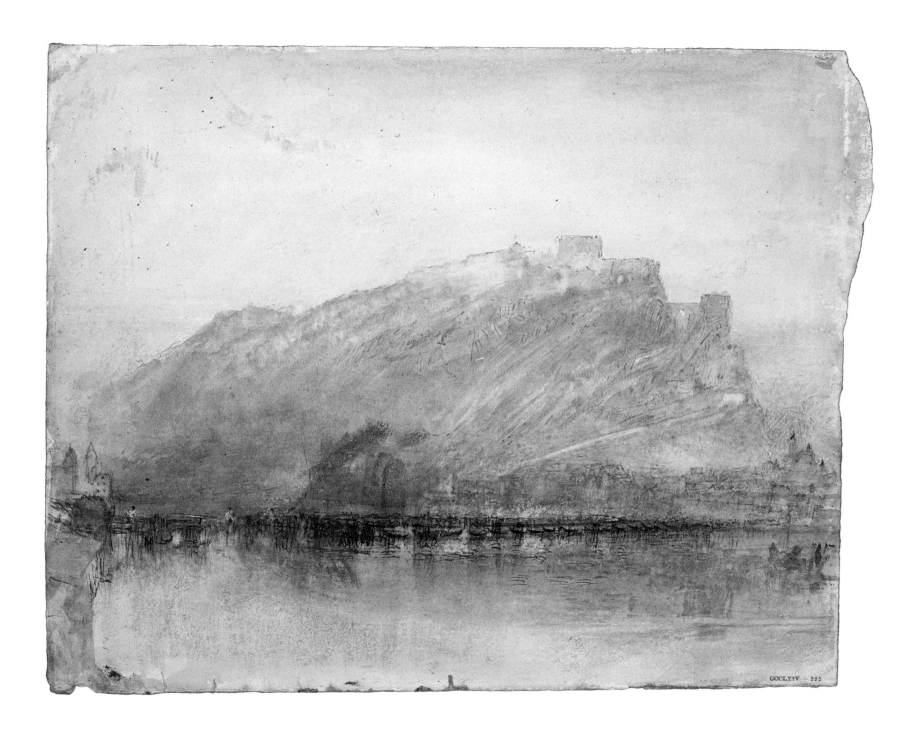

75 Ehrenbreitstein ?1840

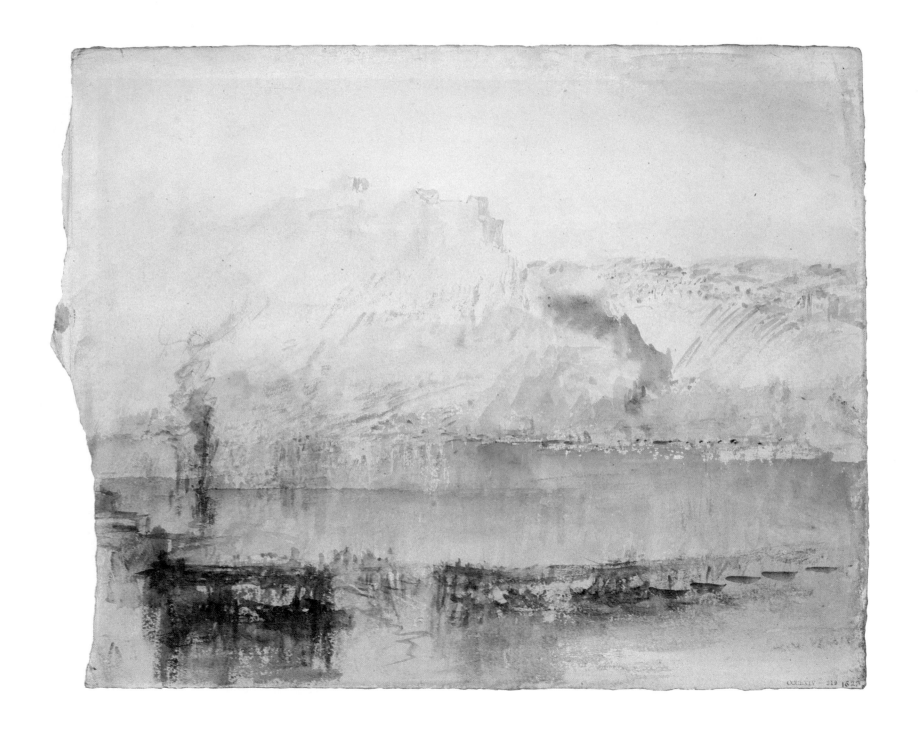

76 Ehrenbreitstein ?1840

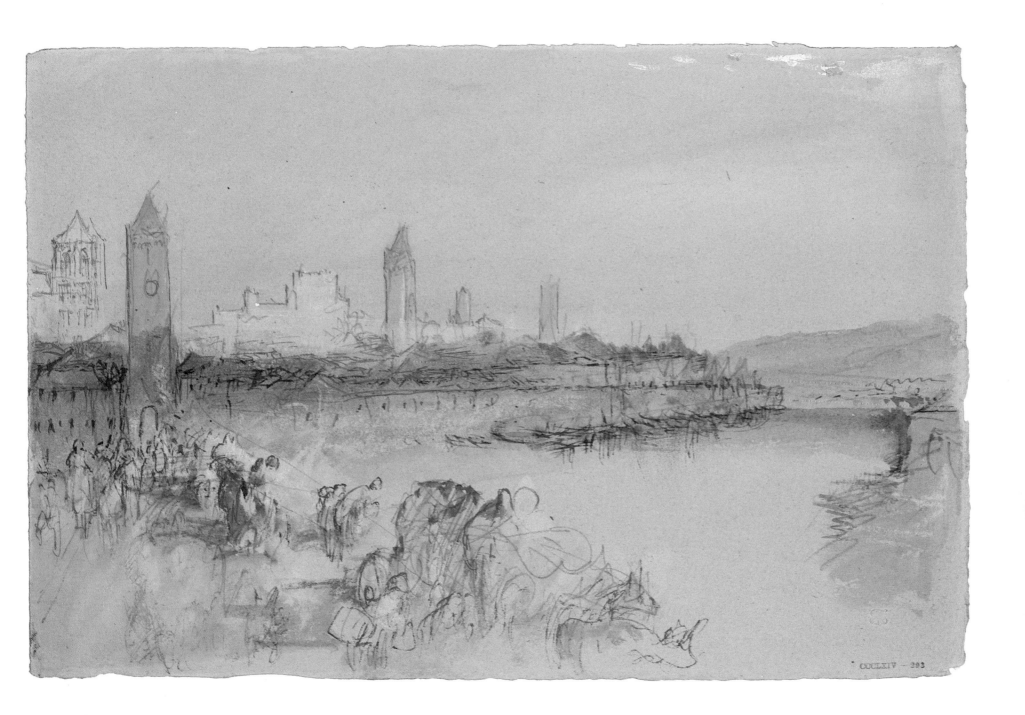

77 Mainz 1840

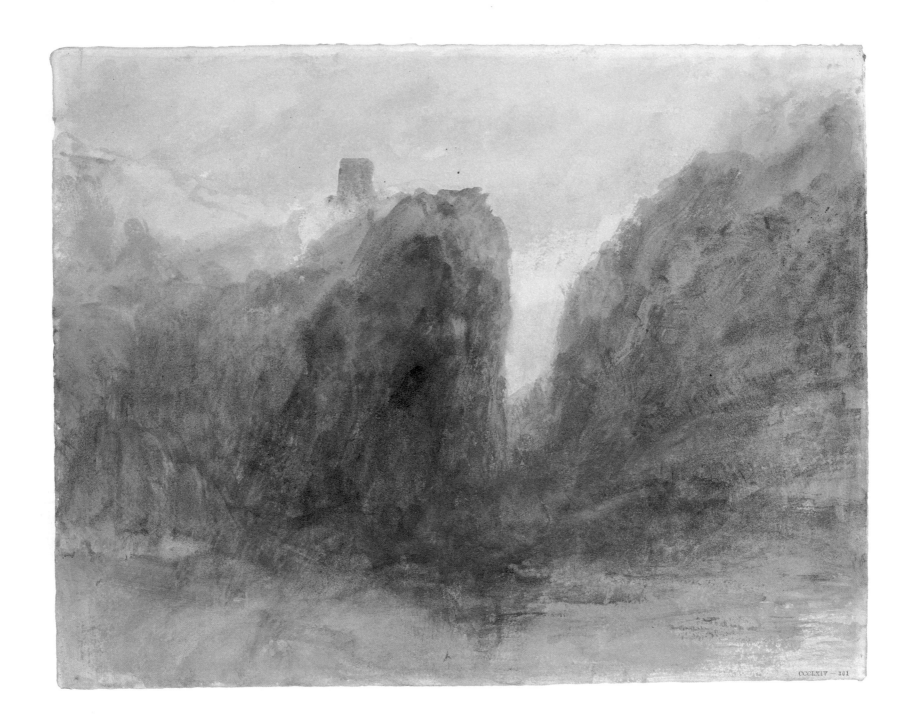

78 A ruined tower on a crag ?1836

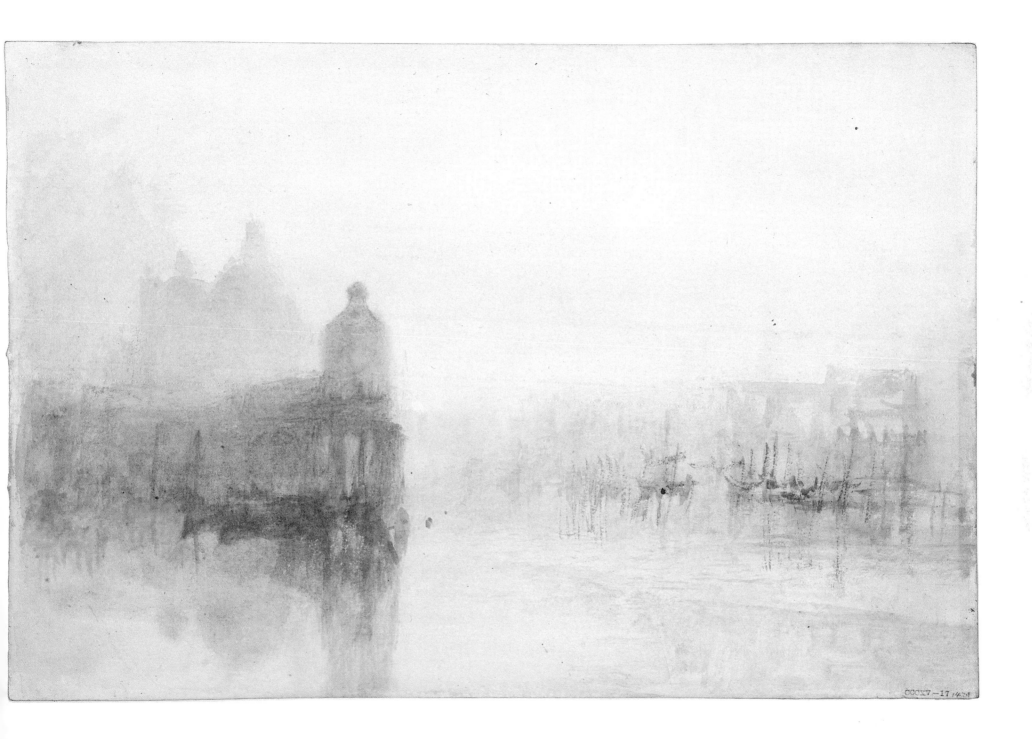

79 Venice: sunset 1840

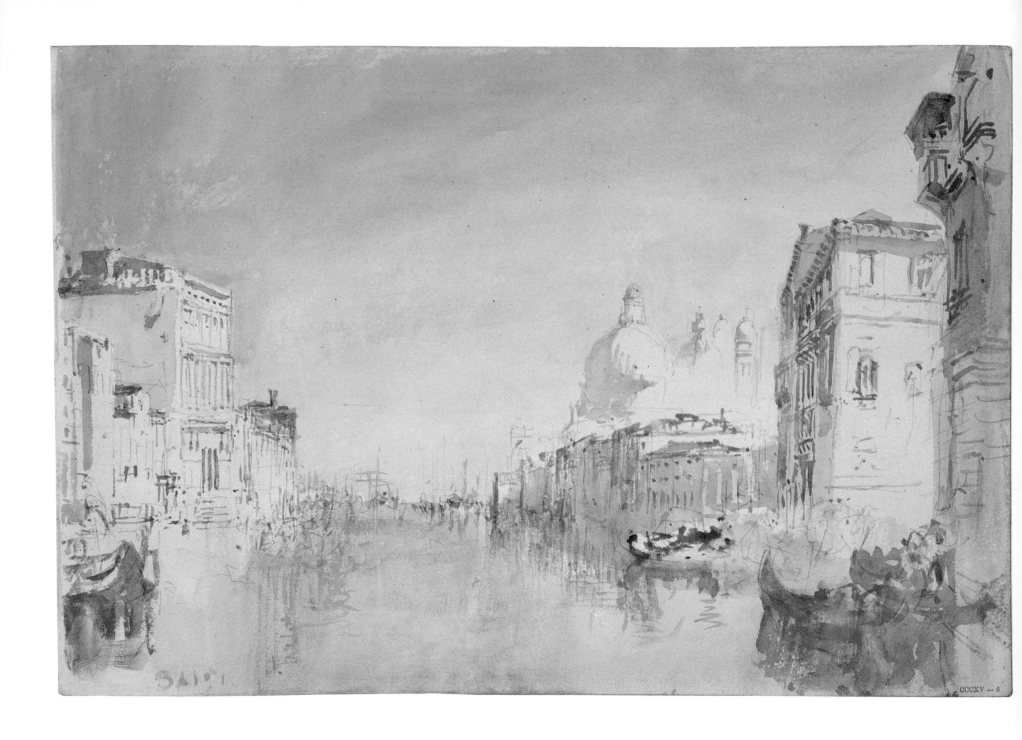

80 Venice: looking down the Grand Canal towards the Casa Corner and the Salute 1840

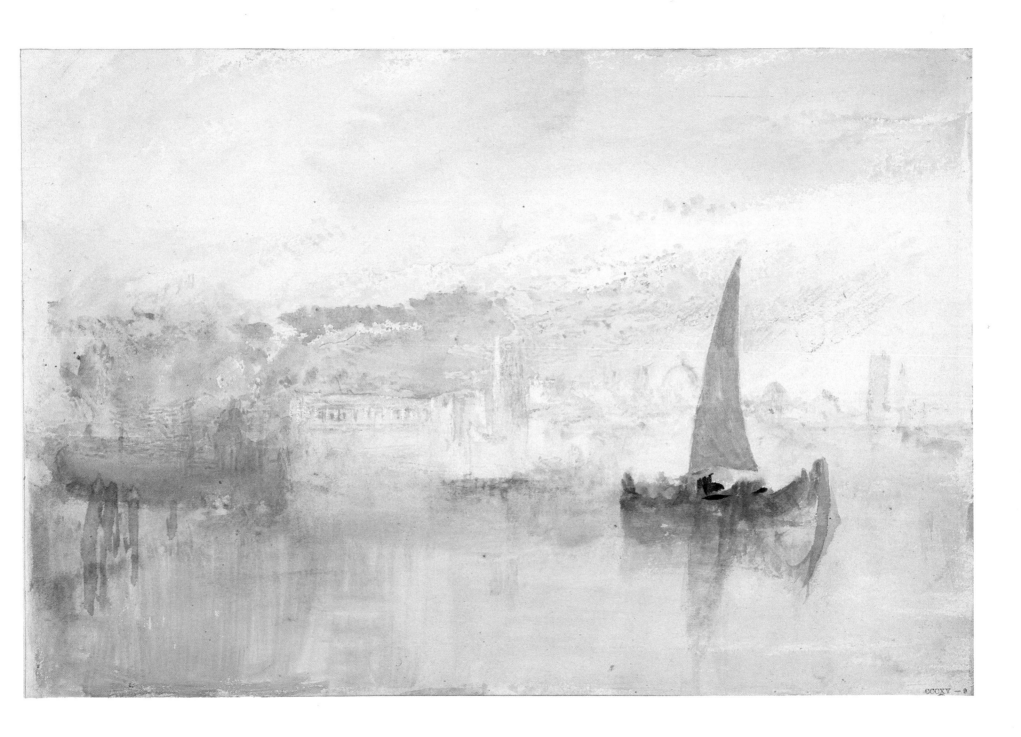

81 Venice: a campanile and other buildings, with a fishing boat 1840

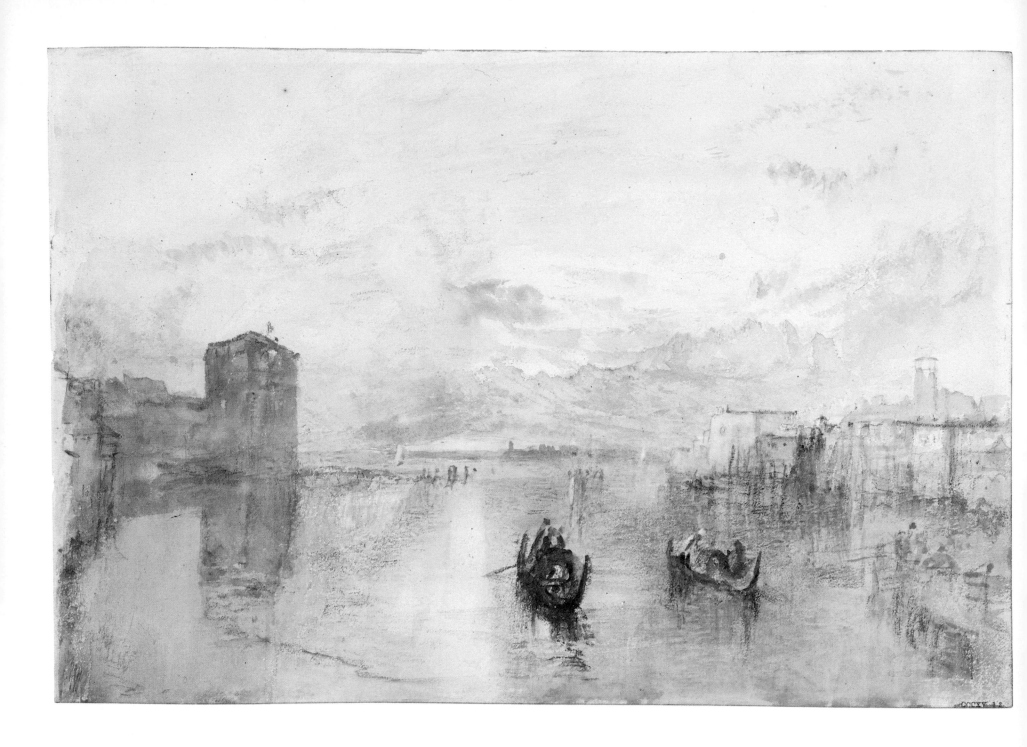

82 Venice: the Giudecca, looking towards Fusina 1840

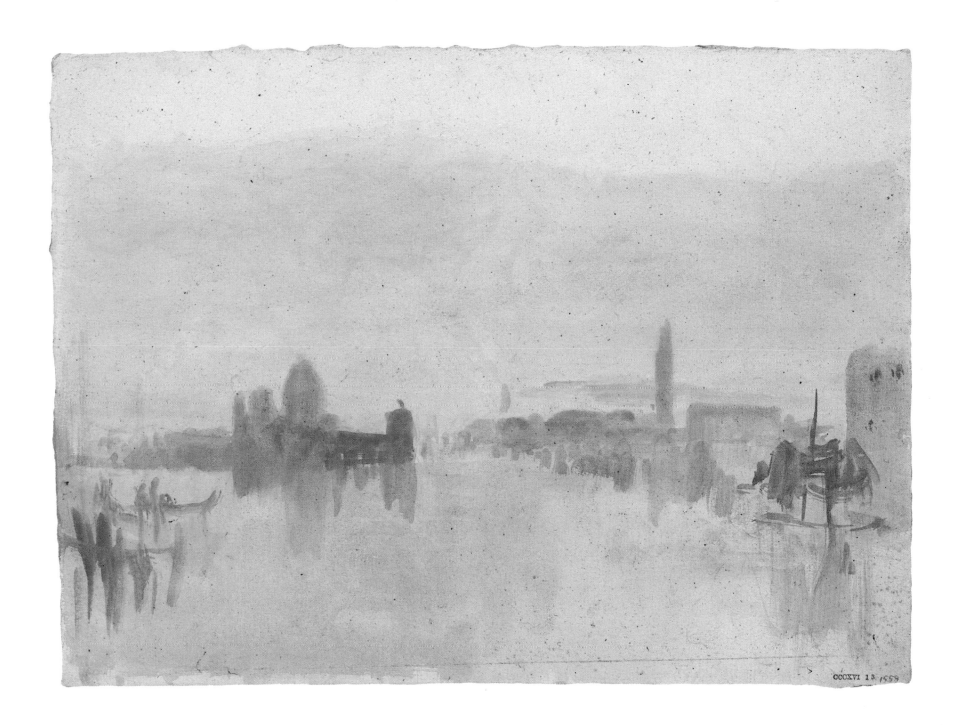

CCXVI 18 1558

83 Venice: distant view of the entrance to the Grand Canal 1840

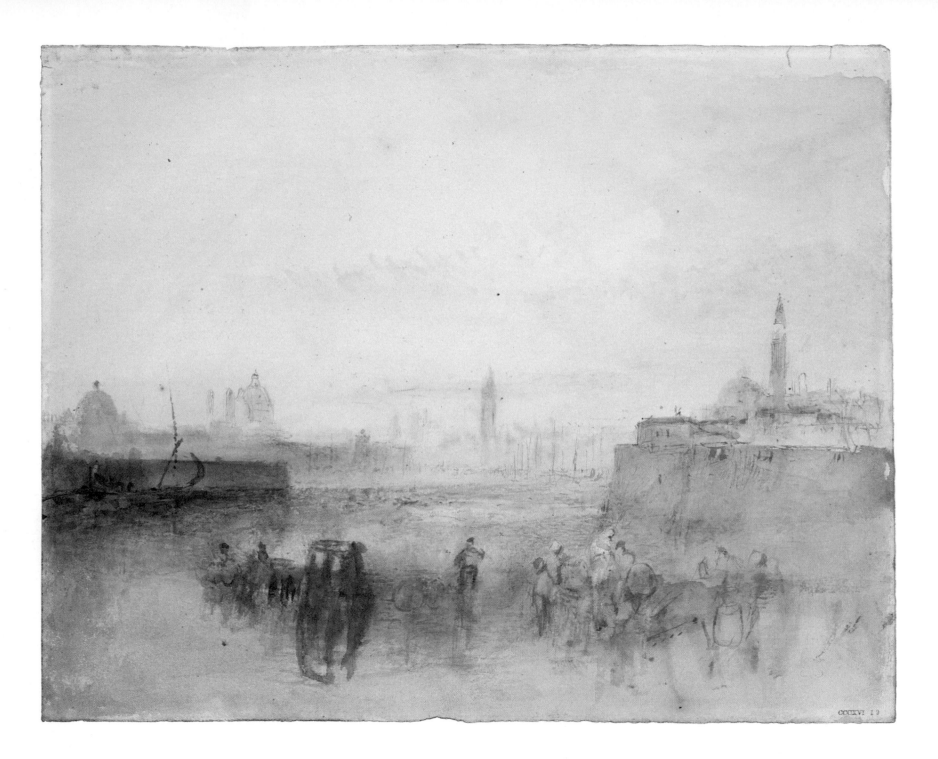

84 Venice: the Salute from S Giorgio Maggiore 1840

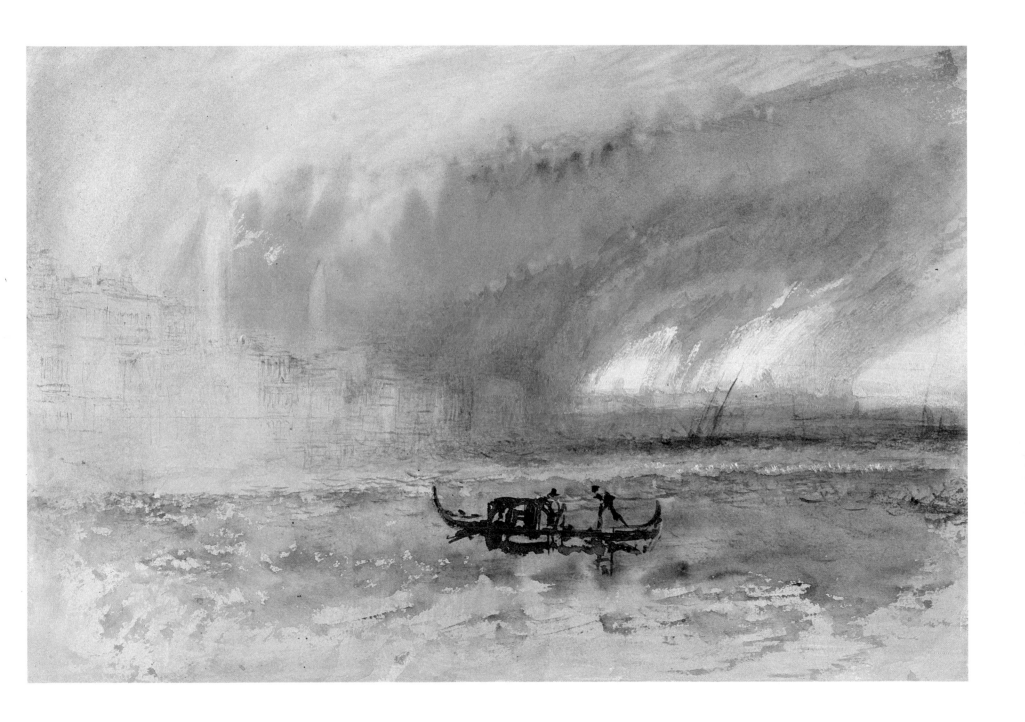

85 Venice: a storm 1840

86 Bedroom in Venice 1840

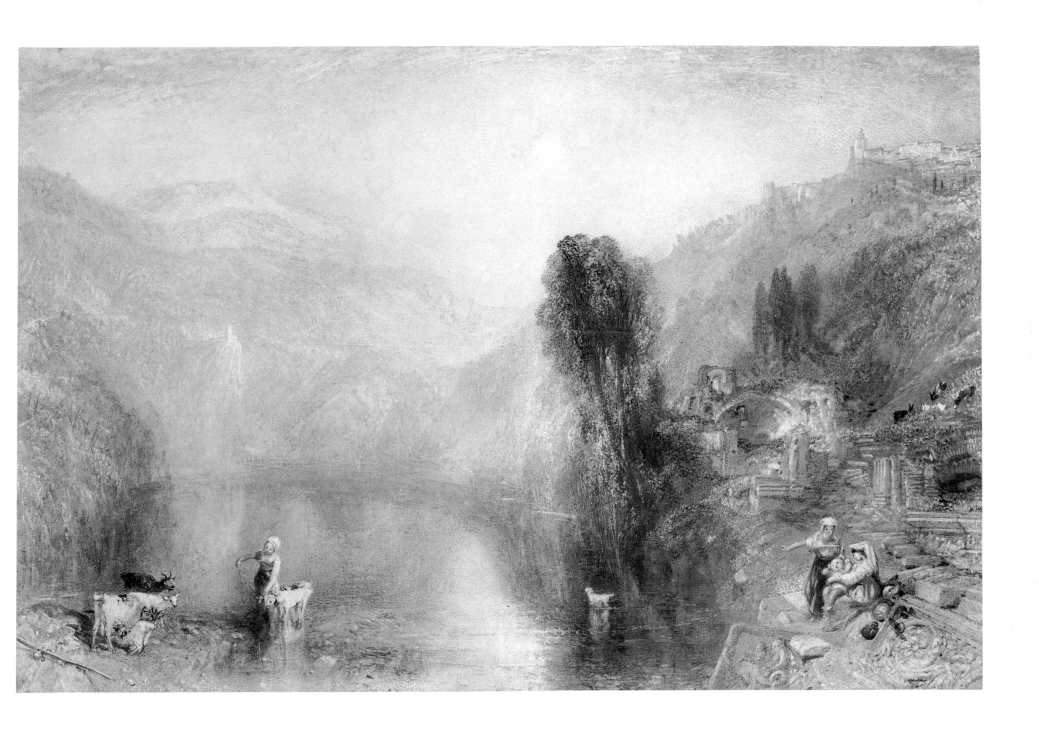

87　Lake Nemi　c.1840

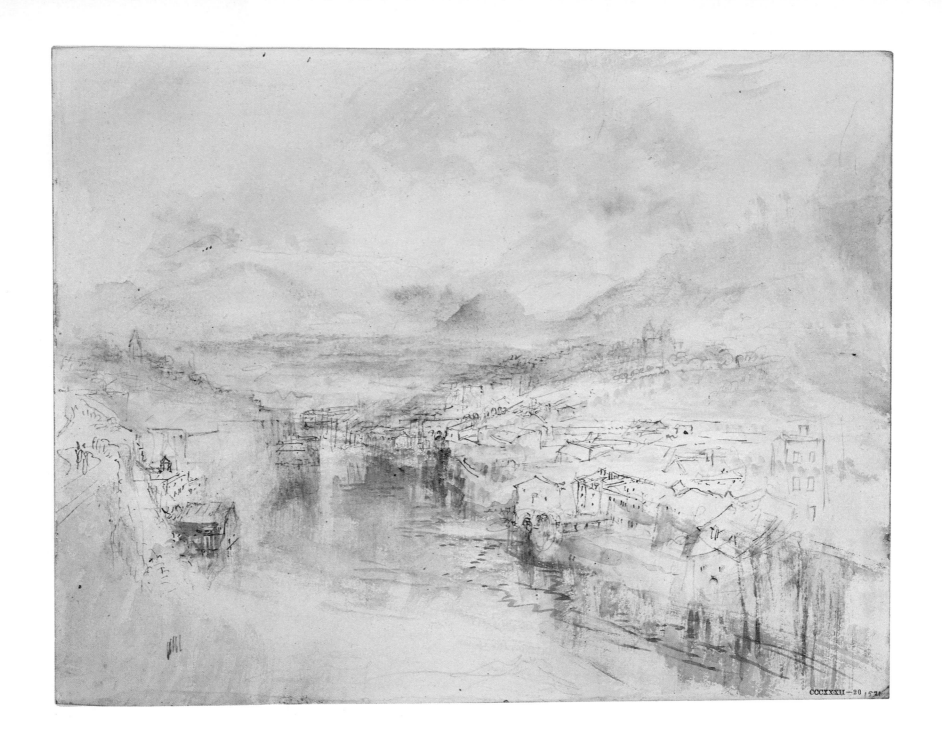

88 Geneva 1841

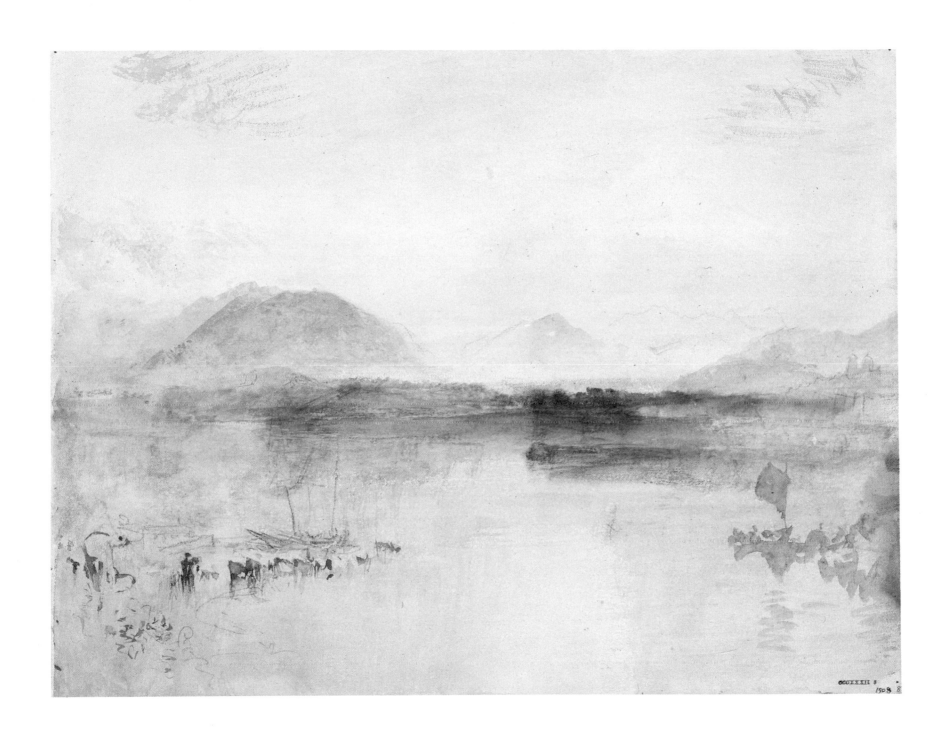

89　Geneva: the Mole and the Savoy hills　1841

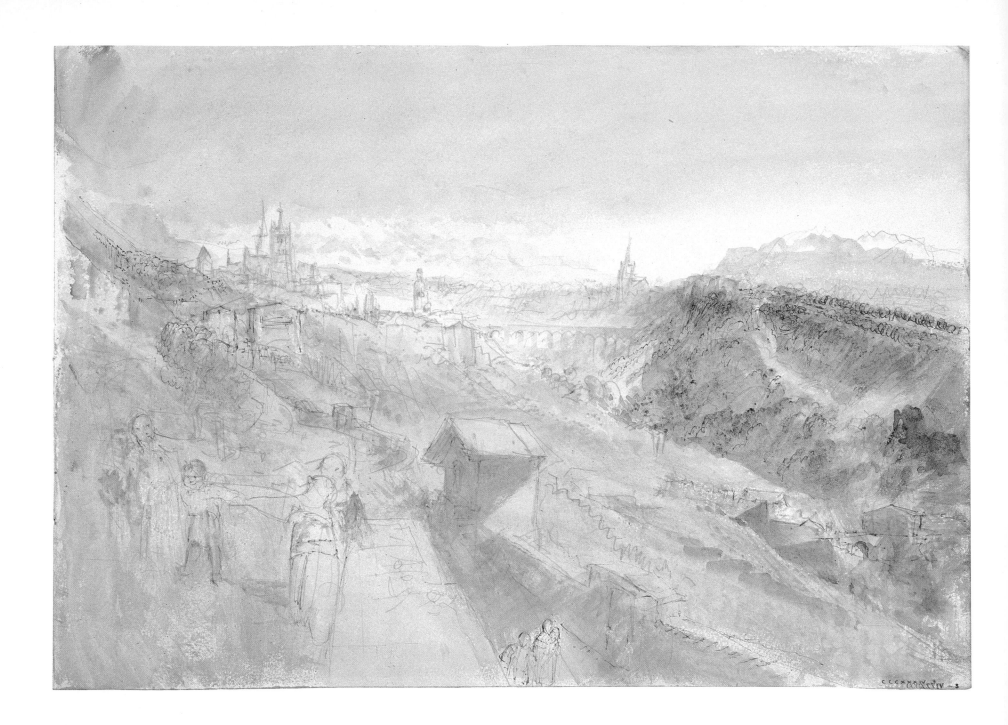

90 Lausanne 1841

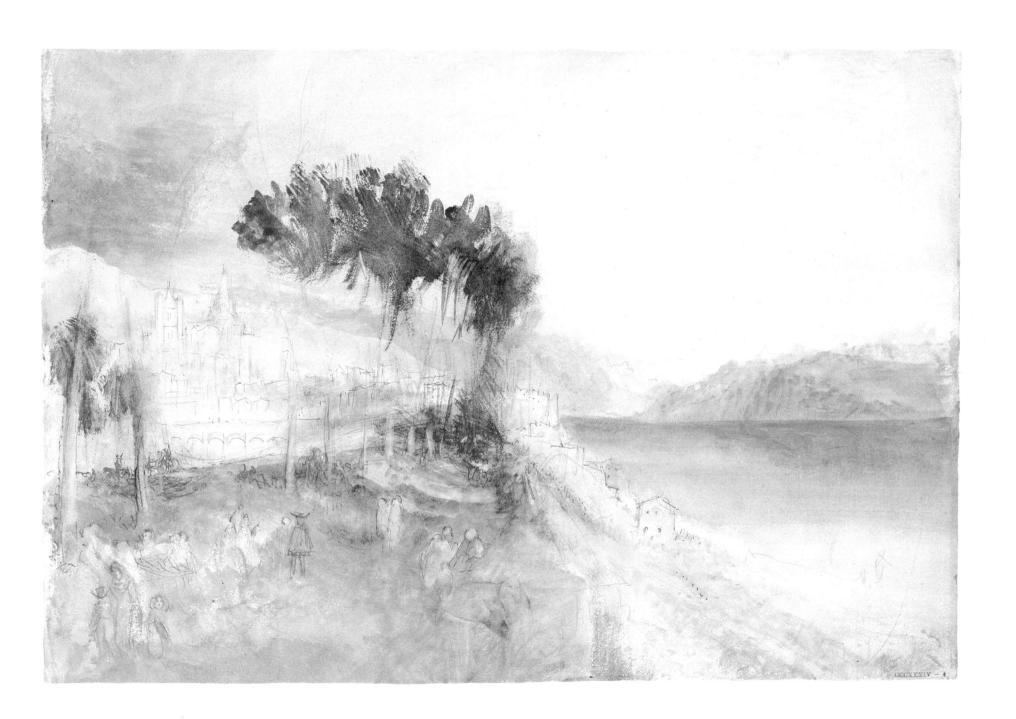

91 Lausanne and Lake Geneva 1841

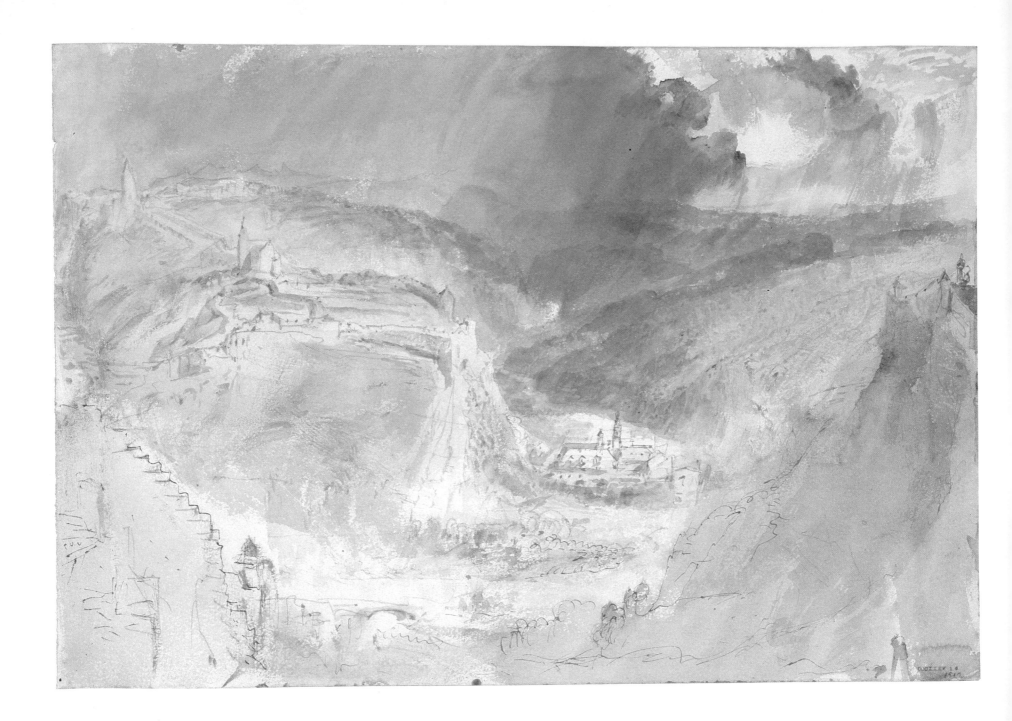

92 Fribourg 1841

93 Fribourg: moonlight 1841

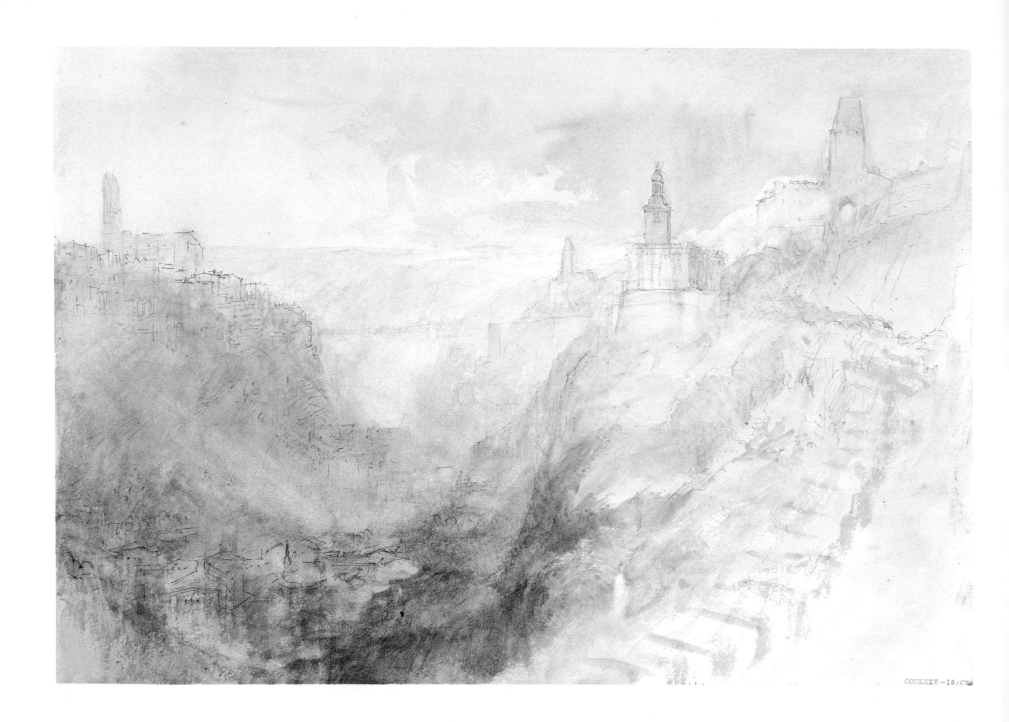

94 Fribourg 1841

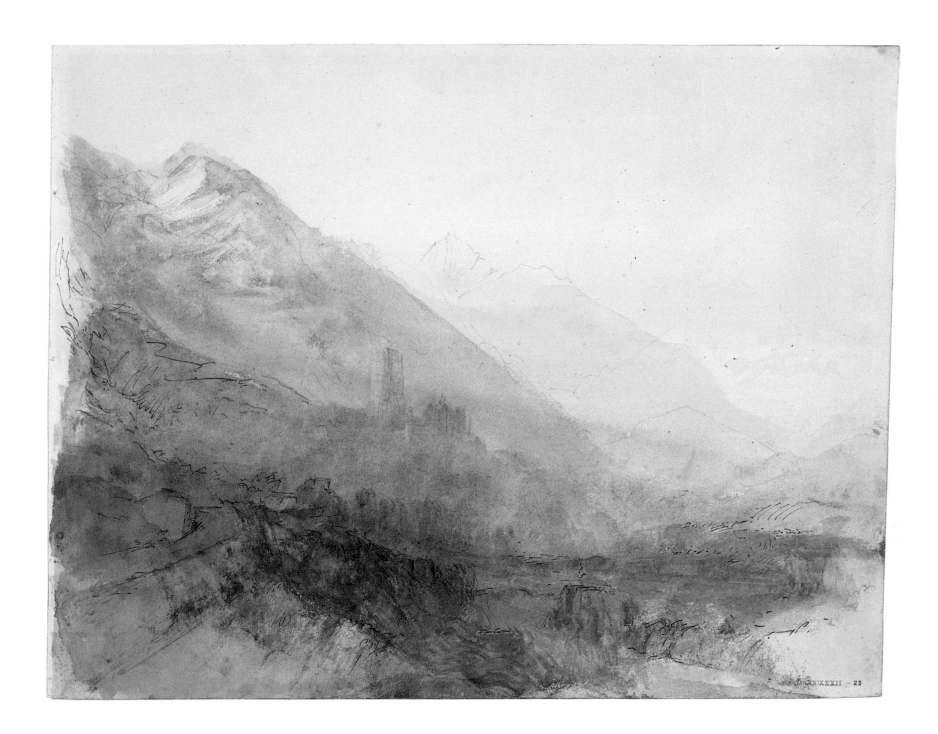

95 Martigny 1841

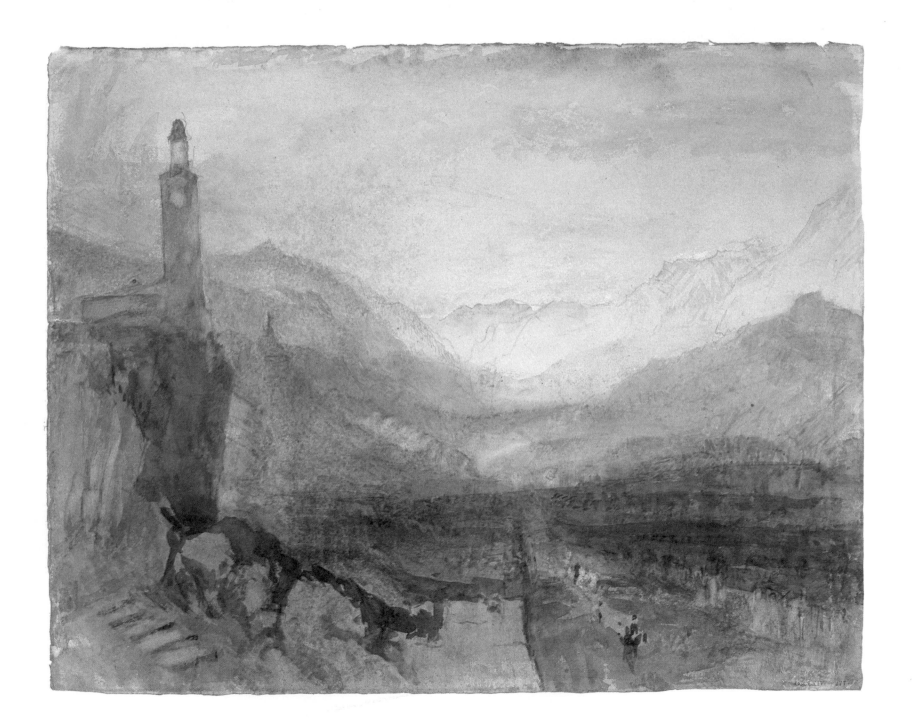

96 Splügen 1841–2

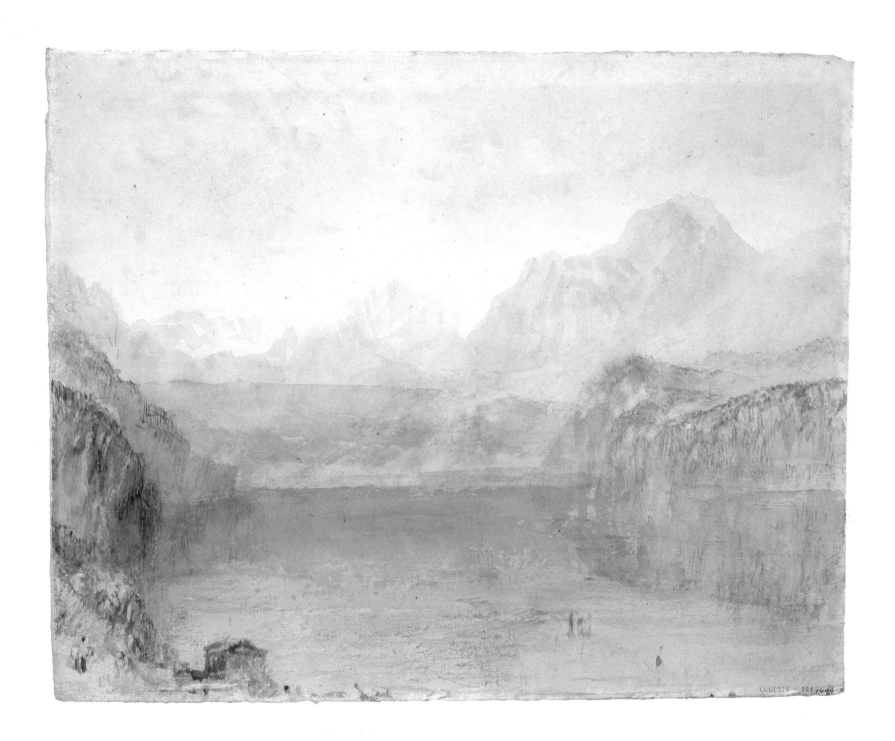

97 Lake Lucerne: the Bay of Uri from Brunnen 1842

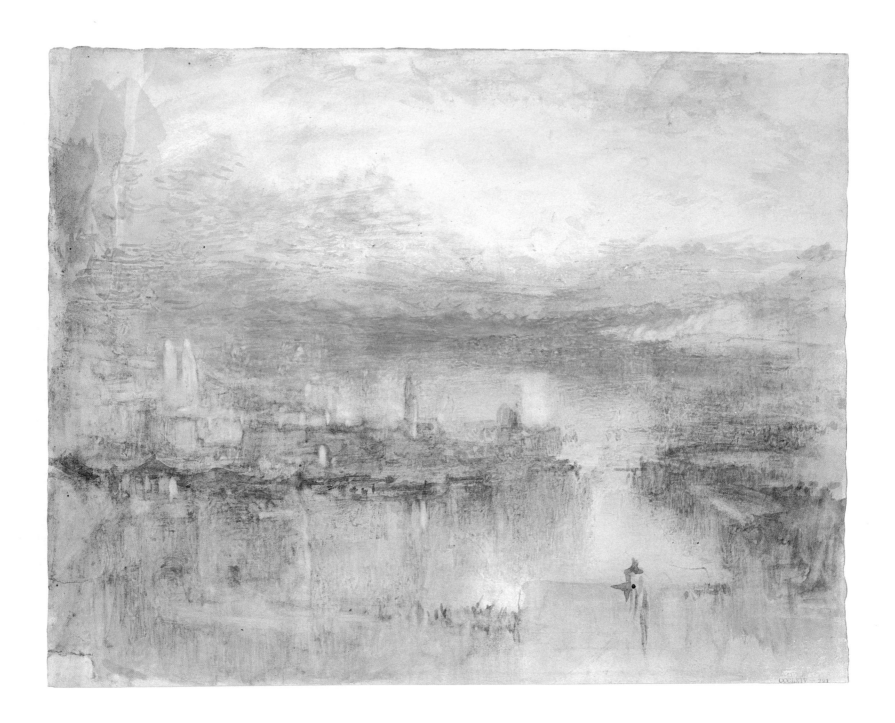

98 Zurich 1842

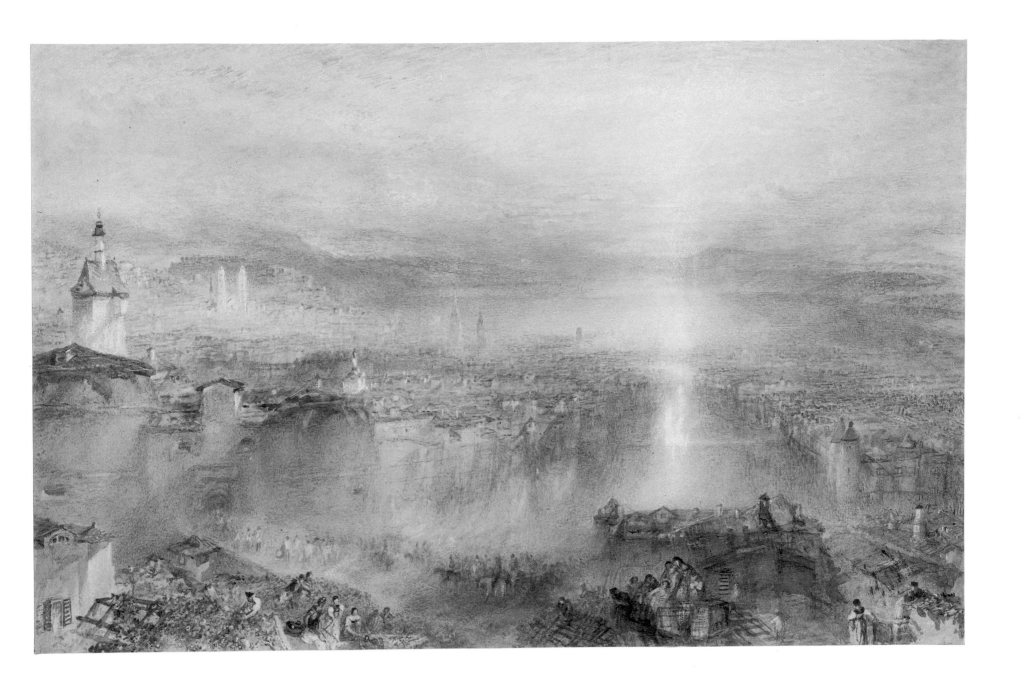

99 Zurich 1842

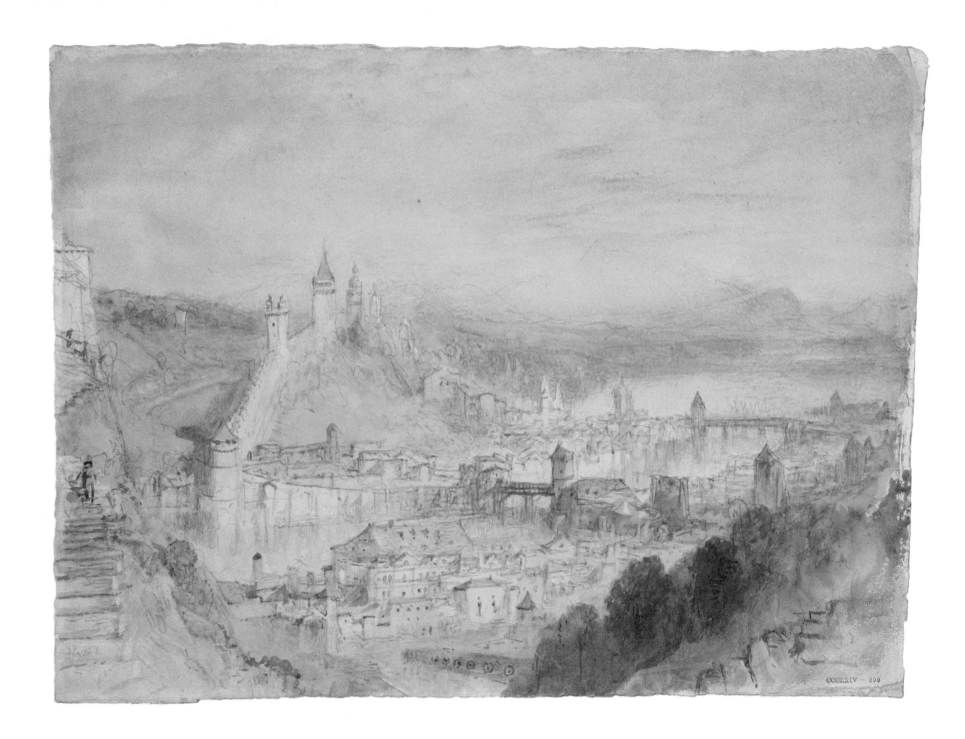

100 Lucerne from the walls 1842

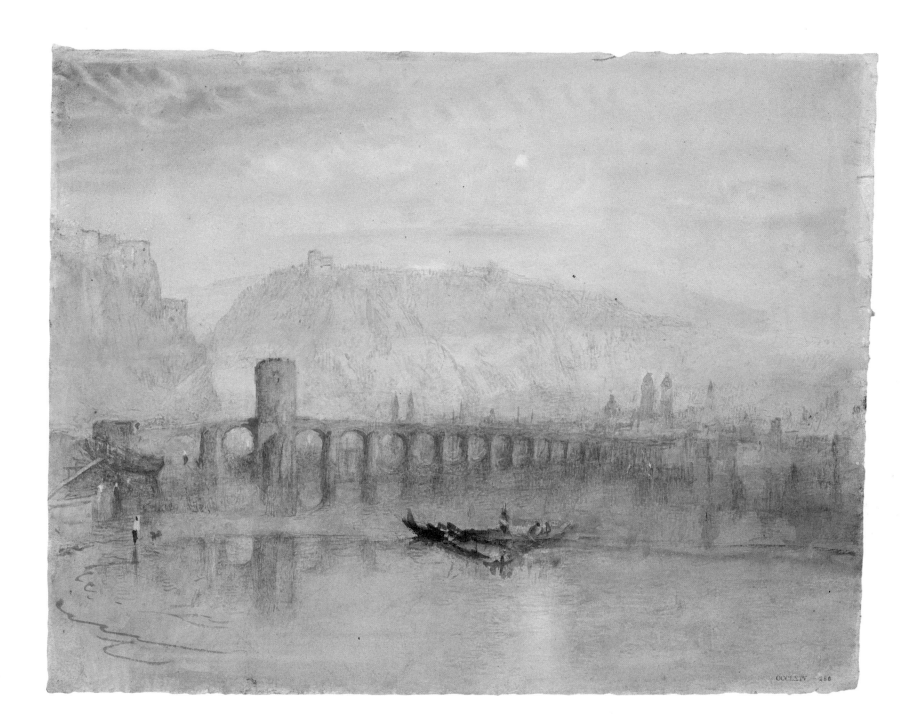

101 Coblenz Bridge 1842

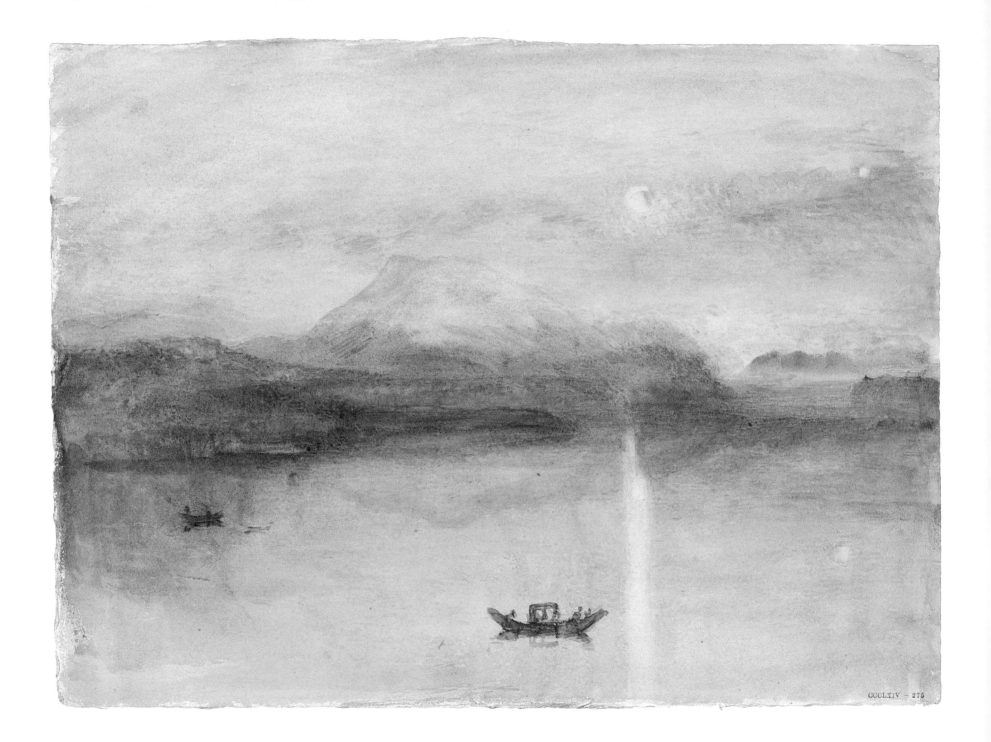

102 The Red Rigi 1842

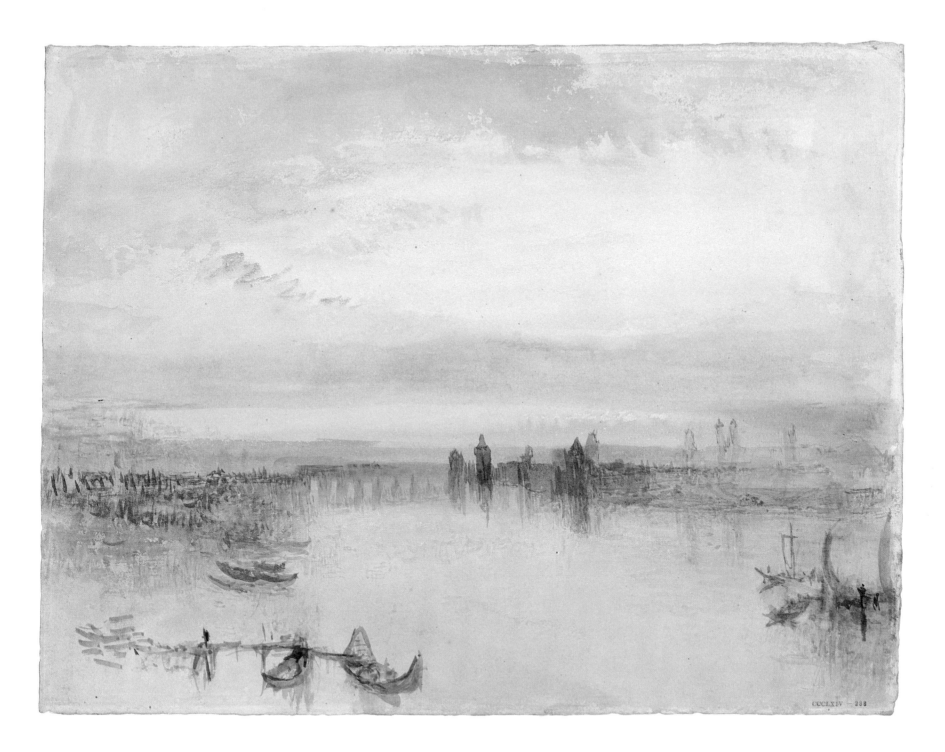

103 Constance 1842

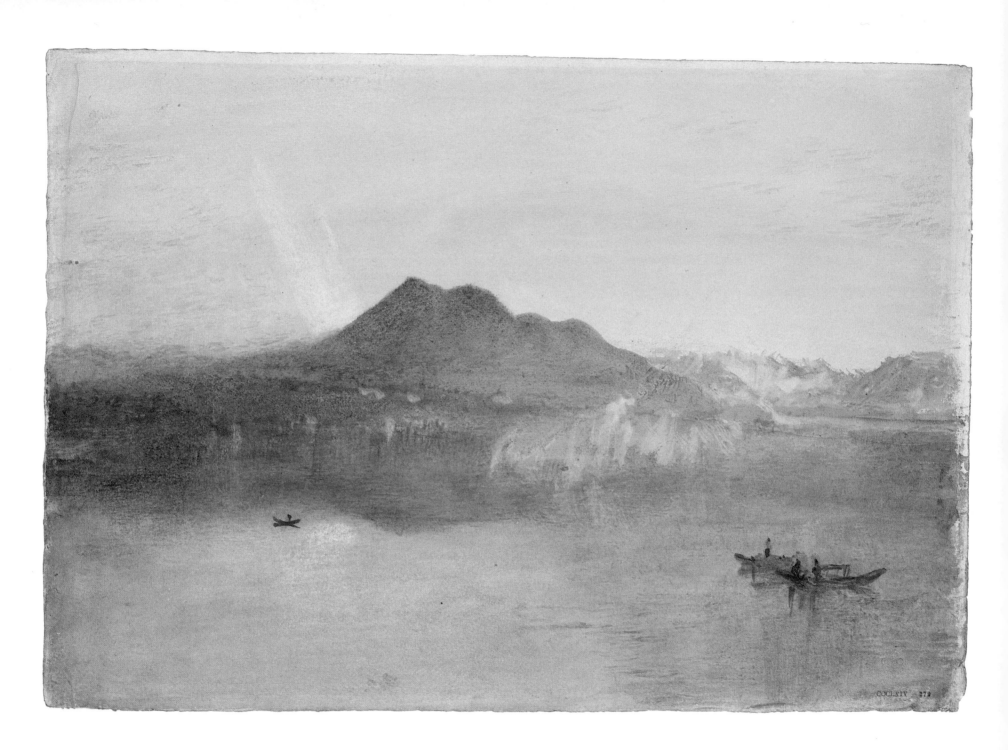

104 The Dark Rigi 1842

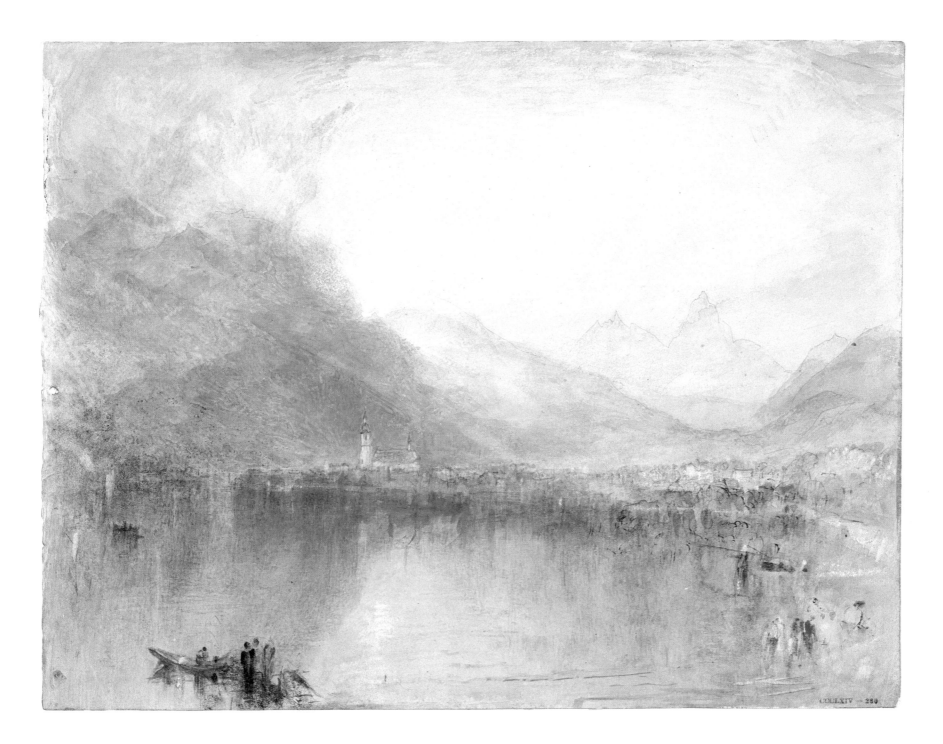

105 Arth, on the lake of Zug 1843

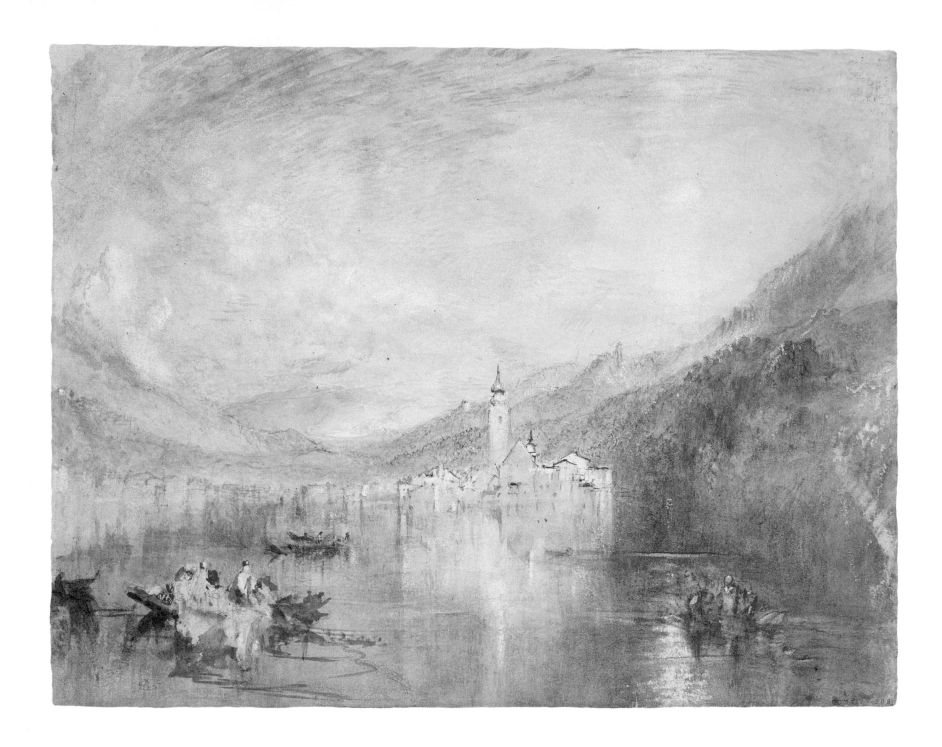

106 Kusnacht 1843

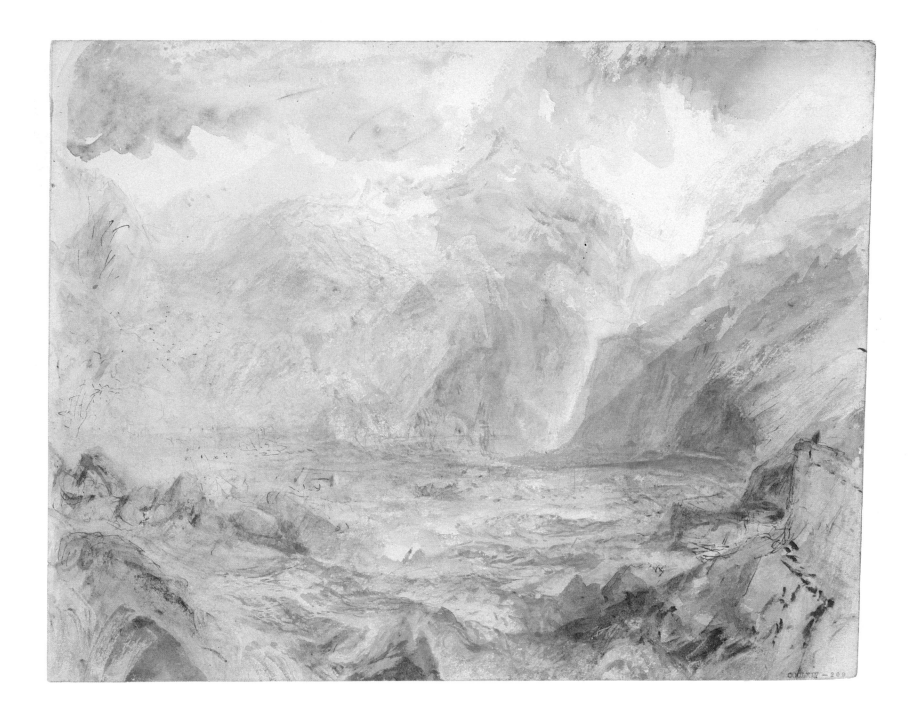

107 The Pass of Faido 1843

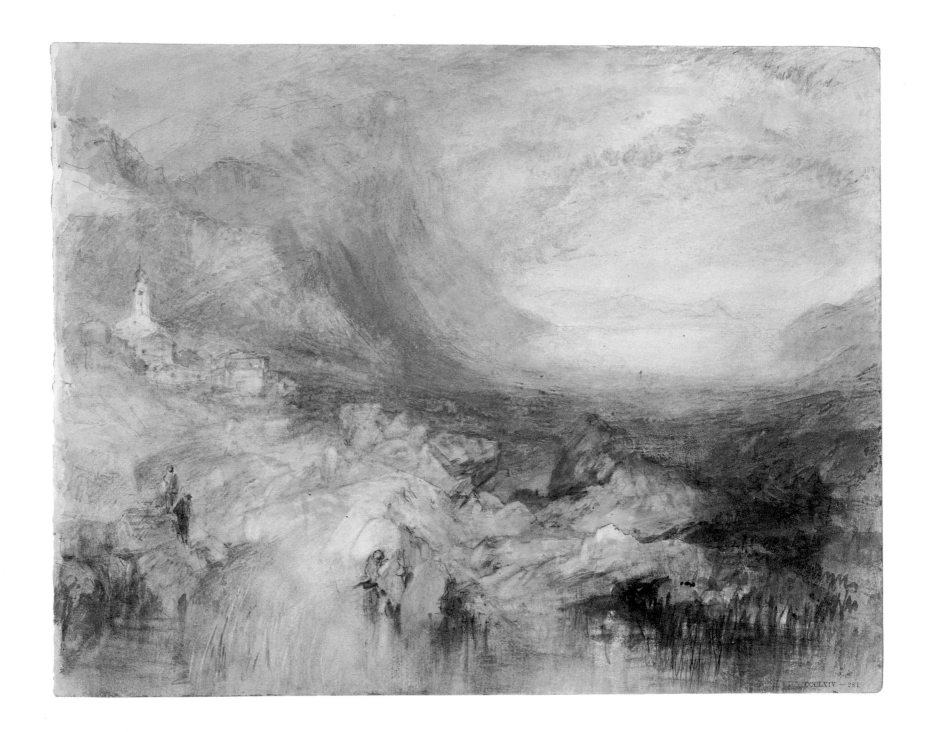

108 Goldau 1843

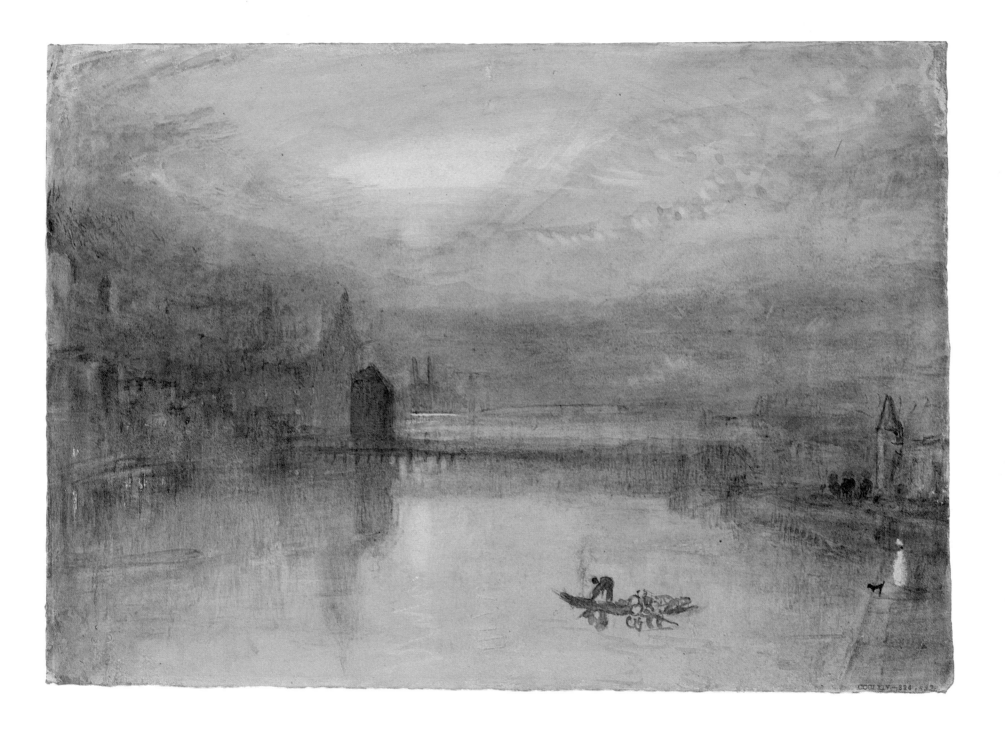

109 Lucerne: moonlight 1843

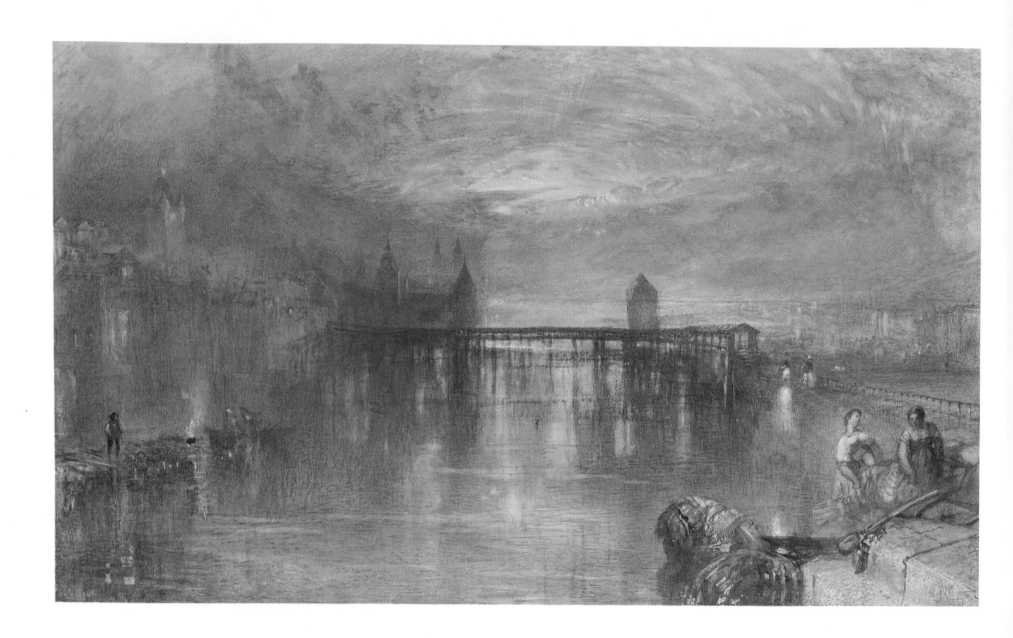

110 Lucerne: moonlight 1843

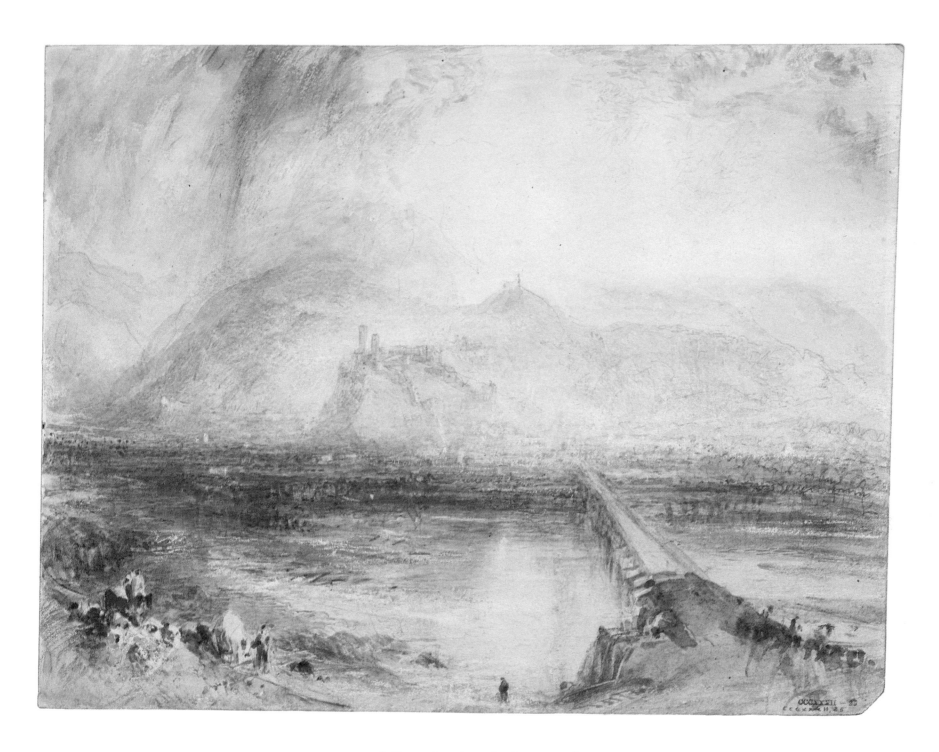

111 Bellinzona from the road to Locarno 1843

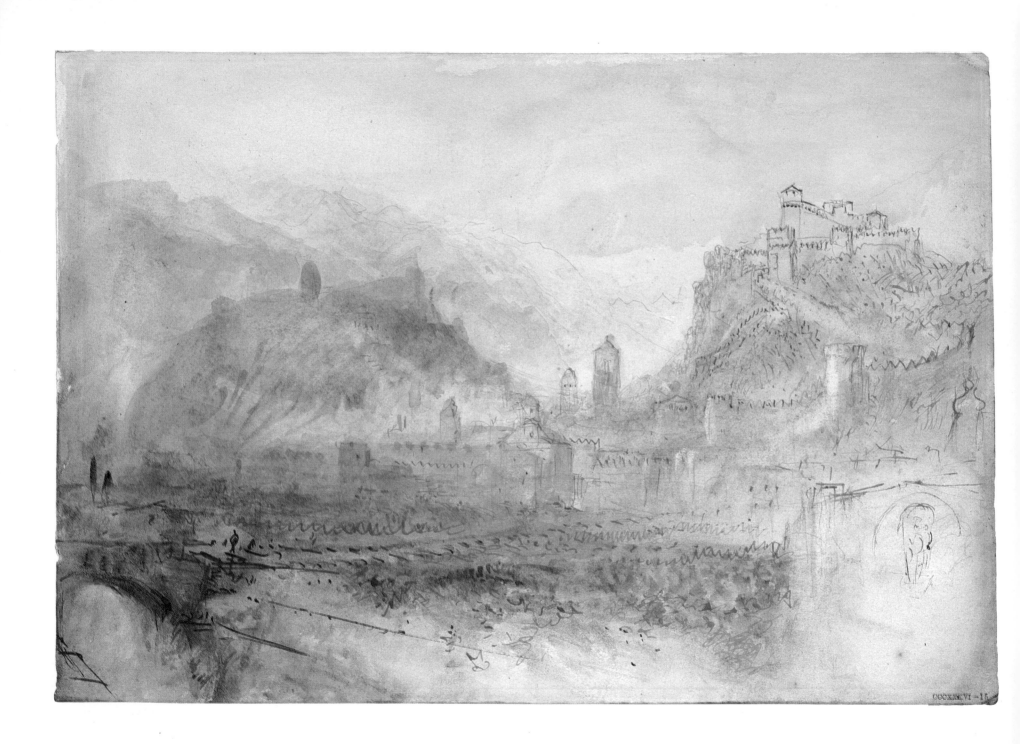

112 Bellinzona from the South 1842 or 1843

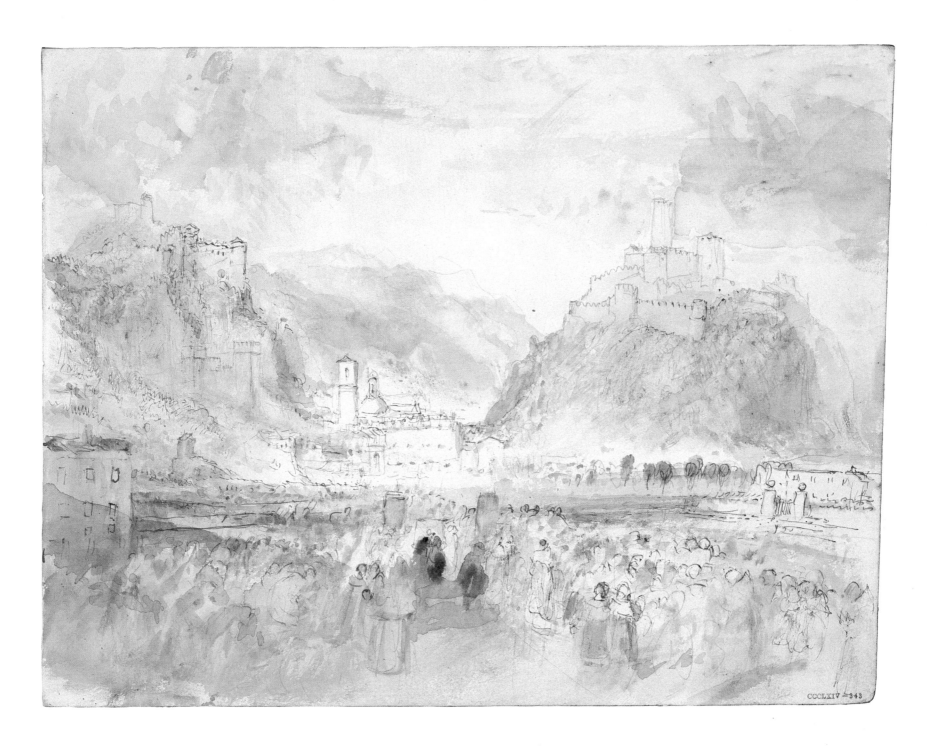

113 Bellinzona from the North: a procession ?1843

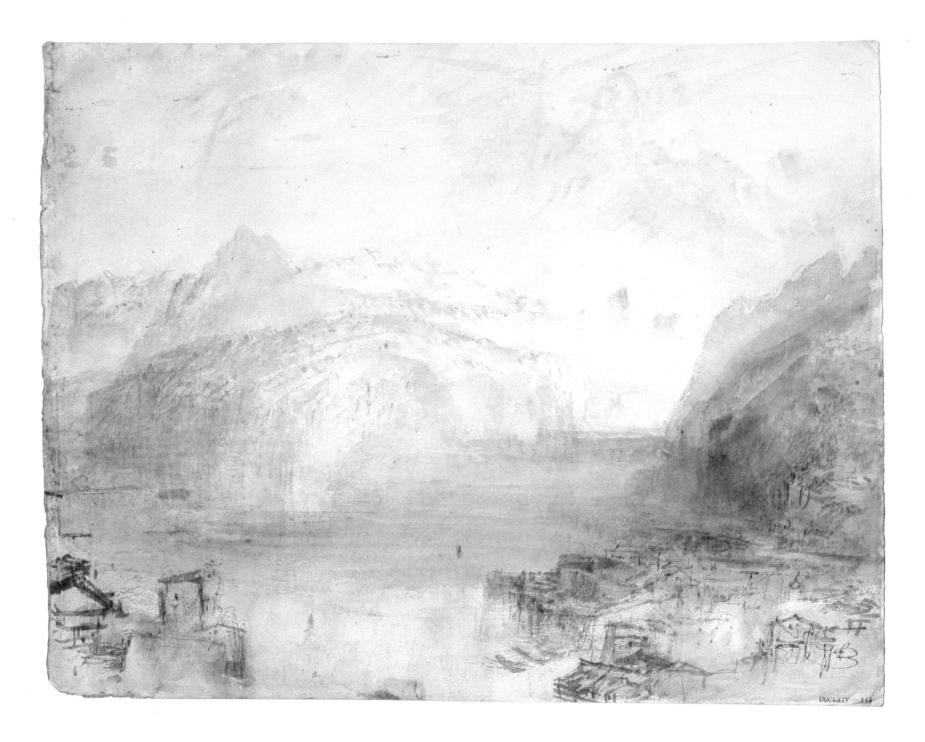

114 Lake Lucerne from Brunnen 1845

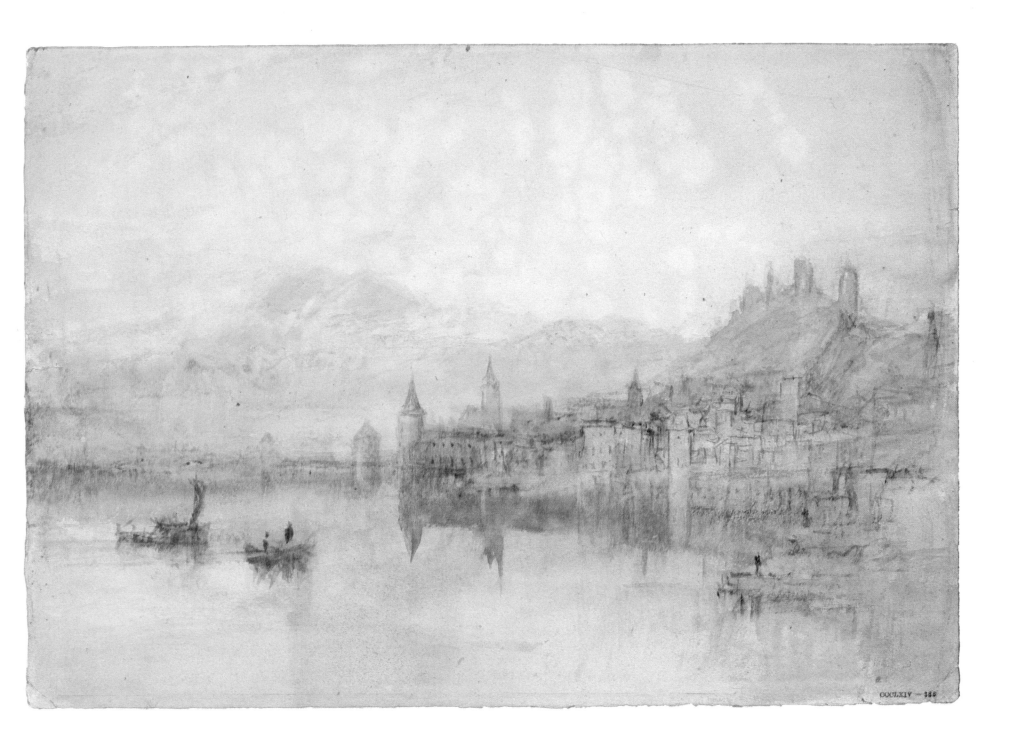

115 Lucerne from the lake 1845

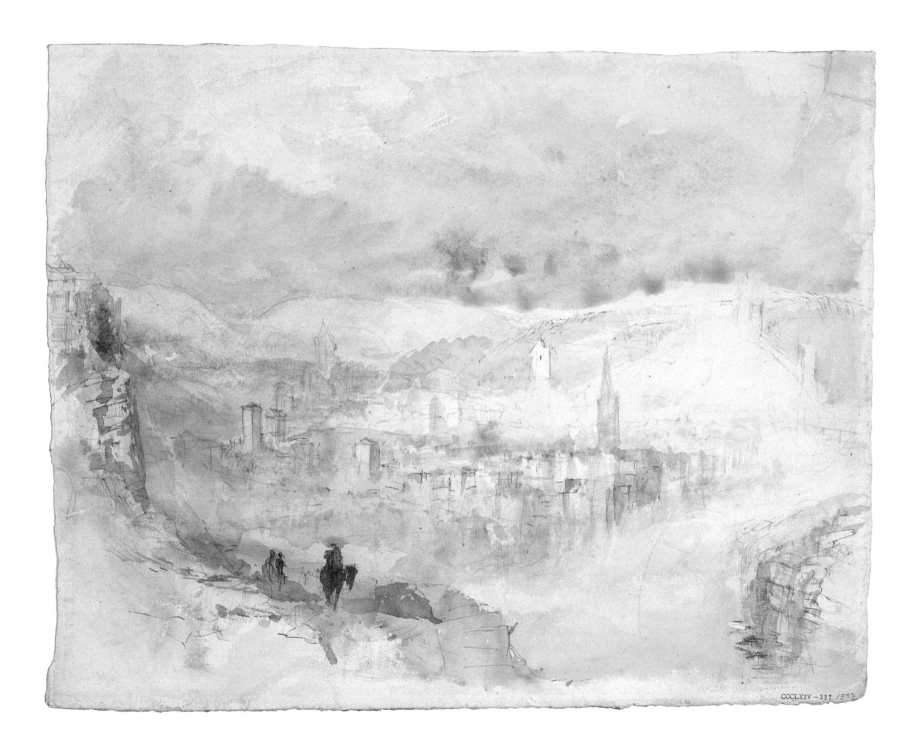

116 Schaffhausen town and castle 1845

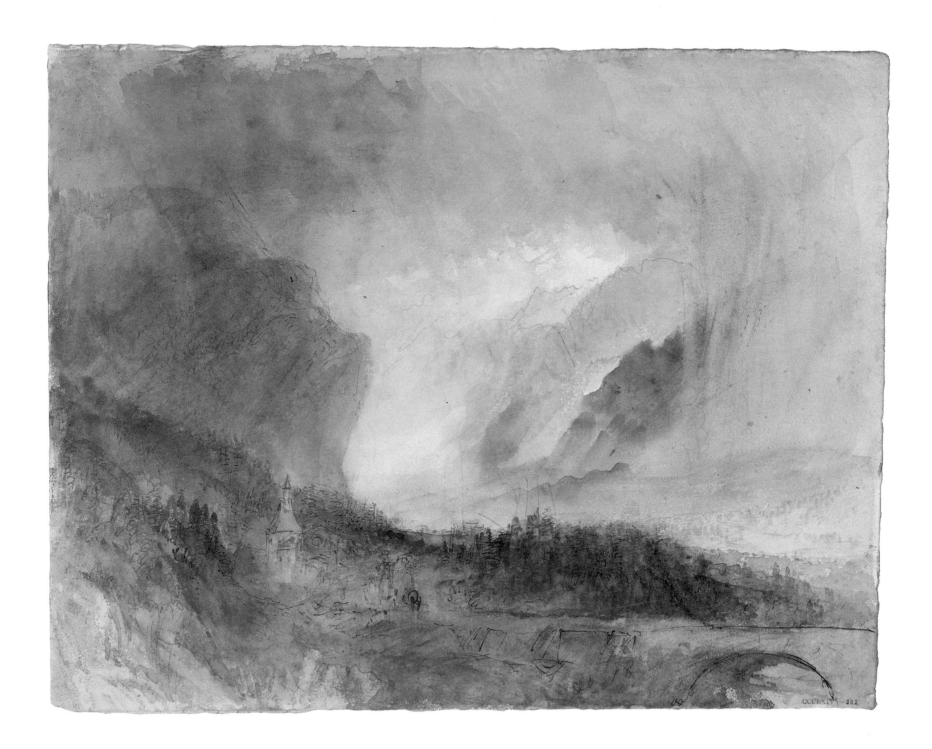

117 The First Bridge above Altdorf 1845

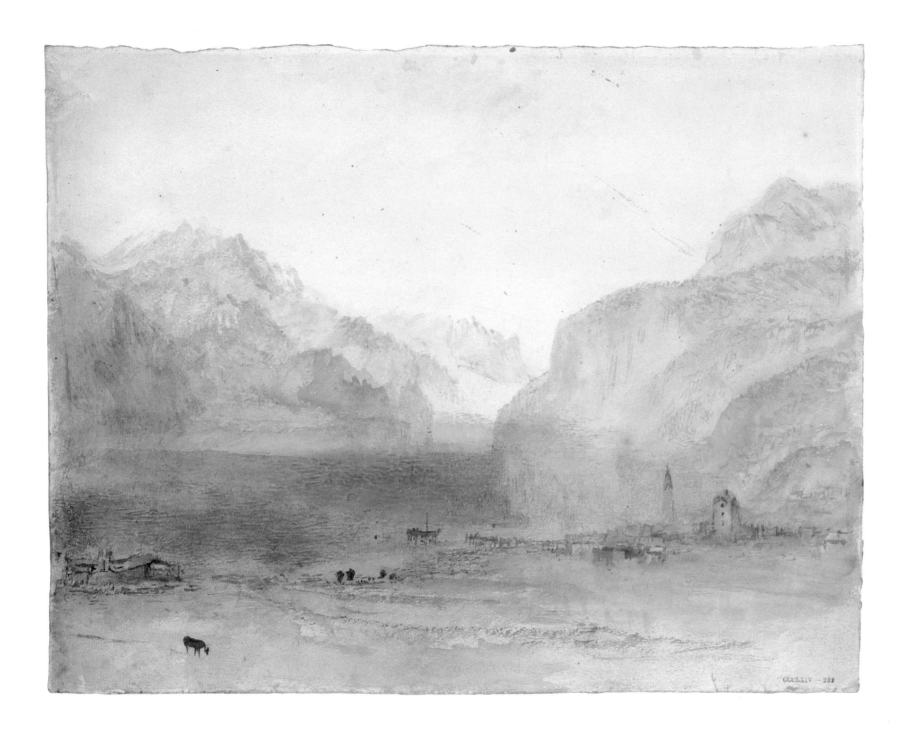

118 Fluelen: looking towards the Lake 1845

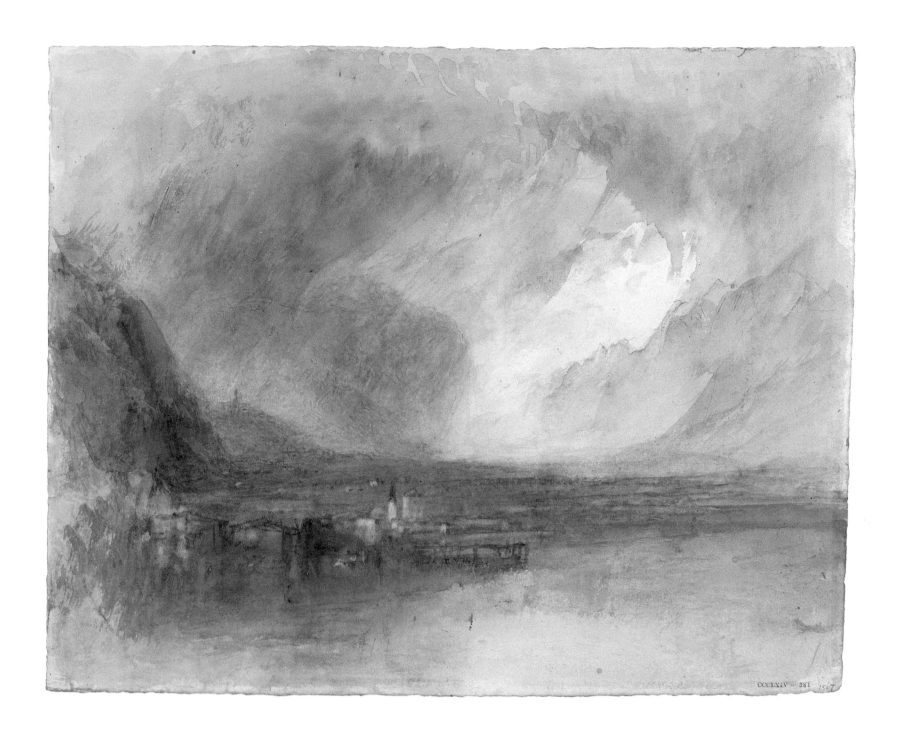

119 Fluelen: looking from Lake Lucerne 1845

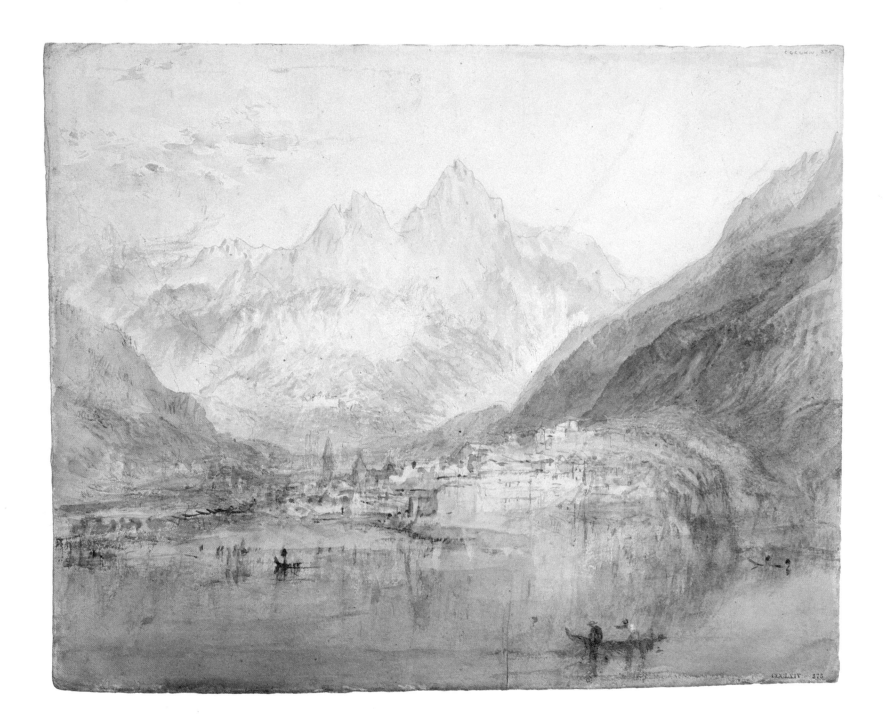

120 Brunnen 1845

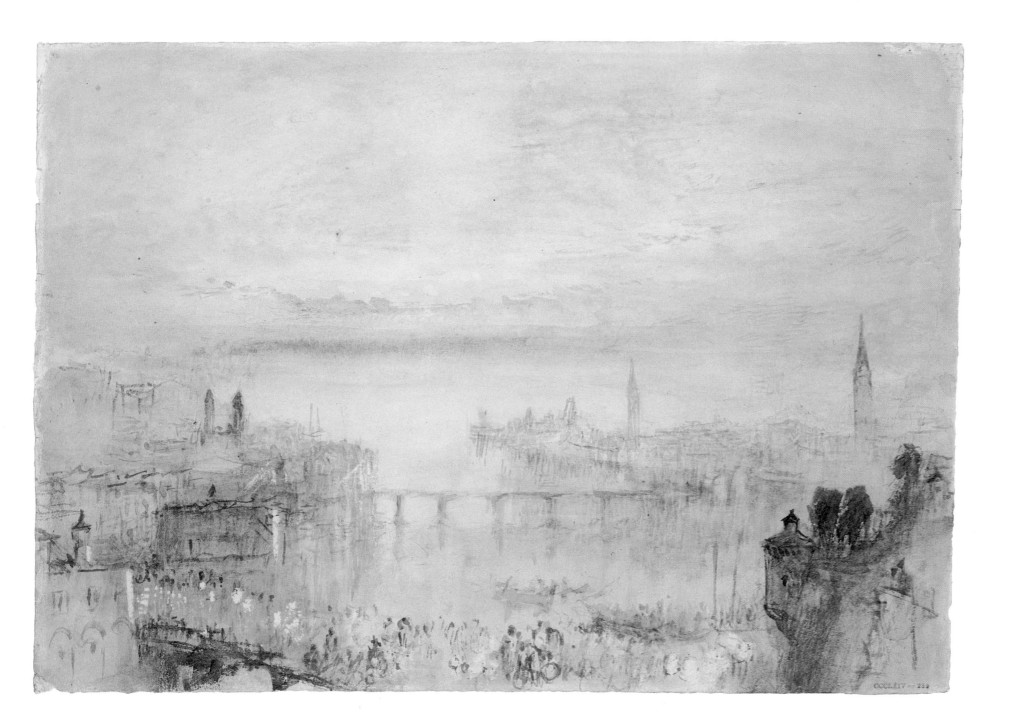

121 Zurich 1845

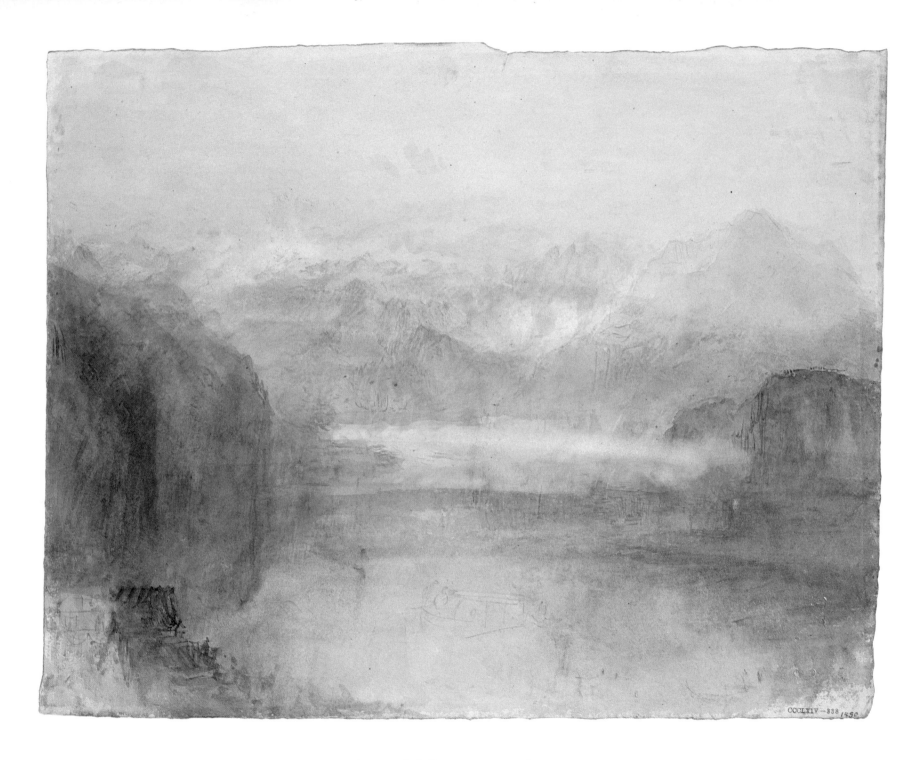

122 Lake Lucerne: sunset 1845

123 A castle near Meran 1844

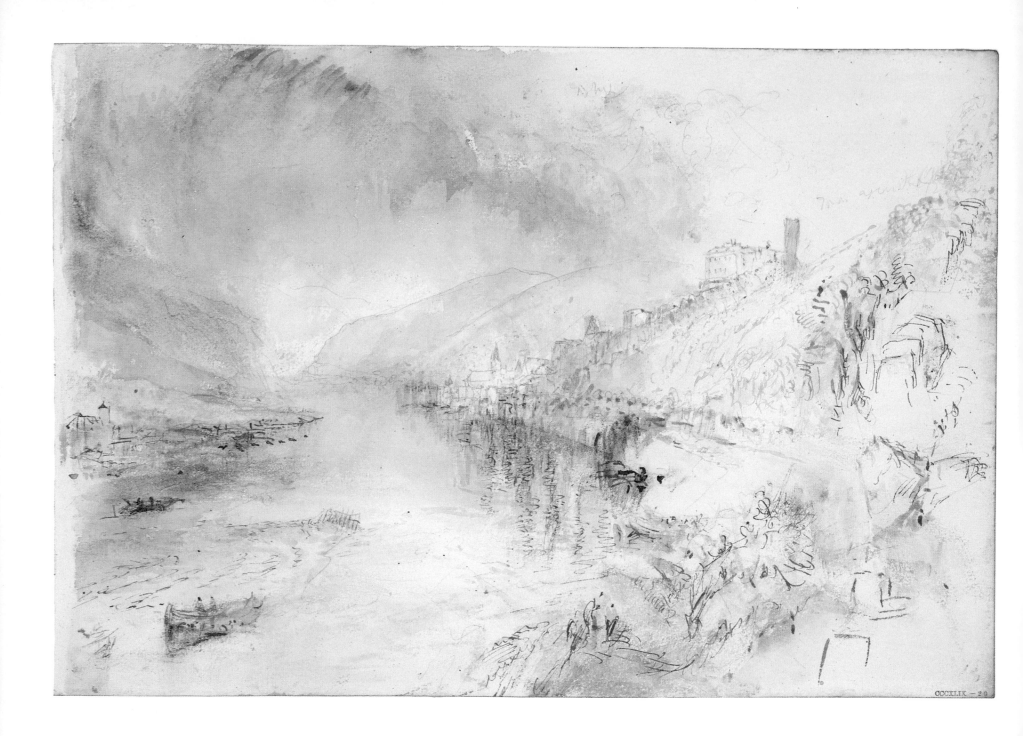

124 View on the Rhine: Rheinfelden? 1844

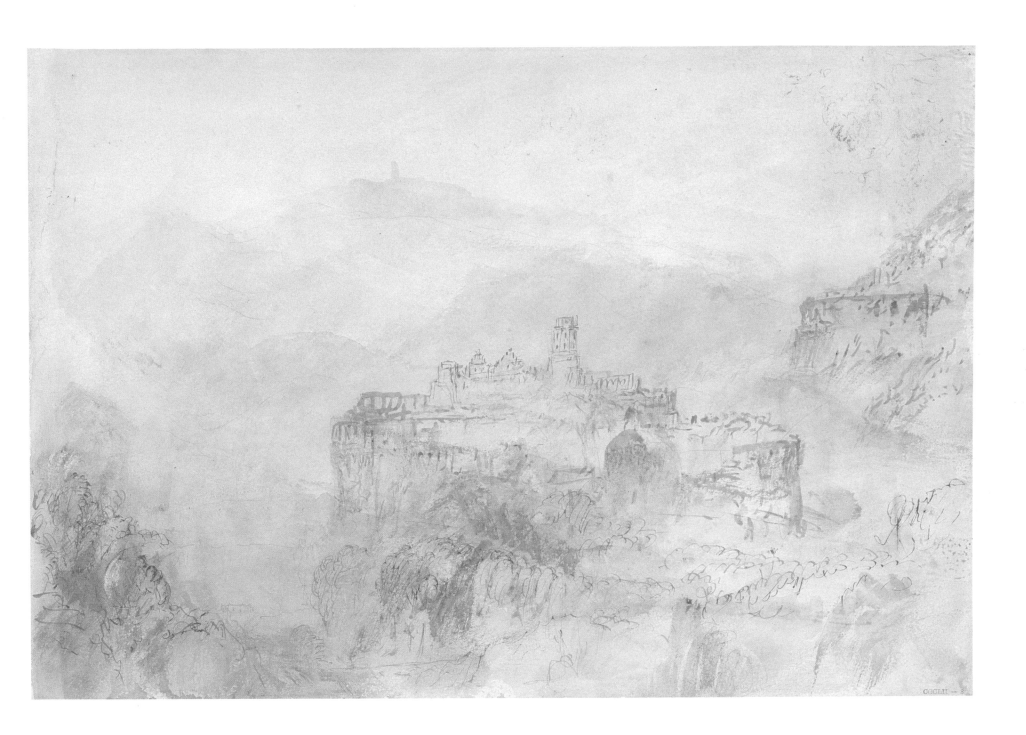

125 Heidelberg: looking down on the castle 1844

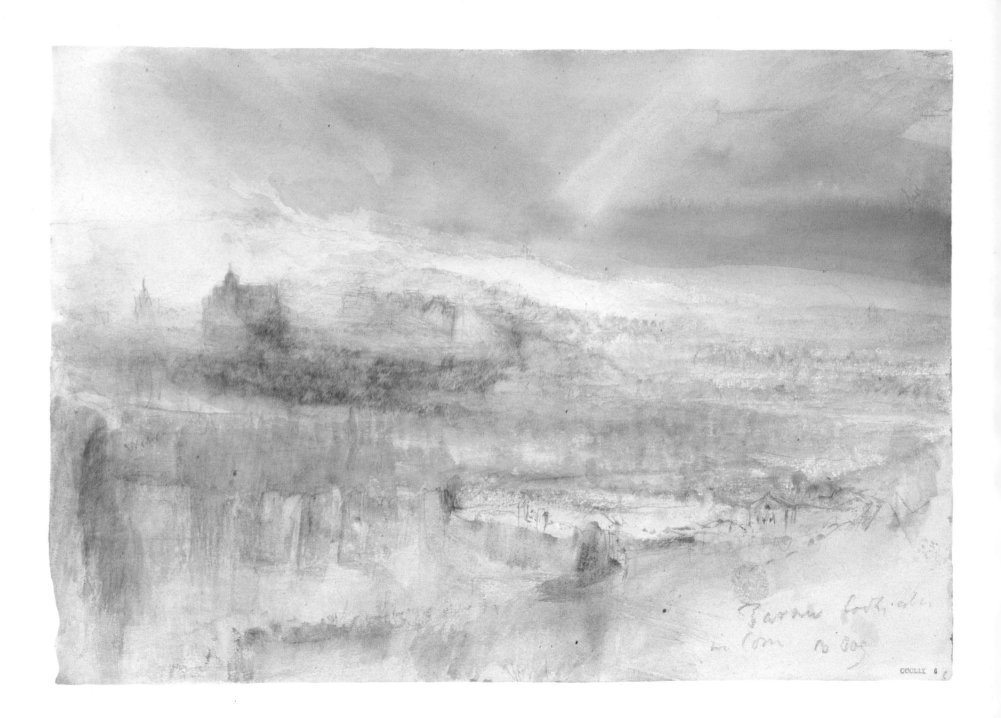

126 Eu, with the Cathedral and Louis Phillippe's Château 1845

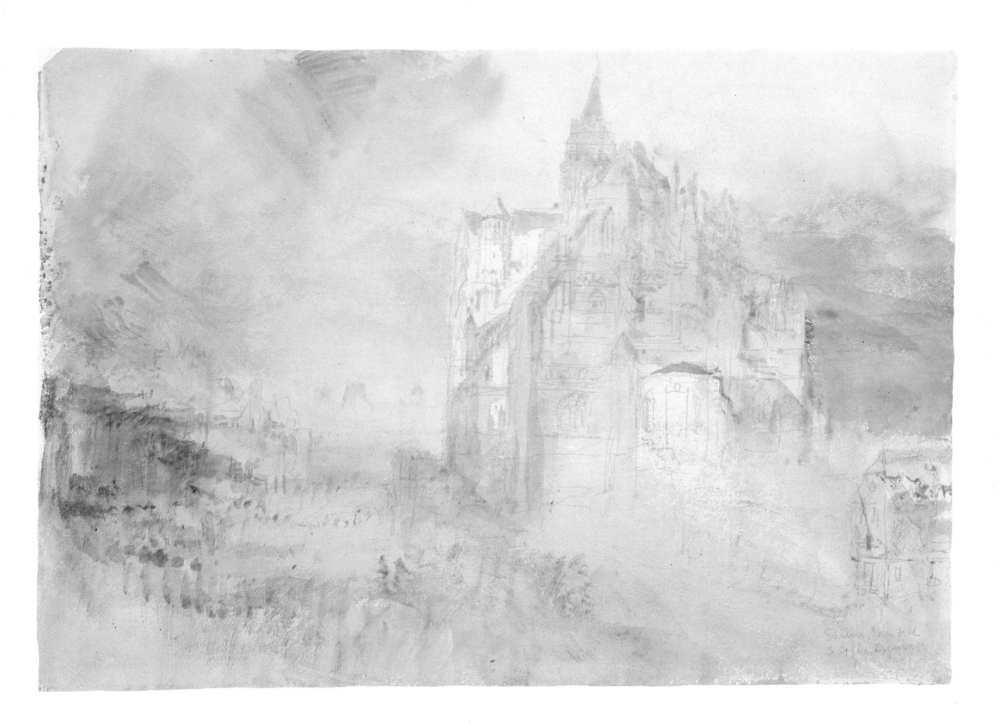

127 The Cathedral at Eu 1845

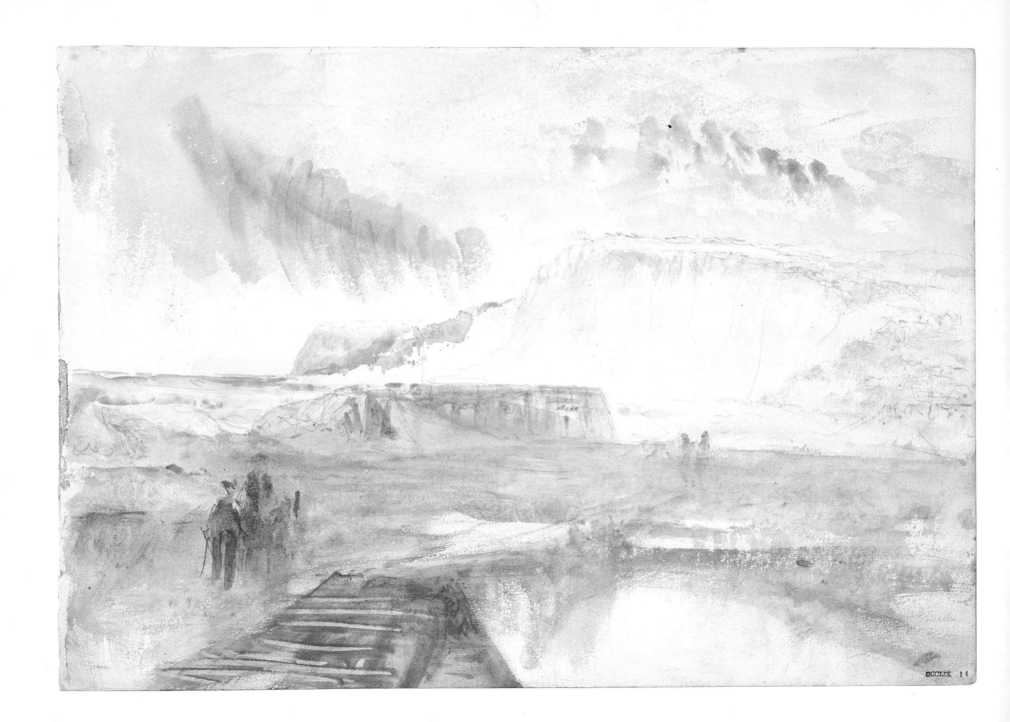

128 White cliffs at Eu 1845